C000285936

METALLICA
THE BLACK ALBUM
IN BLACK & WHITE

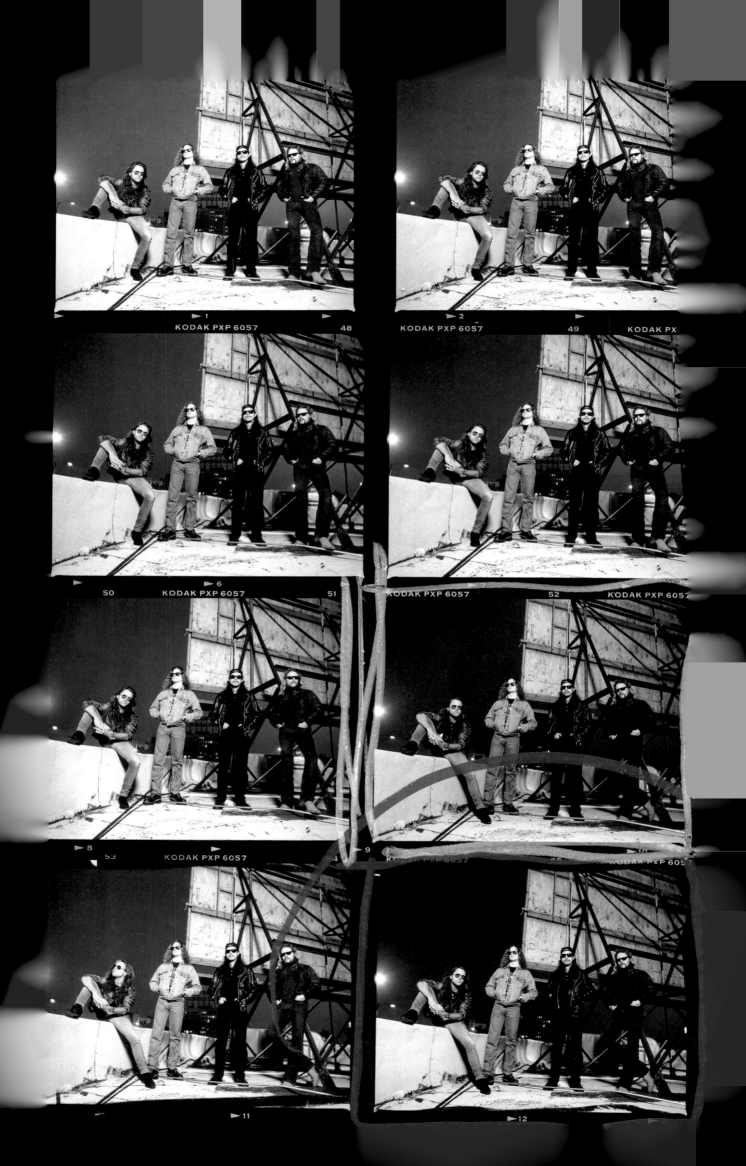

METALLICA
THE BLACK ALBUM
IN BLACK & WHITE

ROSS HALFIN

REEL ART PRESS

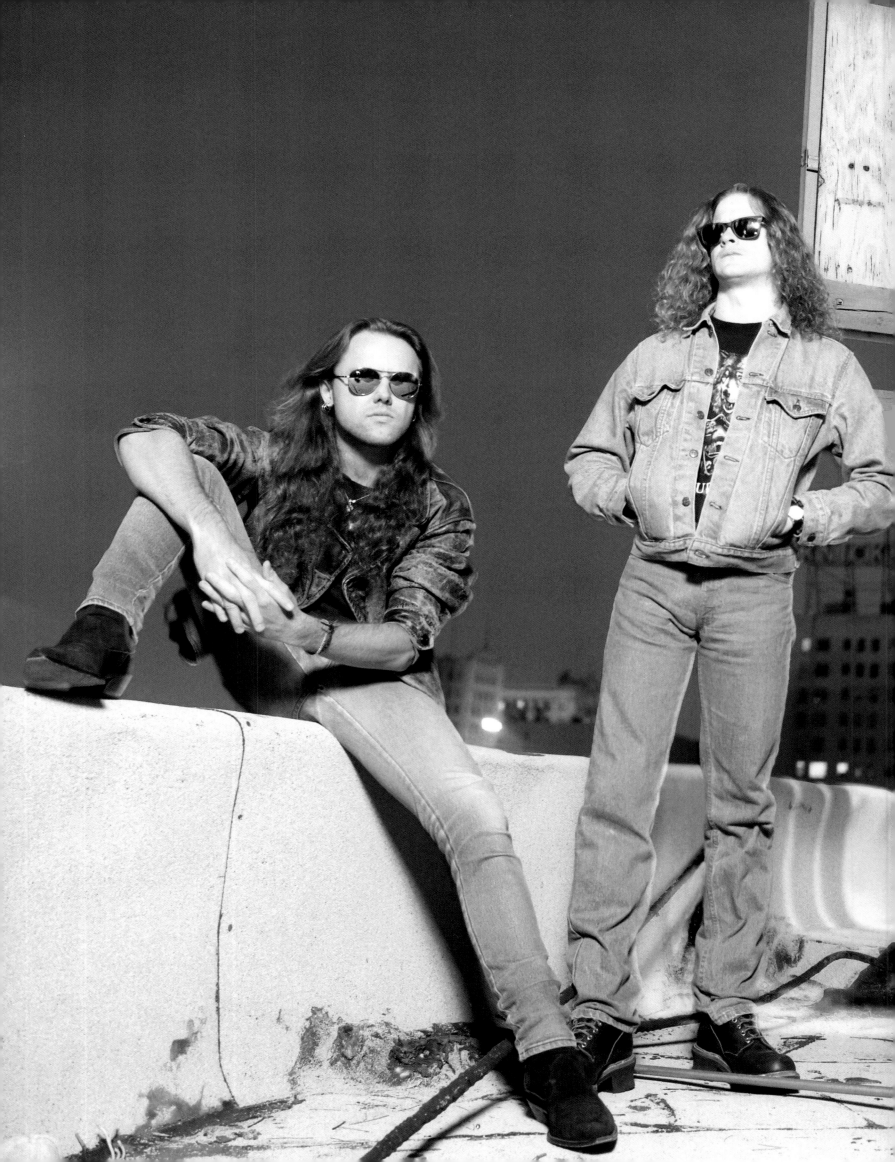

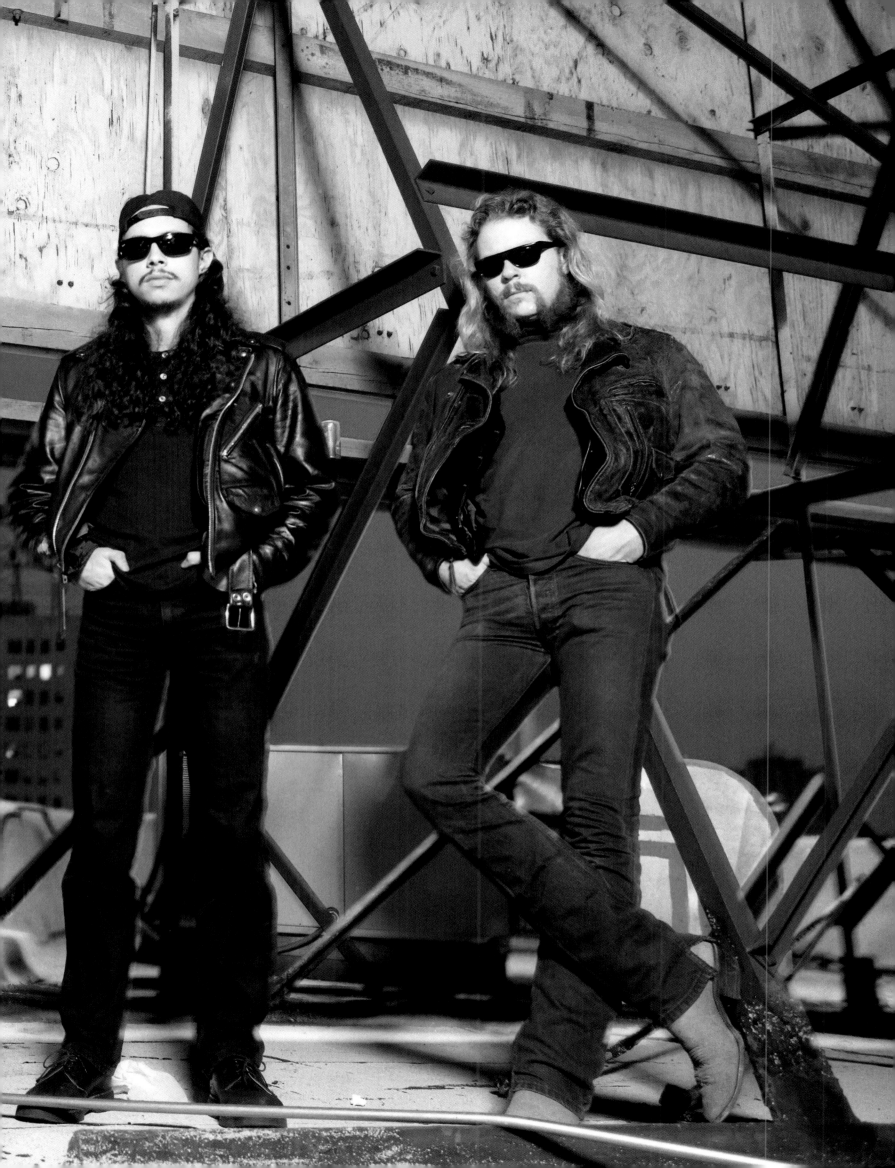

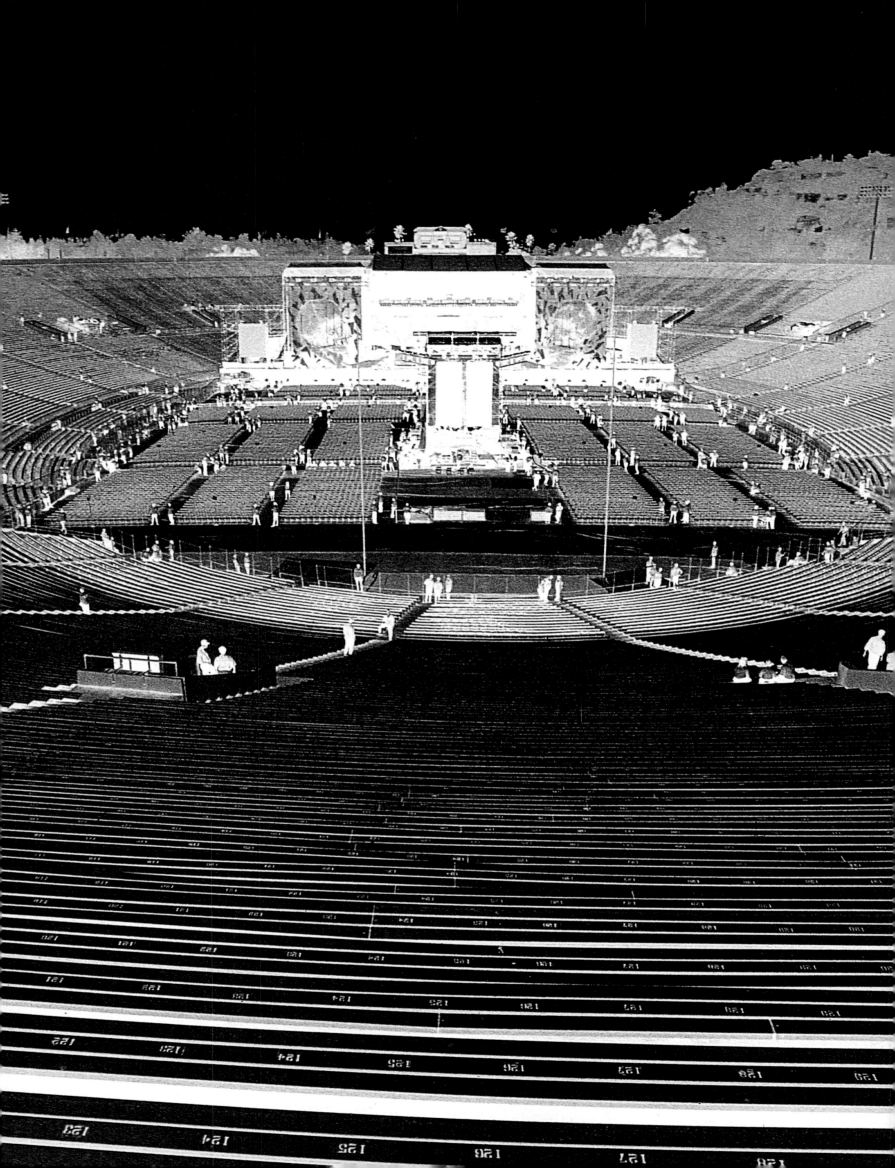

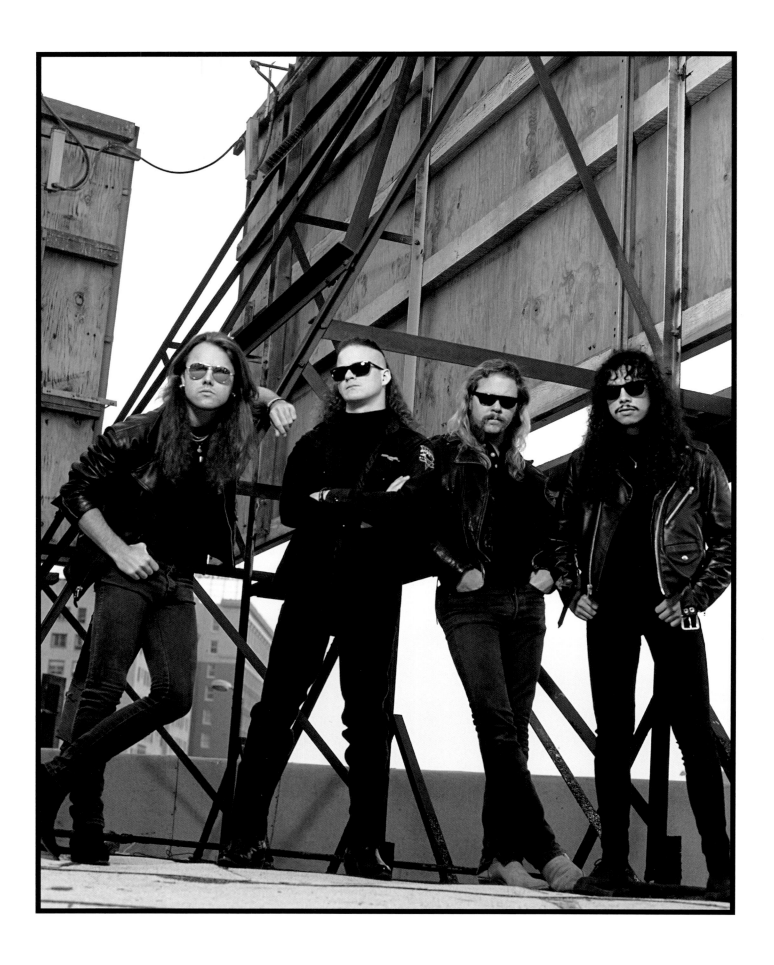

ROSS

What do I say about the *Black Album*? It turned Metallica from a large garage band into an arena then stadium act and it changed everything. By the end of the *Black Album* tour things were not the same. They got a private aeroplane for the first time, which I photographed them next to in Jacksonville, Florida, and James didn't want the photographs to be used because he thought it made them look too detached. I think he had a vision that the "kids" thought that they travelled around in a small bus, and the photos weren't used for a long time. Now, all bands fly privately.

I originally came up with the idea of doing the tour book all in black and white and as you got to the middle it exploded with the colour of the show. So with this book, I decided to go back and just keep it black and white. When I look at my old photos I always look at the black and white first, they stand the test of time. Here in black and white it shows the division from what the band were to what they have become. It is strange looking back at these pictures – I have a distinct memory of when they'd walk to the stage, it would be the tour manager, myself and the four of them . . . now that just wouldn't happen.

My relationship with Metallica is a strange dichotomy as I see myself as an all-round photographer – particularly with portraiture and reportage – whereas Lars purely sees me as a live photographer. When I'm shooting them on stage, I don't just wander around, I know what I want to photograph and my *raison d'être* is to always do it during the last song of the set and the encores. You won't see me up there during the first song (unless it's a stadium to capture the surprise of the crowd). I'm good at reading people. When you're up on that stage it's not simply a matter of sticking a camera in someone's face – you have to read the artist, whether it's James, Lars, Rob or Kirk, and you have to read the moment. I'm good at reading the body language of when they want me there or when they don't, and I can generally tell when someone is more focussed on what they're doing rather than interacting with me. I want to give you, the audience, the idea that you are there and what it's like to really be there, which is really how Lars views what I do for Metallica.

On the *Black Album* tour, we would always go to places and do pictures and we would stop wherever we felt somewhere had a vibe . . . you have to realise with Metallica, it's always about

the vibe. The idea of all of us walking around looking for spots to take photos would be more or less impossible today, but I suppose that goes with the territory of a band who have gone from a garage band to what they are now. The *Black Album* is very much the representation of when that happened. You could say it's their *Led Zeppelin IV* – or in their world, their *Number of the Beast* – it changed everything.

Thirty years on, they're not the same and you're not the same. I'd like to think that I'm still the same but I'm probably not either, you'd have to ask one of them.

I'd like people to view this as an art book. I'm serious, Metallica are an art. They always use that "Metallica family" expression – which, being British, I find a bit silly and rather cringe inducing – but then looking back at this, if you were there then you really are part of that family.

Werchter is probably my most famous shot, but I like the pictures from Berlin at the beginning of the tour and the shoot around Hollywood when they were just finishing the album – we'd spend hours doing pictures and have a great time. My all time favourite picture is the three of them, rather the worse for wear, taken at 3 a.m. flying from Moscow to London: Kirk is kissing Lars' finger, cut on his snare drum during the show.

This book is really just a collection of photos I like. I have so much from this era I could do several books. Some of these you will probably recognise and some you won't, but these are the ones that personally mean something to me.

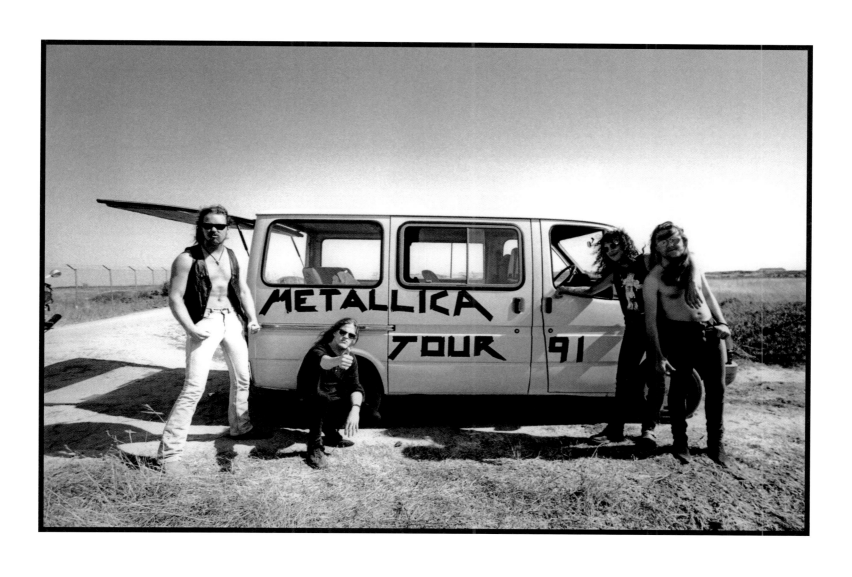

JAMES

Well, there's lots to say about the times around the *Black Album*. So many things changed for us externally after the album's release. The perception of the importance of Metallica changed greatly. Obviously with songs like 'Sandman', 'Unforgiven', 'Nothing Else Matters' becoming embraced by a lot of the world, we became a household name. It was on our terms as artists, but so much else was out of our control. Anonymity and flying under the radar, which had always been so easy for us, became more and more difficult. Dealing with fame and the strangeness of all the attention was not much talked about but had an effect on us. The dream that we had dreamt of reaching was happening. Touring for three and a half years on that album around the world was spectacular. Seeing crowds from all over the globe – despite our cultural differences we're all the same. Everyone showing their passion, love and identification with our music. A plethora of "firsts" resulted. We all knew that this was our calling in life and this connection made it very obvious. It changed our lives and hopefully helped the world connect. This book shows our amazing journey around the *Black Album*. It brings back wonderful memories for me and, hopefully, you.

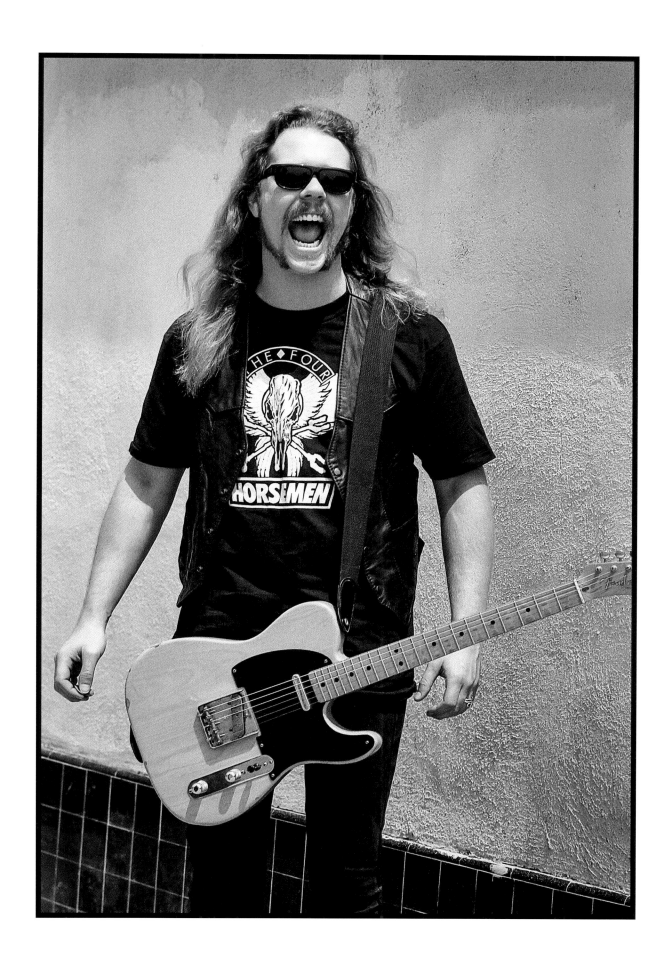

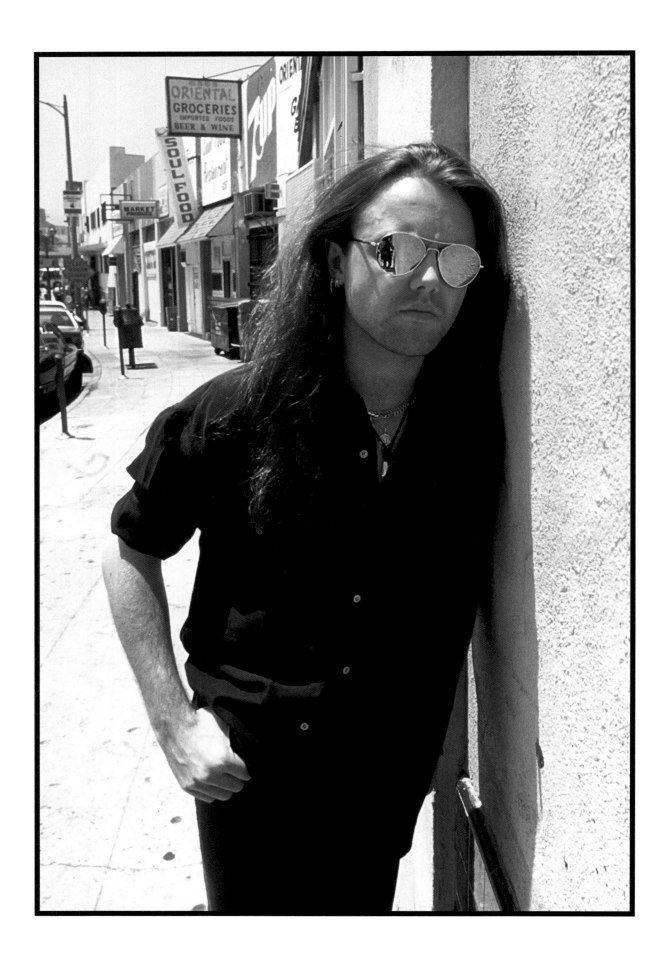

LARS

Ross Halfin . . . *Ross Halfin??!!* What could I possibly say about Ross that I haven't said before? And that he hasn't already said about himself through the years? Is there really anything to add to the legend? Maybe infamy is a better choice of word. I think this may be the 272nd intro piece I've been asked to write about Ross. I *did* initially ask whether I could just submit one of those old ones in place of a new batch of nonsense, but since the specific marching orders were to focus more on the *Black Album*, hopefully this time it will be different enough and I won't be repeating myself.

With Ross it boils down to one thing . . . being in the right place at the right time. Nothing more, nothing less. It's about access, it's about persistence, it's about being ready at a split-second's notice, having your finger on the trigger when something's about to go down . . . as it often does in the rock 'n' roll circus.

Right place, right time in this case plays out equally on three separate trajectories . . .

Firstly: by the time the *Black Album* was coming to fruition, the band was ready. Really ready. Ready to be photographed, ready to be lined up against a wall, lined up in a studio, ready to be placed in any given shape or configuration, ready to pose, ready to dress up, down, ready to be styled, and ready for whatever we perceived at the time it took to play in the big leagues. At this point, we were six years into our relationship with Ross, and we'd been doing numerous "get to know each other" dances in various scenarios, but still somewhat cautious, still somewhat mistrusting, still somewhat guarded, and not yet ready to open the door fully. By the time the songs and the recording were coming together, the confidence level was at an all-time high and we felt better than ever about who we were and how we viewed ourselves with regards to being photographed.

Secondly: as far as live shots are concerned, right time, right place is significantly applicable. Ross would always, unapologetically, maneuver himself to the front, to the side, to the back, to whatever fuckin' position was closest to your face or in your space to get the best shot possible. He constantly had the aura of being entitled to occupy whatever particular spot he found himself in, and on a rock 'n' roll stage with the shenanigans turned up to 111, most people run screaming away . . . but Ross goes further in, closer, unafraid and often finds himself in a place where nobody in their right mind would ever feel they had a right to be . . . other than, of course, the man himself, with his personality mixture of entitlement, aloofness, sense of belonging and

defiant right to be there. So his live shots would always feel more intimate, more in-your-face, and infused with more spit, more sweat, more chaos, more "how-the-fuck-did-this-shot-get-so-close" spunk than anyone else out there. And all four of us were soon willing enablers . . . letting Ross be the fifth band member on stage at most of the gigs on the *Black Album* tour.

Thirdly: since he was always around, inserting himself as the center of attention – whether it was at a hotel, in a vehicle, on the plane, in our dressing room – he pretty much consistently had a camera ready to go and capture any, what we call "fly-on-the-wall", craziness. And with Ross sharing our space, that craziness often got exponentially crazier. Like an early version of reality TV. Similar to the current "the digital cameras are rolling non-stop because they fucking can" mentality. Or today's "share what you're having for breakfast" social media attitude. He was just there, all the fuckin' time, and thirty years ago that was a pretty rare thing. So it gave him the access and ability to continuously capture those "fly-on-the-wall" moments because, for lack of a better way of saying it, we just couldn't get fucking rid of him. And between you and I and the four walls, as much as we heard ourselves moan and complain, we secretly did enjoy having him around and we all loved the way he televised to the world what we were up to at any given time. And when I think back to those three years, from the fall of '90 to the last show on the tour in Belgium in the summer of '93, there were a lot of people everywhere on this beautiful planet, fans and bystanders alike, who wanted to take the ride with us and experience the journey, no matter where we went, no matter what we were doing. In the almost forty years we've been doing our friendly little neighborhood rock band, there was *definitely* never a time when we were more up for it and keen in sharing what was going down than the first three years of the nineties.

Like I said, it all boils down to one thing . . . being in the right place at the right time. Nothing more, nothing less. . . . Well, maybe some extra-tight rock clothes, some extra-long hair with an extra hairbrush or two, an extra pair of rockstar shades, an extra couple of raised middle fingers and a fuck load of attitude . . . both from the subjects and the photographer. And Ross Halfin was absolutely *in* that right place *at* that right time.

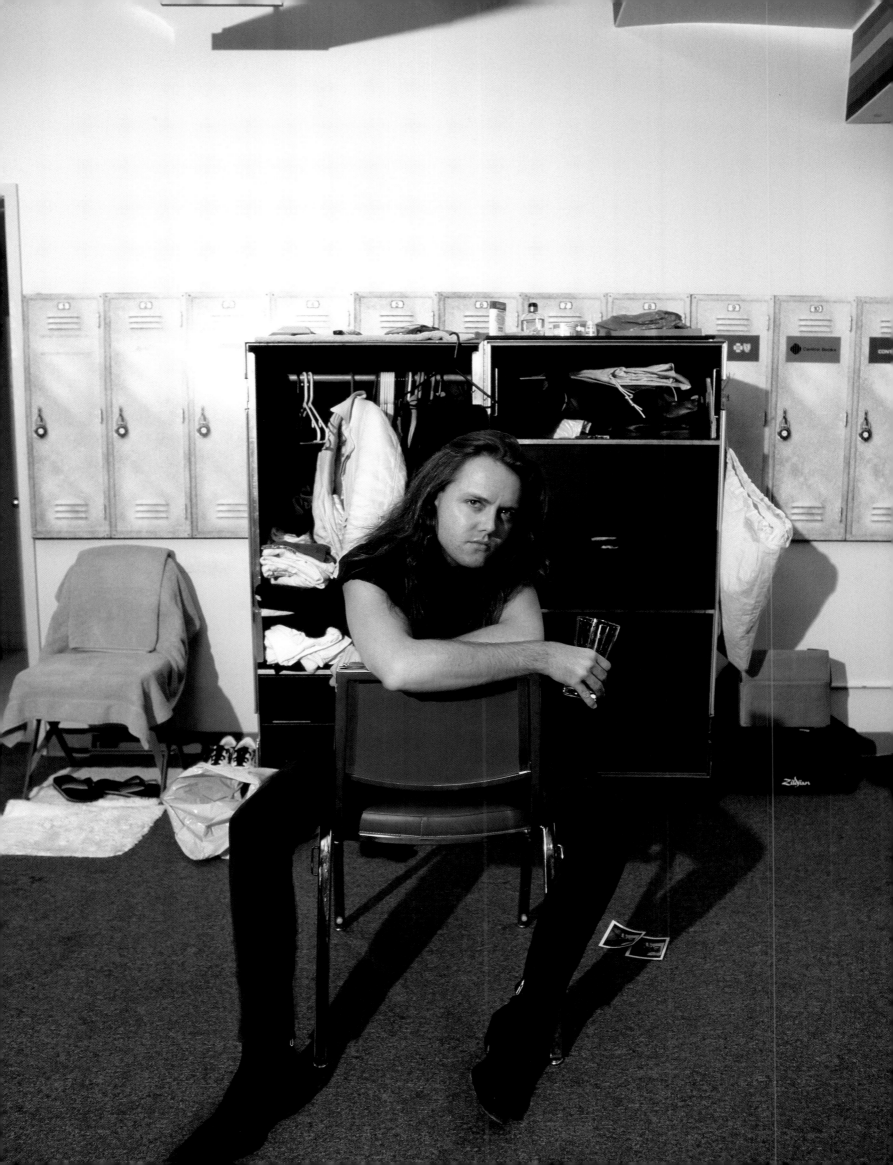

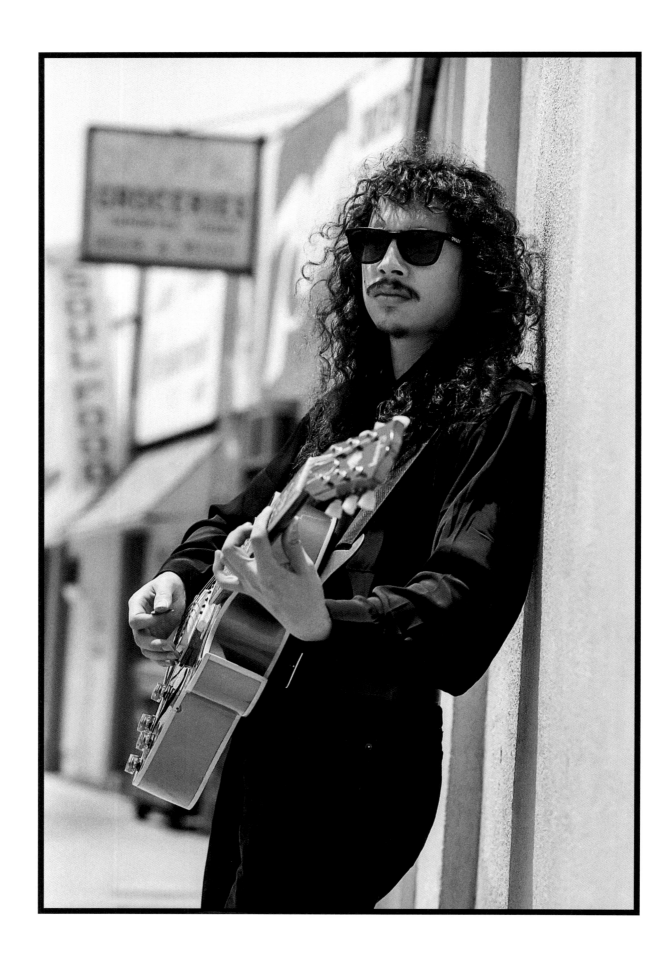

KIRK

Right. The *Black Album* . . . the recording, the never-ending tour . . . I remember Ross coming out two or three different times while we were recording the album to take pictures. While we were doing the drum tracks, while we were laying down guitars, during mixing . . . he came out to the studio at different stages and every time we took a ton of pictures. And some of those pictures ended up being the black portrait shots that came with the album; those four dark, surrounded in the shadow, portrait shots. That was Ross's idea. He had heard we were calling it the *Black Album* and he said, "Well, if it's going to be the *Black Album*, let's do black portrait shots." So that's how those came about.

I remember when he finally heard the music, when we were in the final stages of mixing everything. We went out to the studio and took a bunch of shots and one thing I remember is waiting to see if Ross would mention anything about the music. There have been times in the past where we've finished an album and he'd come out to take pictures for it and he'd always mention the music. Well this time, with the *Black Album*, he didn't mention the music at all. Not one bit. Which says to me that the music must be really good because he can't think of anything to criticize. He can't think of anything to say about the *Black Album* to wind us up about because the album is so streamlined in the way it sounds. It sounds like it's supposed to sound. Even to this day he doesn't really talk about it. He talks about our other albums a lot. He talks about *Master of Puppets, Justice For All, Load*, all the albums . . . but he never really mentions the *Black Album*. It's actually something I've always been curious about, but I guess it tells me he liked it somewhat, because to me it feels as if he's showing respect for that album, which he doesn't show for a lot of the other albums.

And it was around this time, working on the *Black Album*, when we started getting into the whole concept of photo shoots. We began paying attention to that side of it, doing portraits and group shots, not just a bunch of live shots. That was around 1989, 1990, when we decided that group shots and portrait shots were good. If you look at the photos before then we didn't really have a lot of band group shots because we didn't think they represented the band correctly. But then something changed and we started doing a ton of them with Ross.

It seemed like every six or eight weeks we were doing another photo shoot for the *Black Album*. We did a lot of black and white sessions; against white walls, getting contrasts and shadows. And I think this is because all of a sudden there was a demand for it. Because the album was doing so well, people wanted pictures. They wanted new pictures. Refreshed, up to date, contemporary shots, and it seemed like even if a picture was a couple of months old, they would still want the newest shots of us, so we called Ross a lot. He'd come out to Portugal, he'd come out to Budapest, Los Angeles, London . . . we did so many photo sessions during that time we were meeting up with Ross on a regular basis. That's just how it was and that's why there's such a large amount of pictures from this period.

And then on top of that, we all thought Ross's live shots were the best live shots out there. When he shoots live, he is the best, so it was really important for us that we always had the best live shots. It was also really important that people saw the Snake Pit stage. At that time, it was something we had to sell to our audiences. It was a different sort of thing. People didn't know what to expect, so it was important to get those pictures out there. It was also important for us to have good shots of us out on the road and actively working. We wanted to give these songs and this album the highest profile we could give them and Ross was ready and willing to do that. To this day, I still think he's one of the best live concert photographers ever.

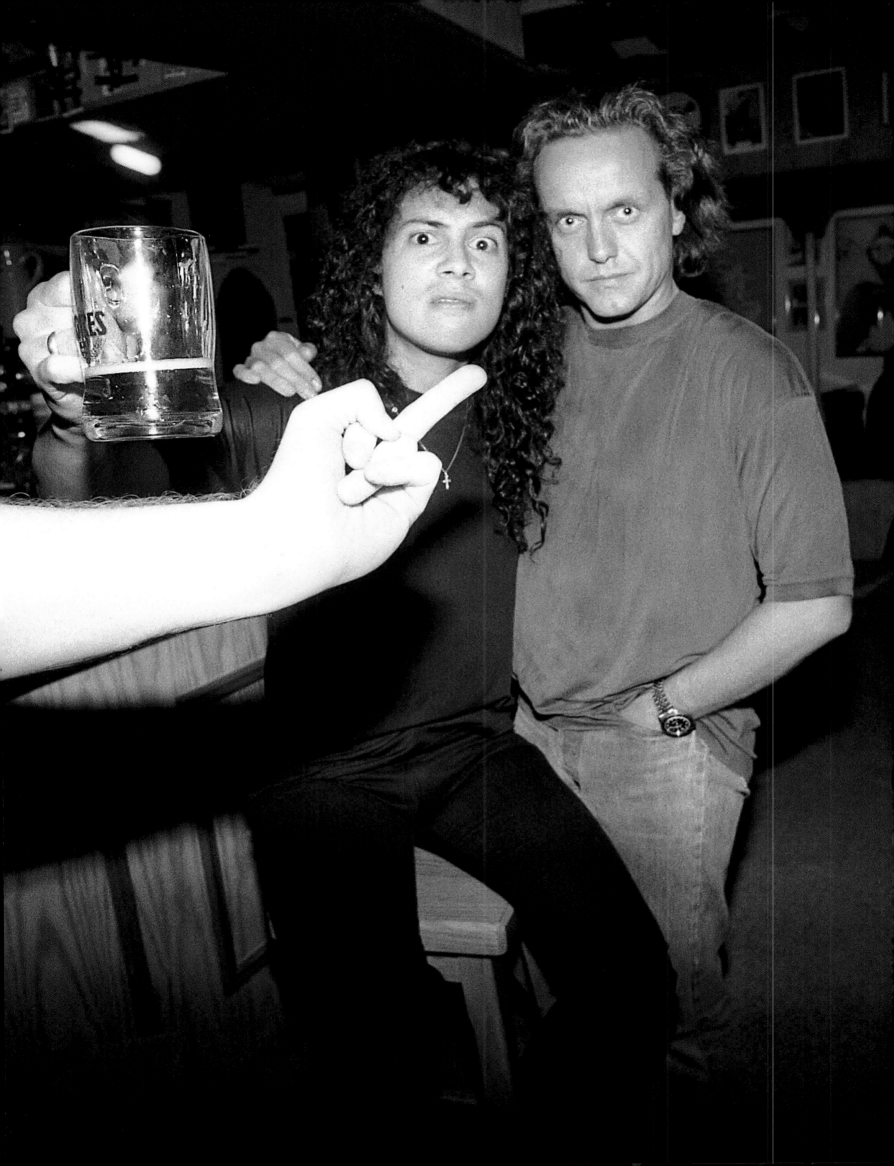

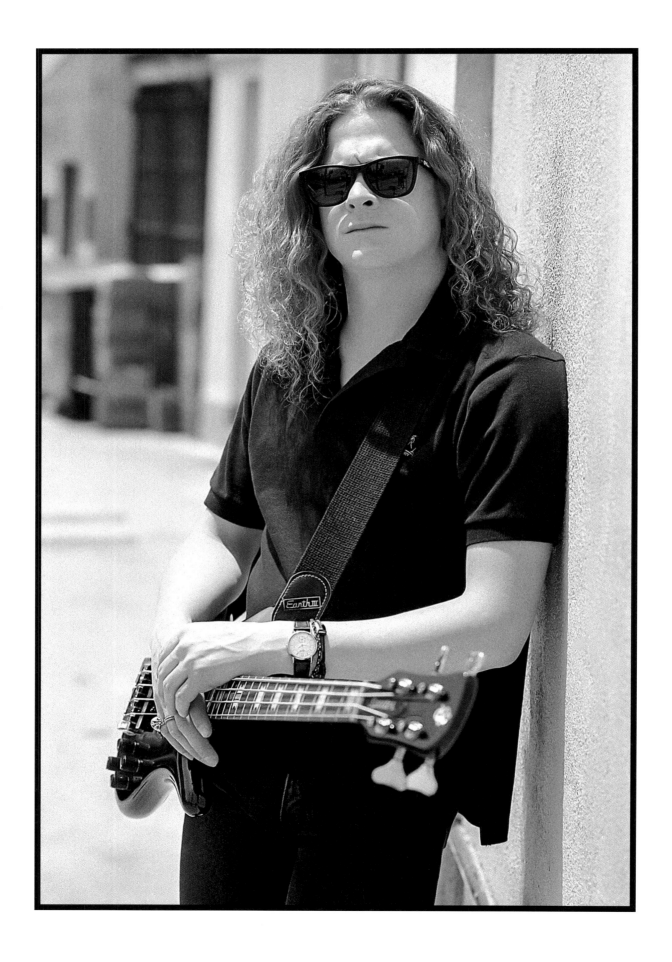

JASON

So many new places, faces and spaces for us to experience together as a band, as a gang, as conquering heroes. *The Ambassador Kings of American Metal Music!* That's how I would sum up the time spent on the massive tour that supported Metallica's fifth album. We would fit so much life into a day.

I had joined the band in 1986 and we hit the ground running, not coming up for air until some time in the fall of 1990, on the heels of our first world tours, first global music video and first Grammy.

In October of that year we gathered in Los Angeles, with a new producer, to work on what would become the most successful album in heavy metal music history to date . . . and once we embarked upon the '91-'93 tour and got our war faces on, Metallica was like an unstoppable locomotive rolling down its own track!

Save for AC/DC and Iron Maiden, no other heavy band had taken on such an extensive tour in support of such a popular album and played for so many people that had not been exposed to our type of live performances. Sure, fans had a chance to hear the recordings and see the posters and pictures, however, as there was no internet yet, we had to take it to the people in all corners of the globe in the flesh. It was a feeling of importance, of relevance, of pioneering as Ambassadors of American Music. Groundbreaking.

Angus and Maiden had dared before and won in a great many of the places that we played on the *Black Album* tour . . . but we were the first of *our* kind to make these trips victoriously.

Victorious. Invincible. Bulletproof. The respect that was being shown by promoters, agents and, of course, the fans was, at times, at levels we would not have been able to predict or expect . . . a true test of us as individuals and as a collective. A general overwhelming demand on our time and attention and suddenly greater responsibilities; hundreds of interviews, numerous photo sessions – surprisingly not all of them with Ross Halfin, although looking at the pictures in this book it's difficult to believe anyone else got a chance – video shoots and award show performances. No one wanted to be the weak link, we had our workout regimes and diets organized by then, and we became a finely-tuned machine with great self-confidence. As we saw it, together, as this entity larger than us. . . . We had a very important trail to blaze and flag to fly . . . louder than ever.

All of the miles, sacrifice and hard work had prepared us for this monumental challenge, and we seemed to take it in stride, at each other's side and otherwise. Importantly – because of the commitment, loyalty and outright badassery of our road crew, management, and the folks that traveled with us – we were set up for success, repeatedly, night after night, town after town, country to continent. At one point, the record was Number 1 in 35 countries, if I remember correctly. All shows sold. To think of it now as I open this portal, the feelings are fantastical and emotional. We were firing on all cylinders, and proud of each other, and proud of what we had accomplished . . . truly excited about what we were doing and going to do. Poised to rise. Poised to conquer.

ROBERT

Being a native of Los Angeles and a musician who had the great fortune of recording at the now legendary One on One studios in NoHo (North Hollywood) – home of the famed *Black Album* recordings – just after Metallica had been there, I remember the energy of the city. It was filled with excitement and genuine creativity. Heavy music was at the epicenter of all the magic around town, from Ozzy, to Slayer, to Suicidal Tendencies, to Alice in Chains, to Social D', to GnR, and so many other great bands. But without a doubt, it was all about the mystique, the lore, the power and the presence of the mighty Metallica, thrash outlaws, who were in L.A. bringing their masterpiece to tape in *our* town and *our* backyard. The *Black Album* is the statement record that propelled this amazing band to a whole new height of creative and commercial success, achieving a certain incredible balance of melody, kick ass riffage, and dynamics.

I was one of the lucky ones who got to ride the *Black Album* magic carpet by being in Suicidal Tendencies and opening for 'Tallica' during most of the '93-'94 tour (both in Europe and the U.S.). So these images that Ross Halfin has documented, actually these works of art, are the memories of that time period. From One on One studios to the magic of those international shows . . . and even my memory of that massive bottle of Jaegermeister that I shared with Lars and James in Madrid to finish off that final *Black Album* European tour date (sorry, no photo of that, just a fun personal memory!).

I have to add that Ross always brings his own unique attitude and edge to the eye of any rock 'n' roll storm, always making powerful, beautiful, visual statements like you see here that equal true art, and even at times risking what we call in our hood a "sock up" or a beat down for his and your troubles! Good ol' Ross, how can we not love this man?! When it's all said and done, he captures the image, he captures history and he does it with unique insight. Enjoy this journey from Ross Halfin's lens to your eyes, hearts and souls.

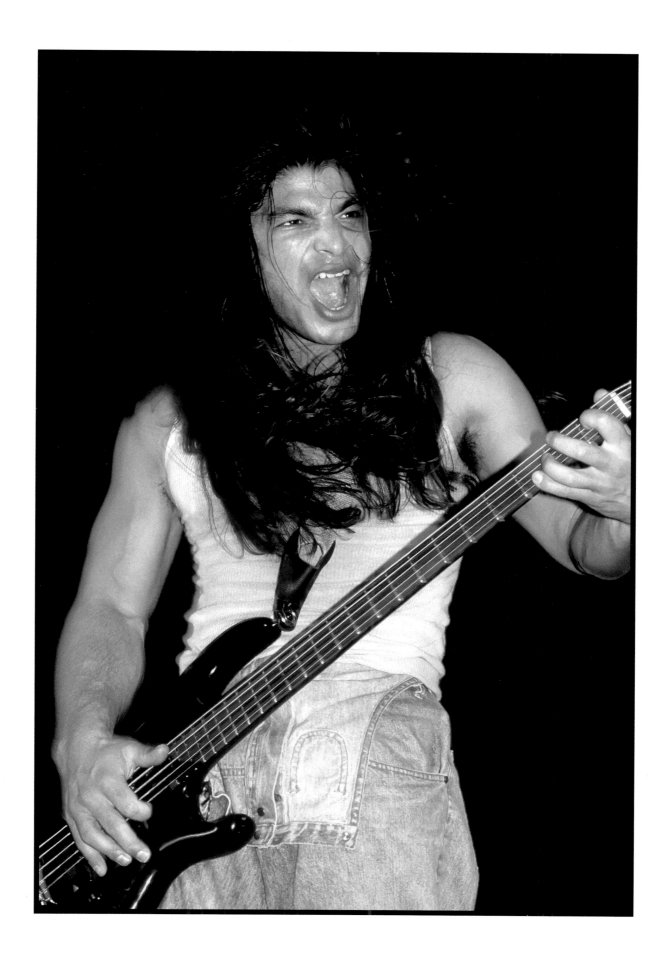

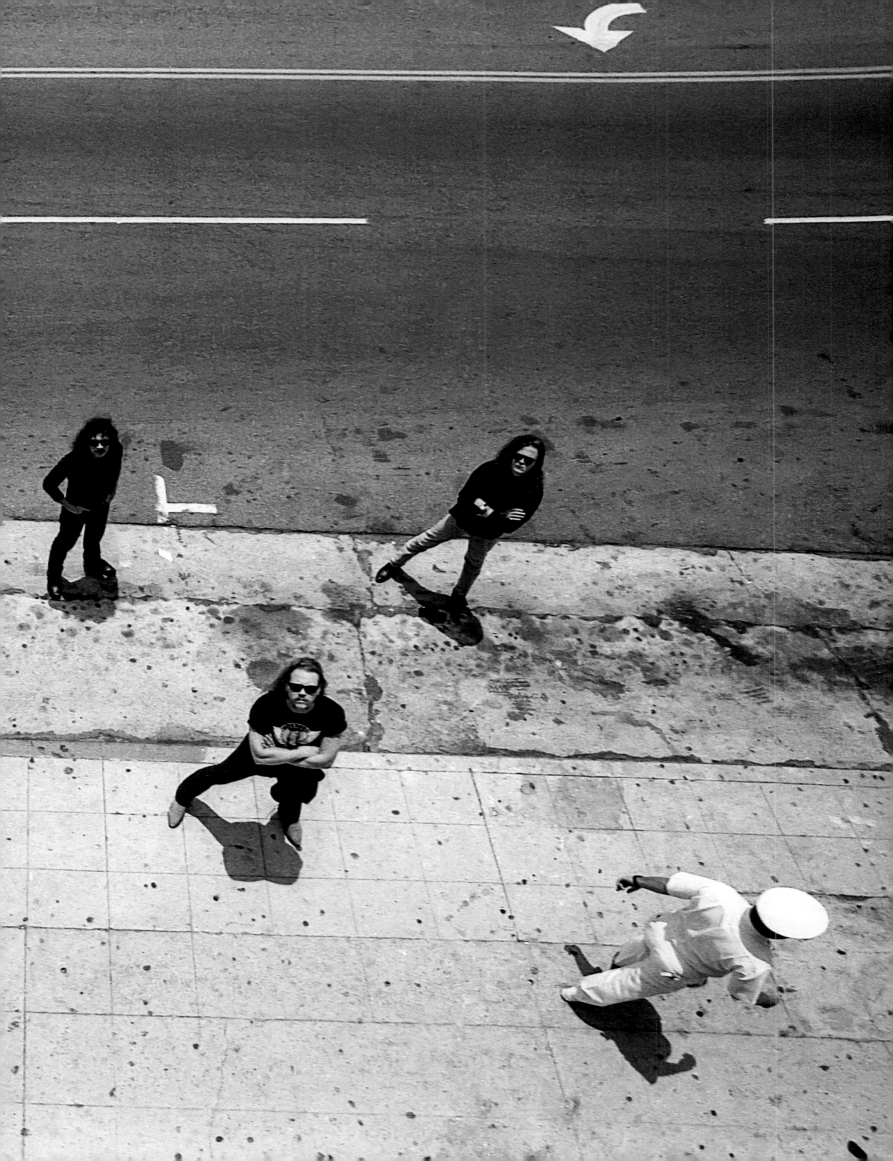

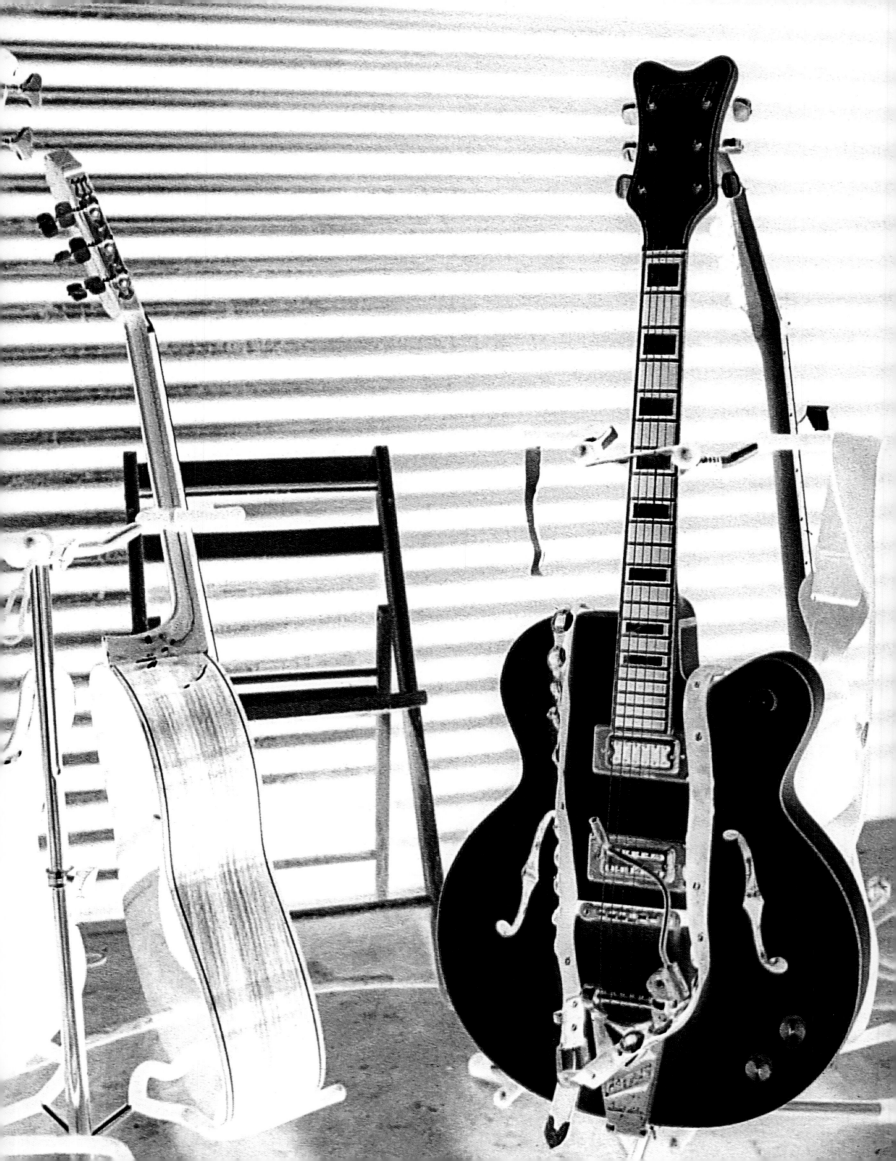

HOLLYWOOD

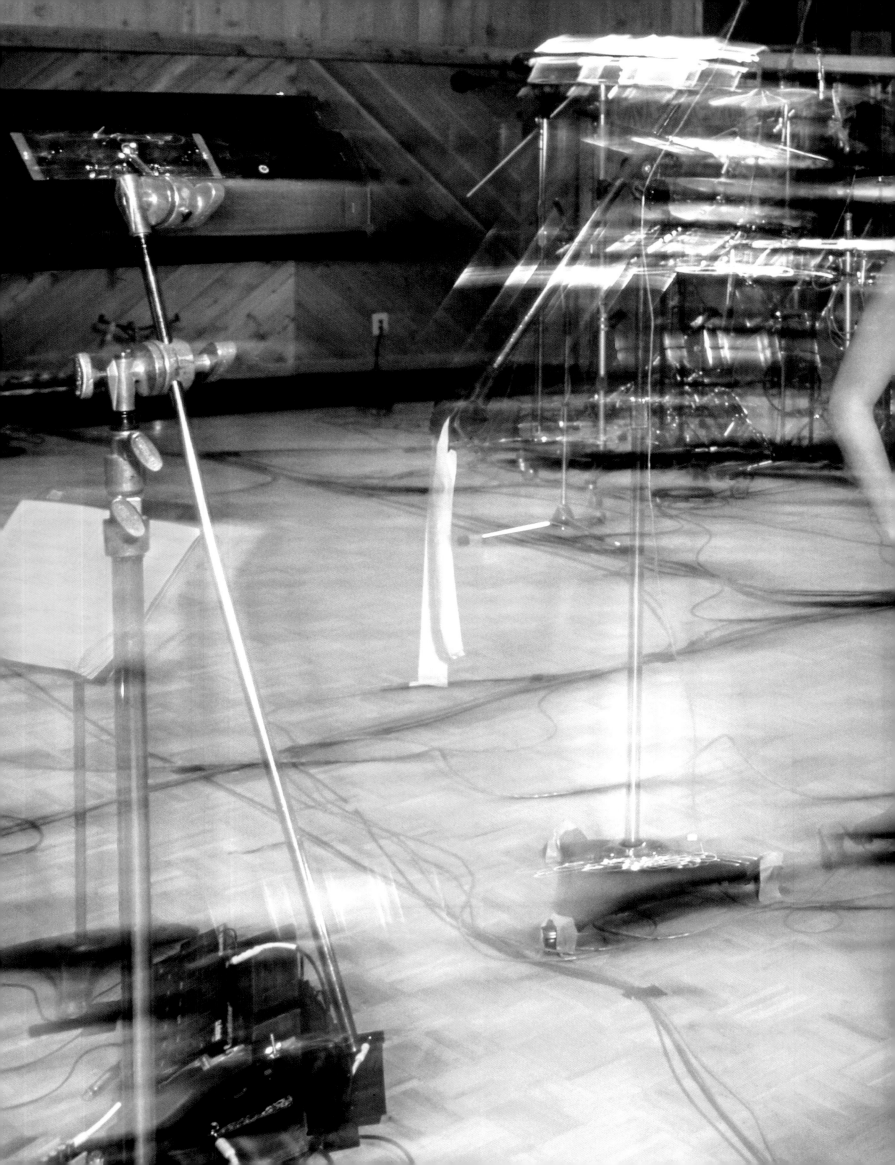

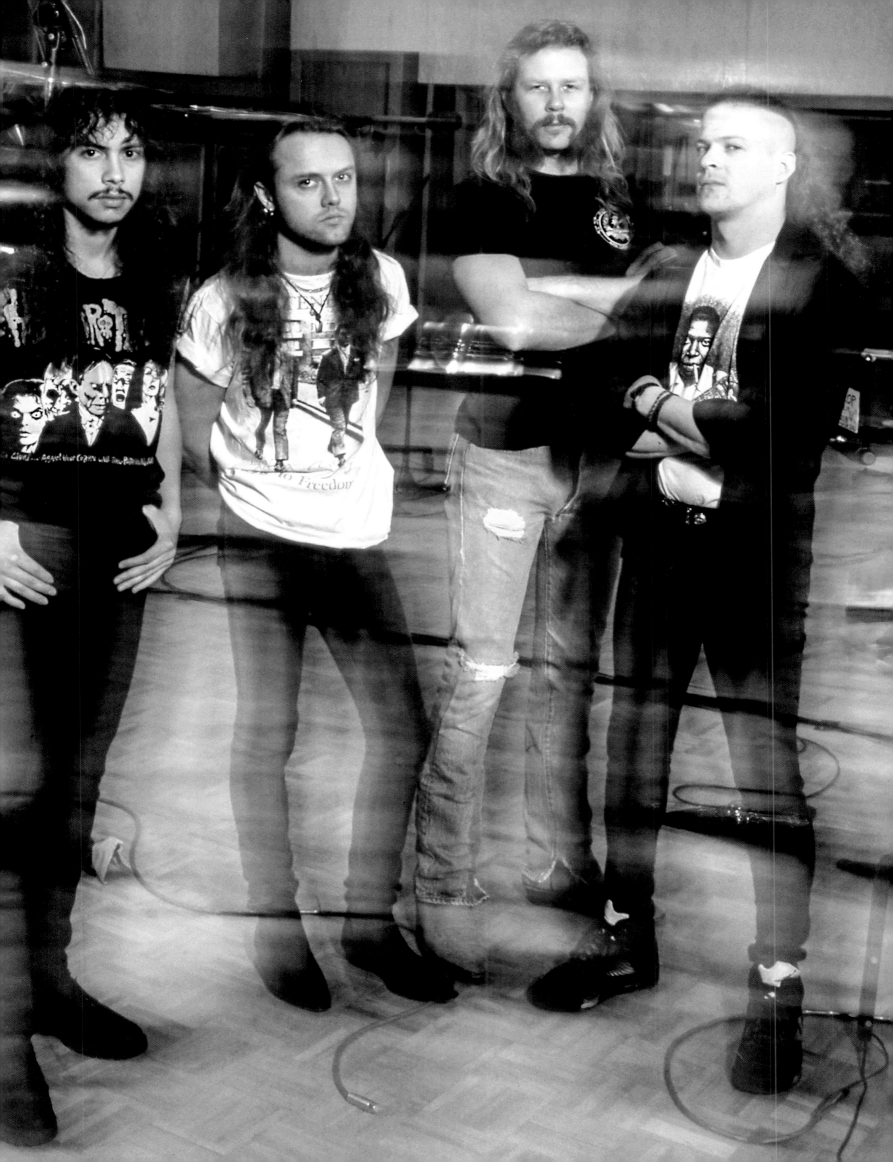

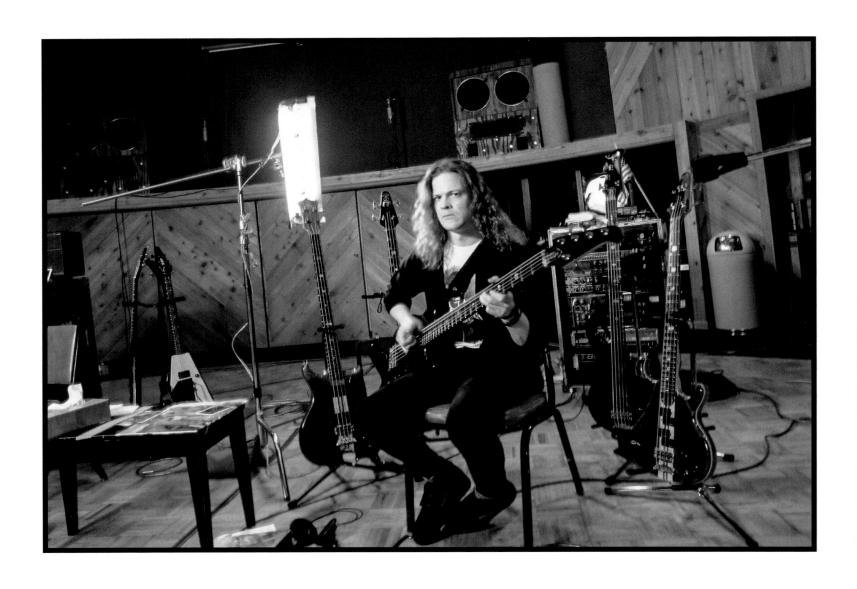

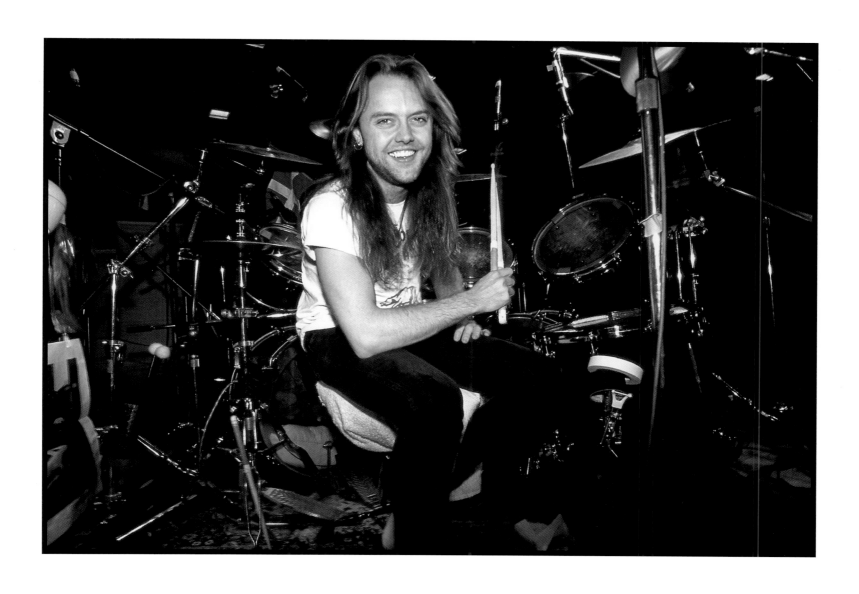

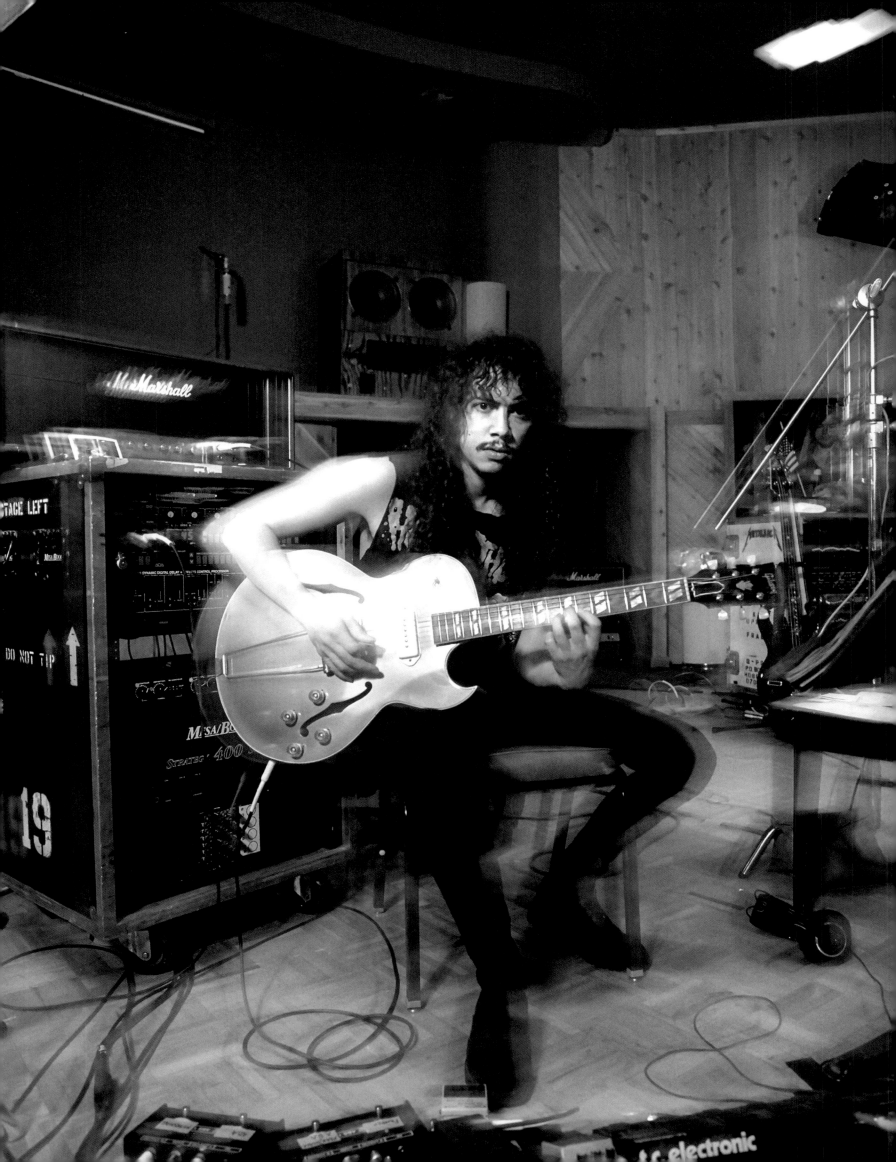

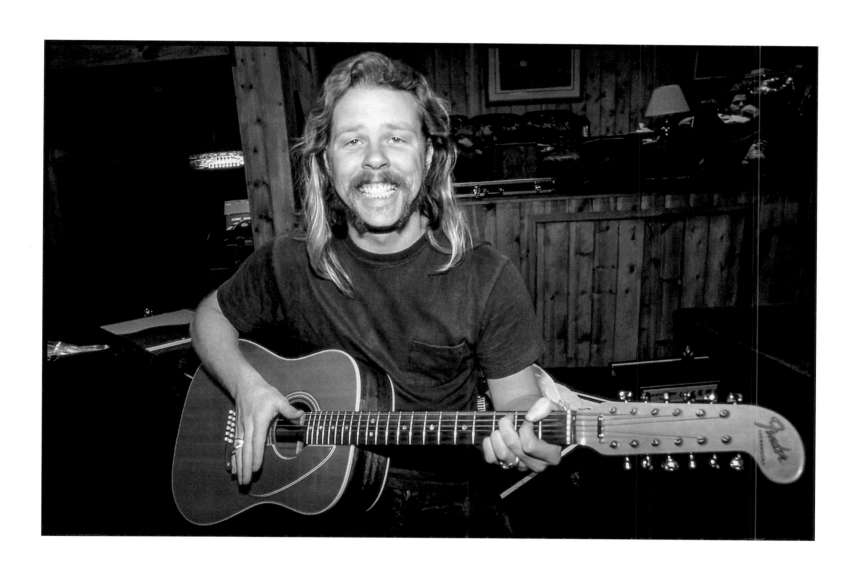

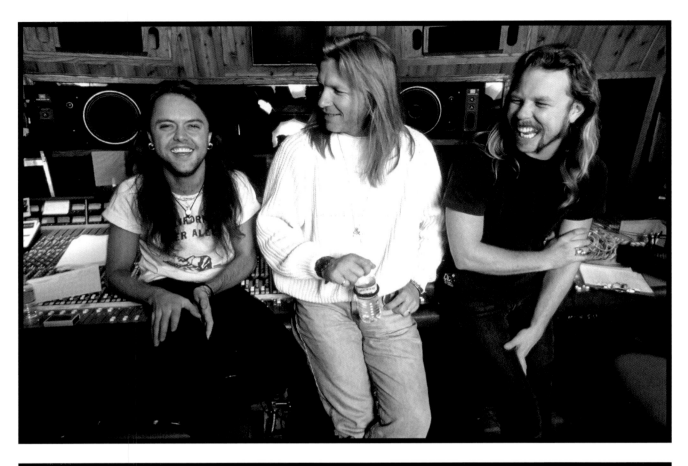

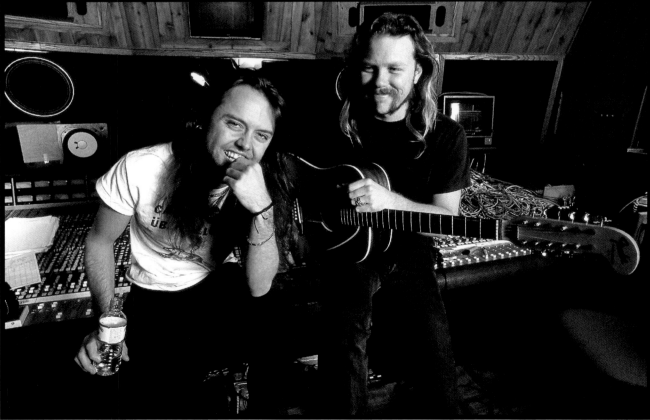

By the time the songs and the recording were coming together, the confidence level was at an all-time high and we felt better than ever about who we were and how we viewed ourselves with regards to being photographed.

LARS

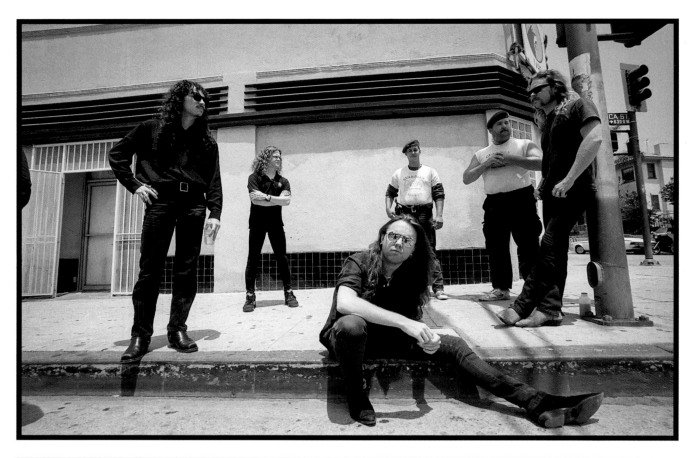

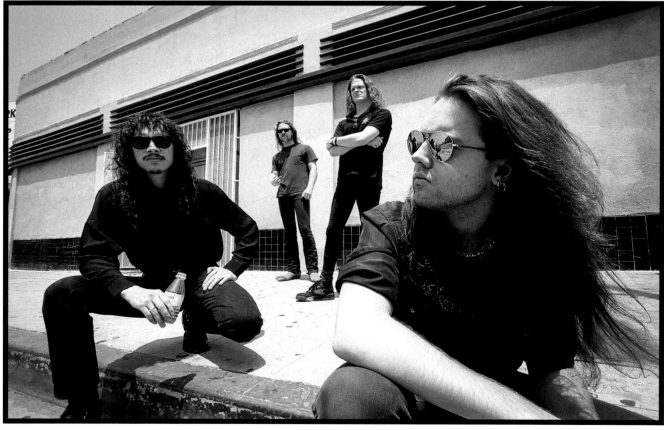

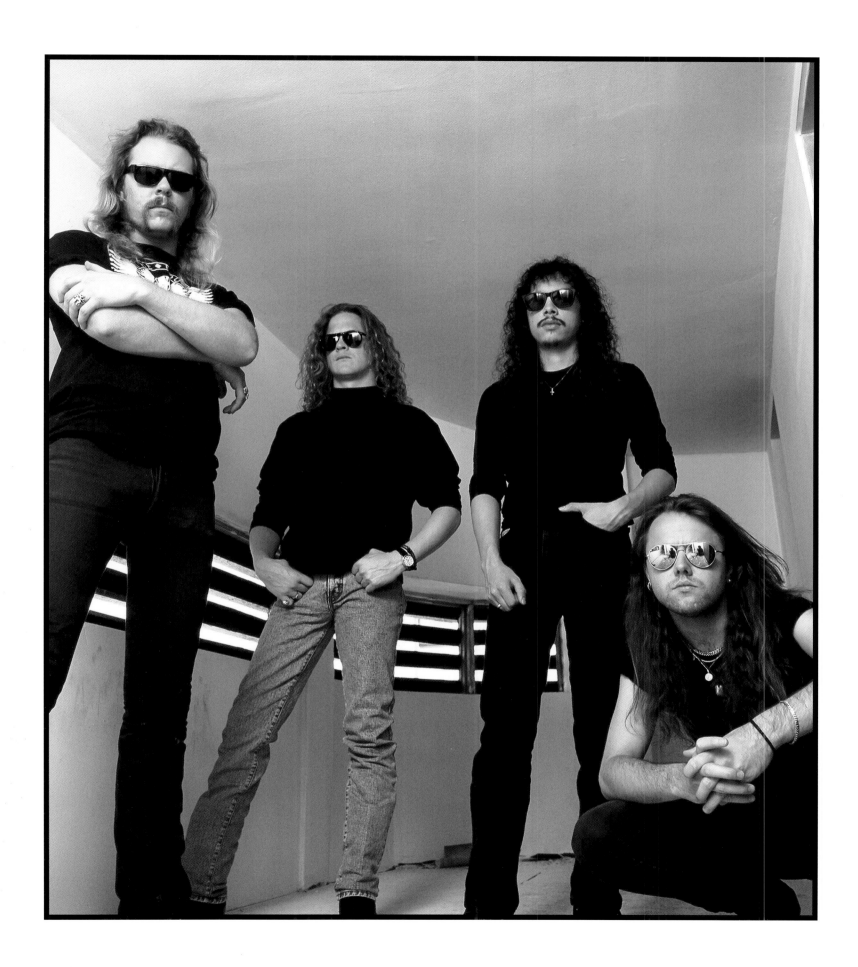

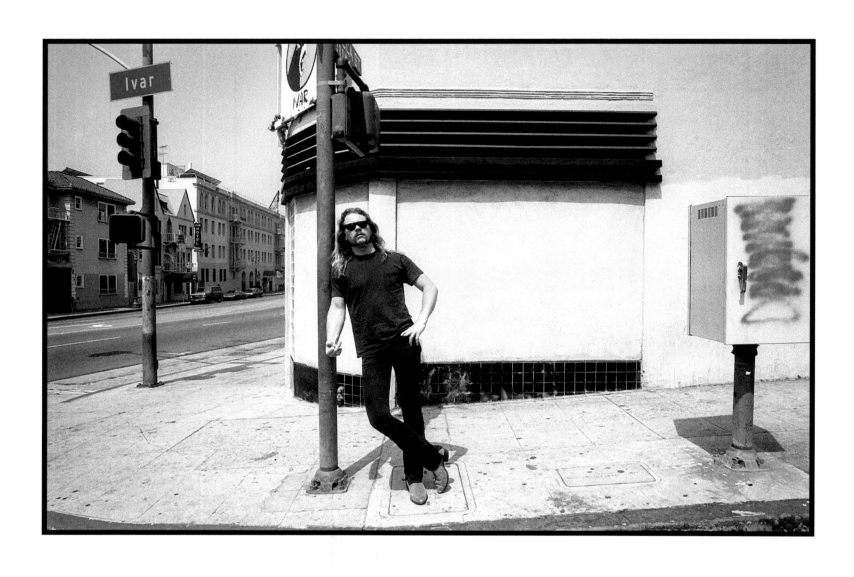

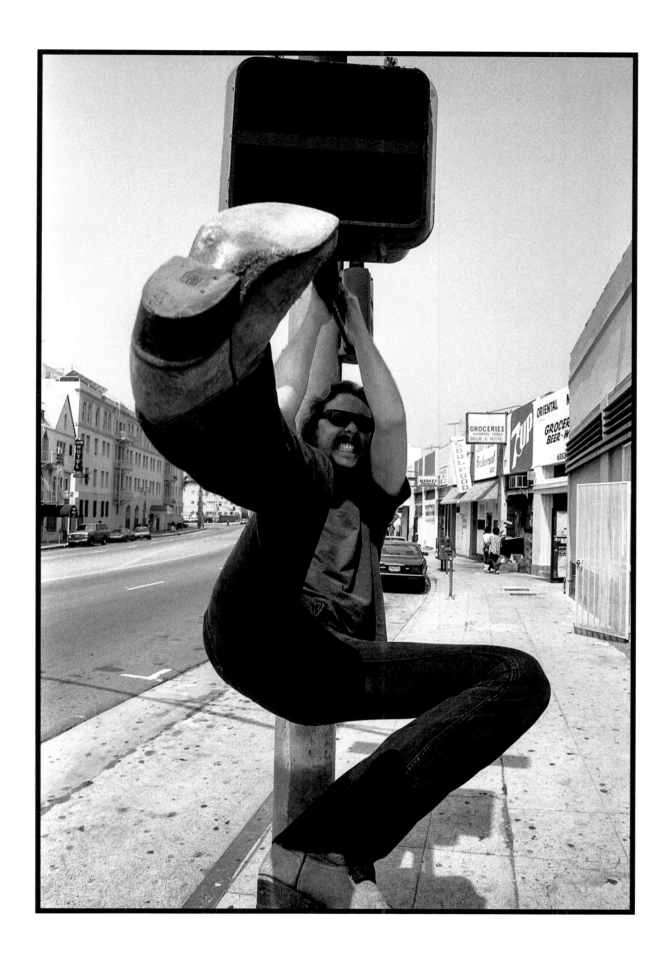

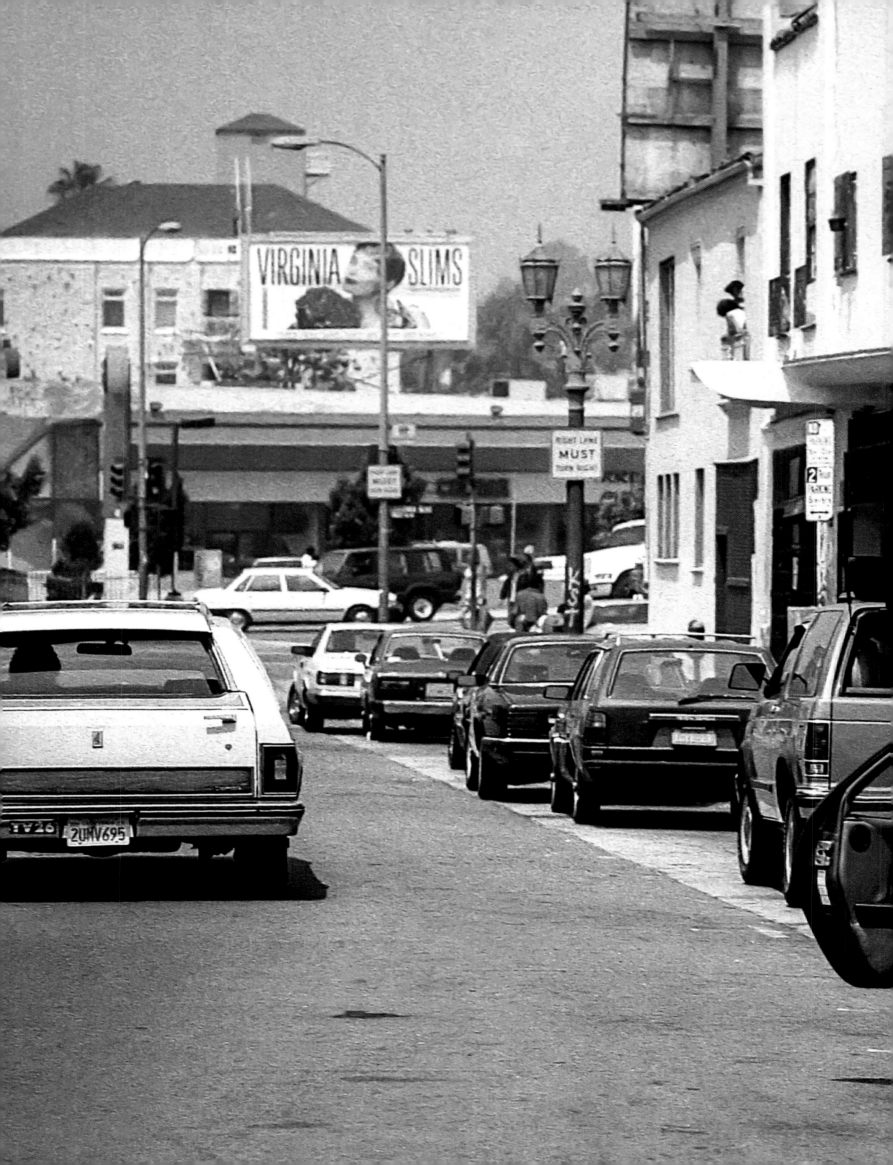

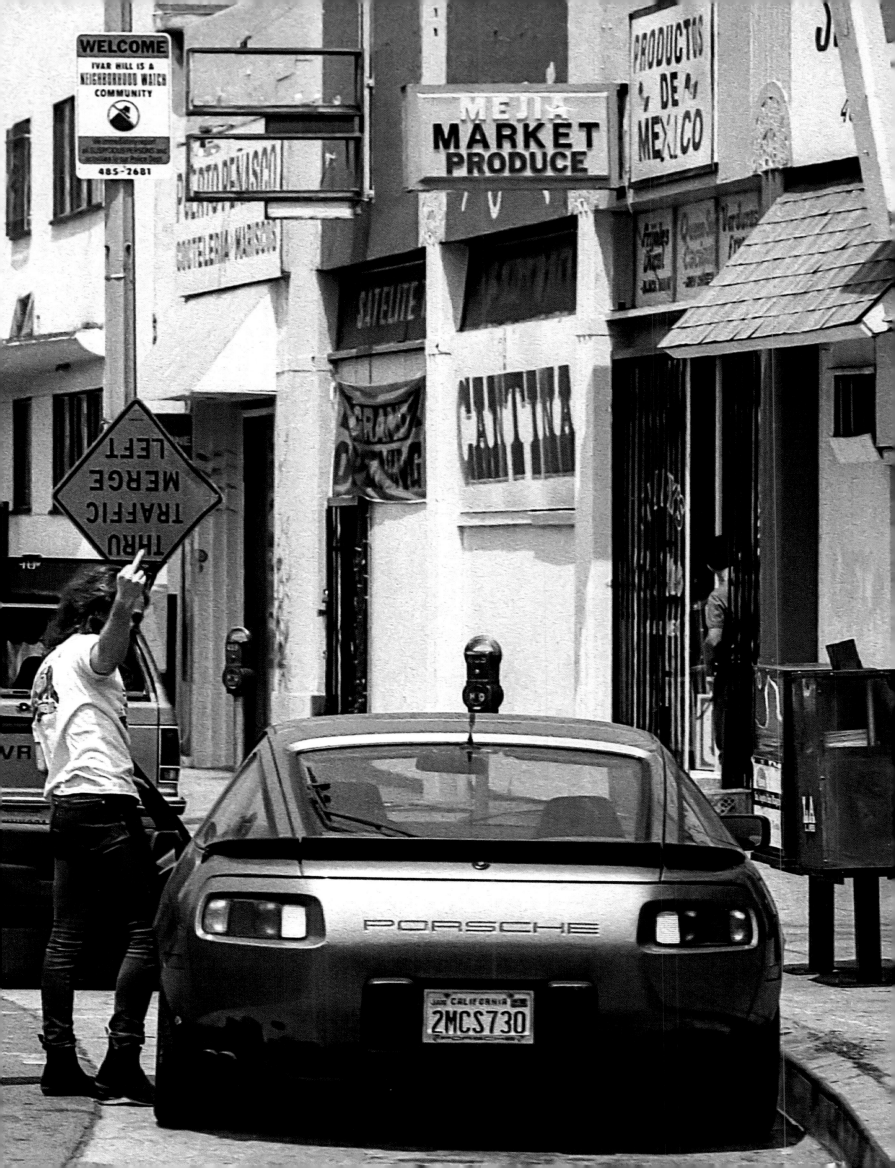

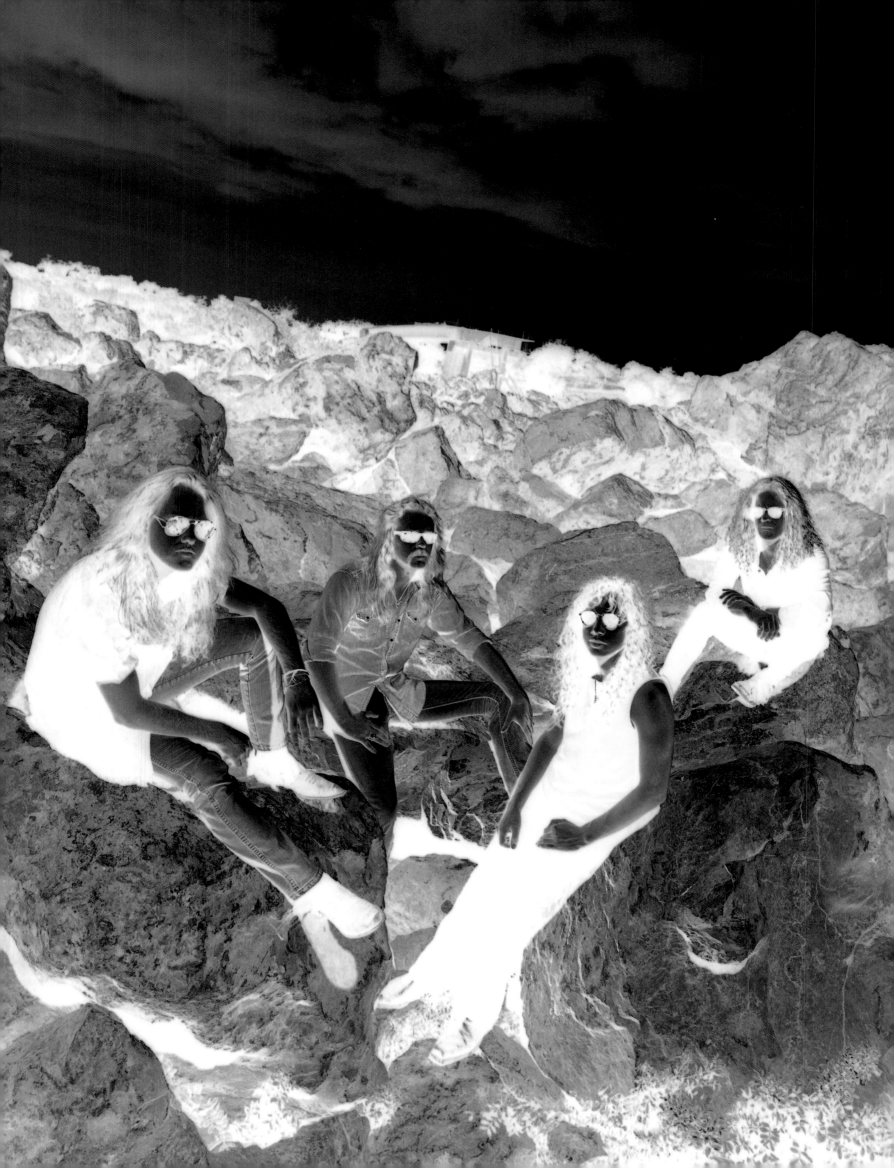

ON LOCATION

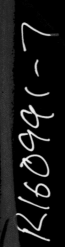

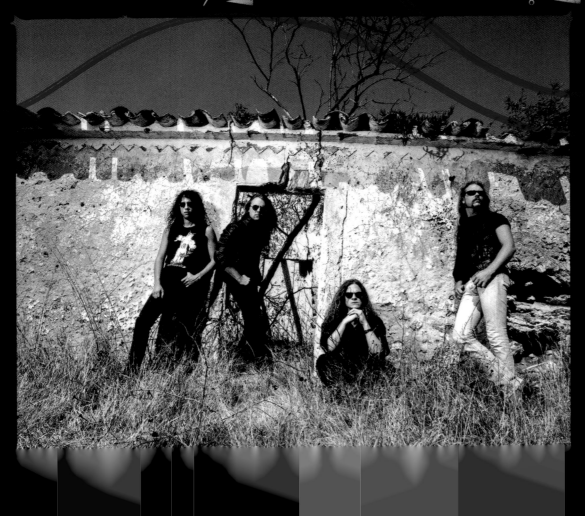

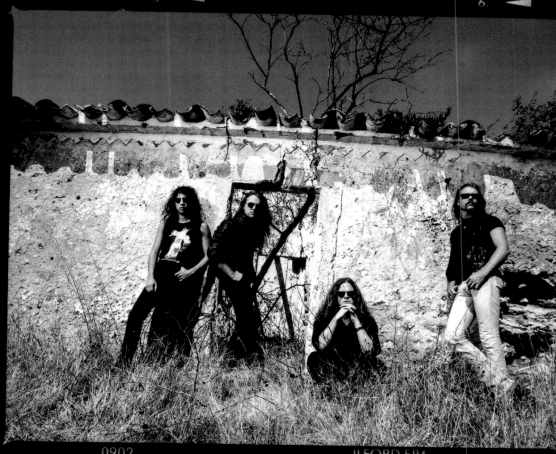
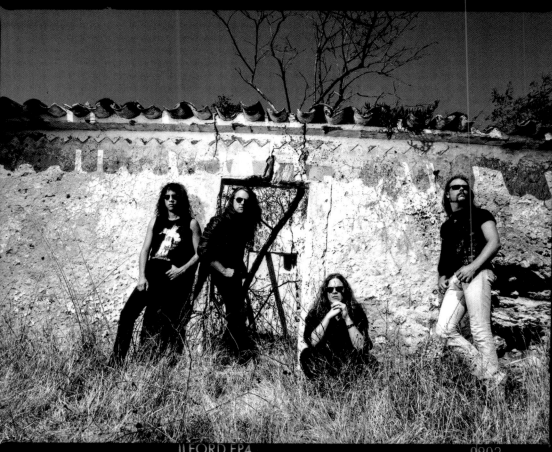

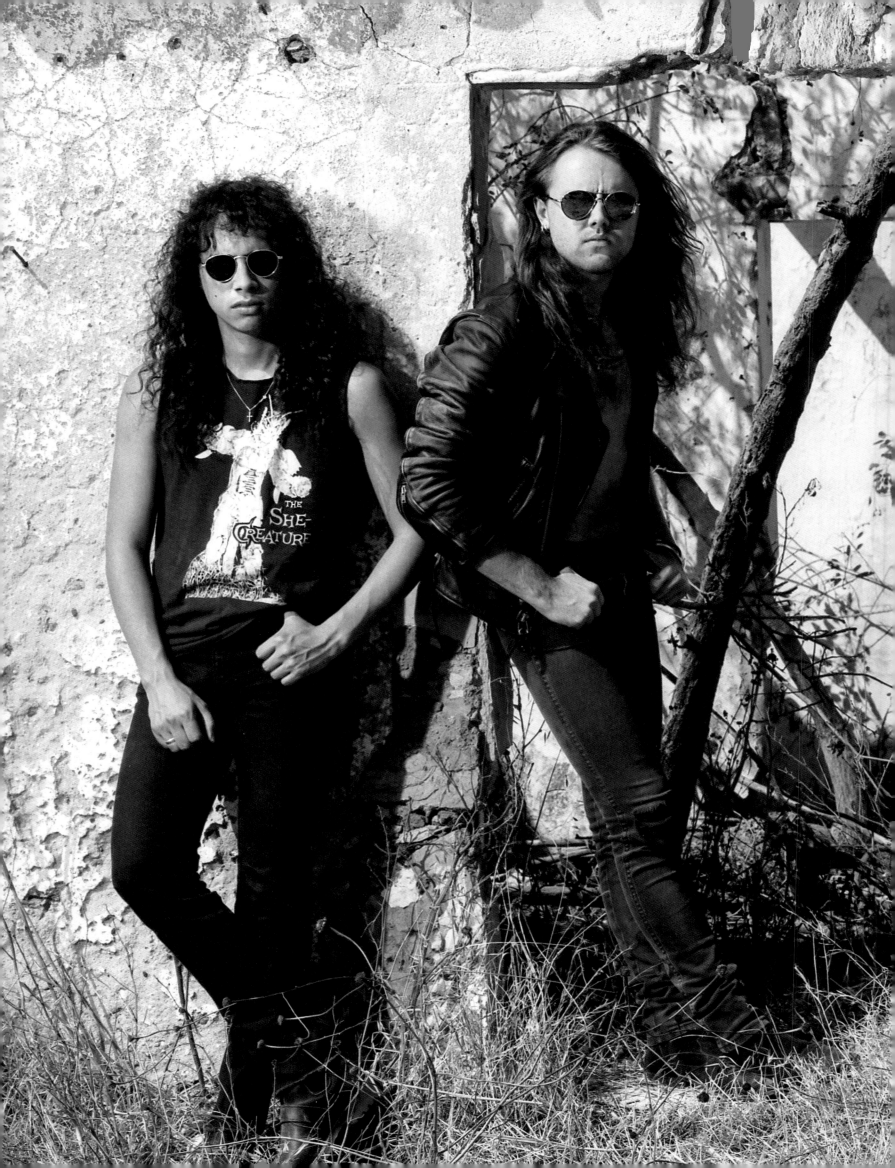

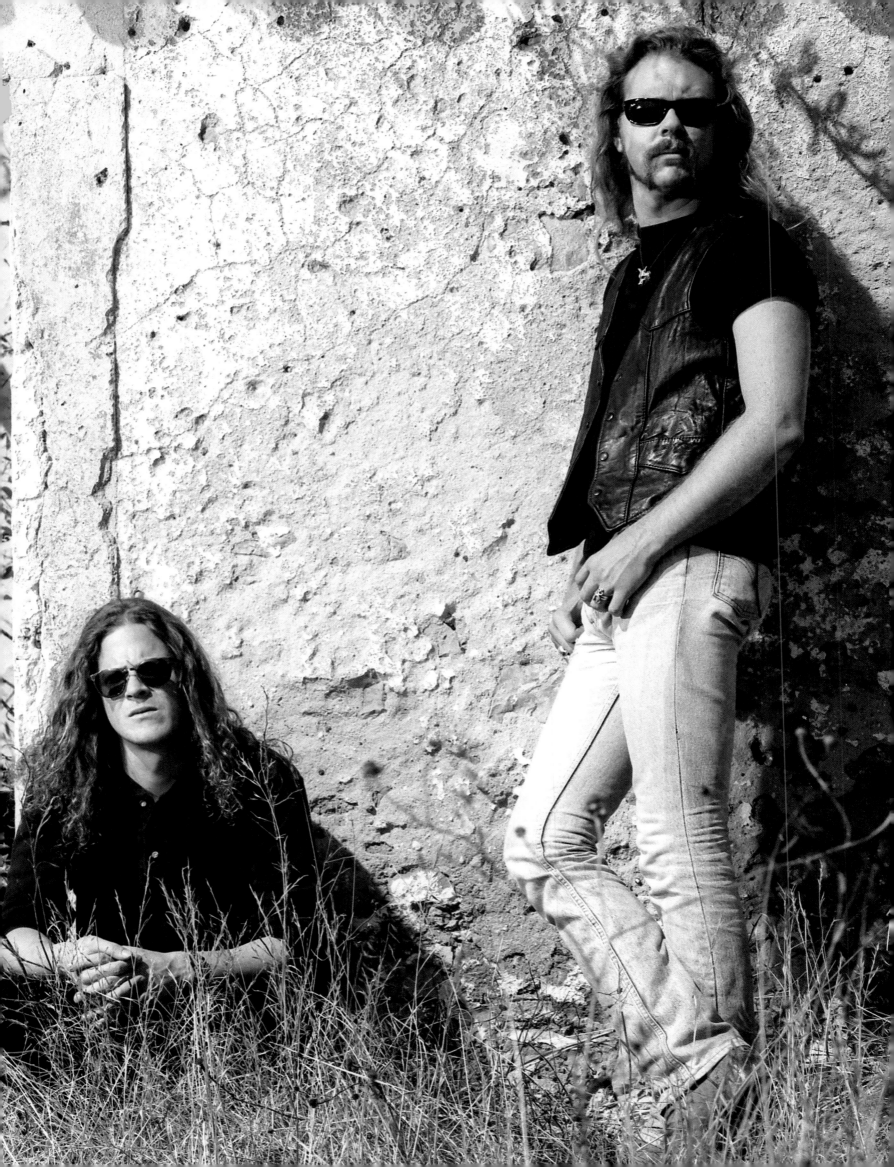

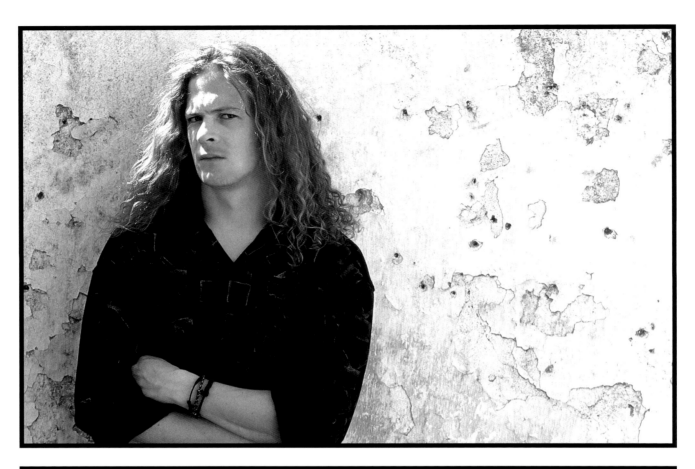

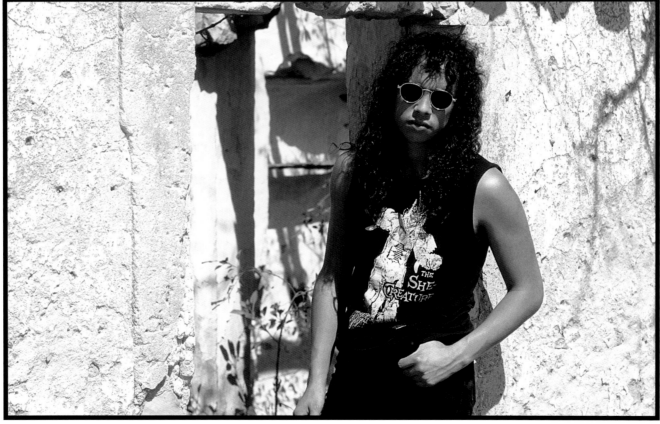

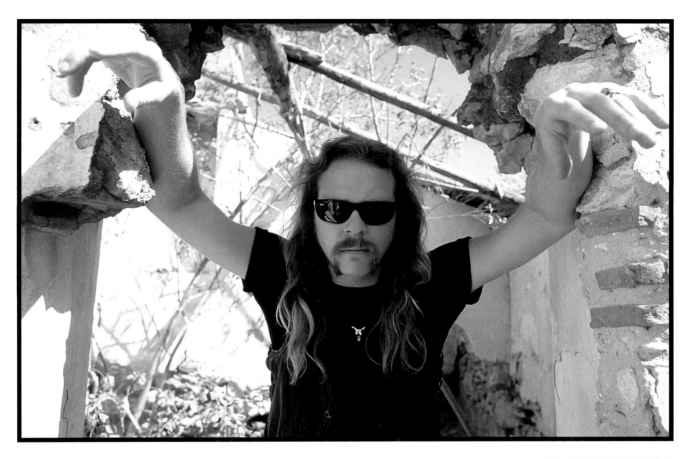

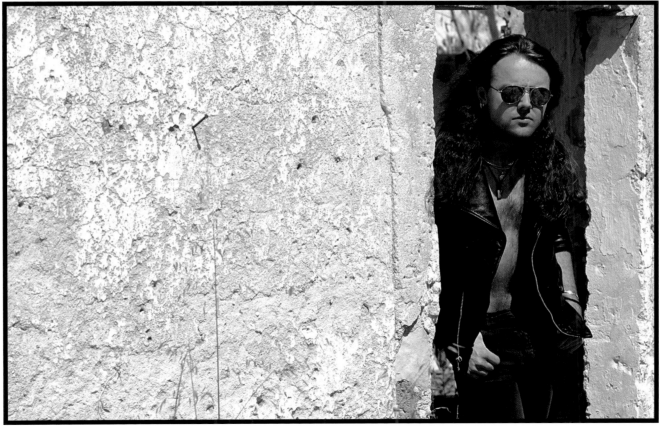

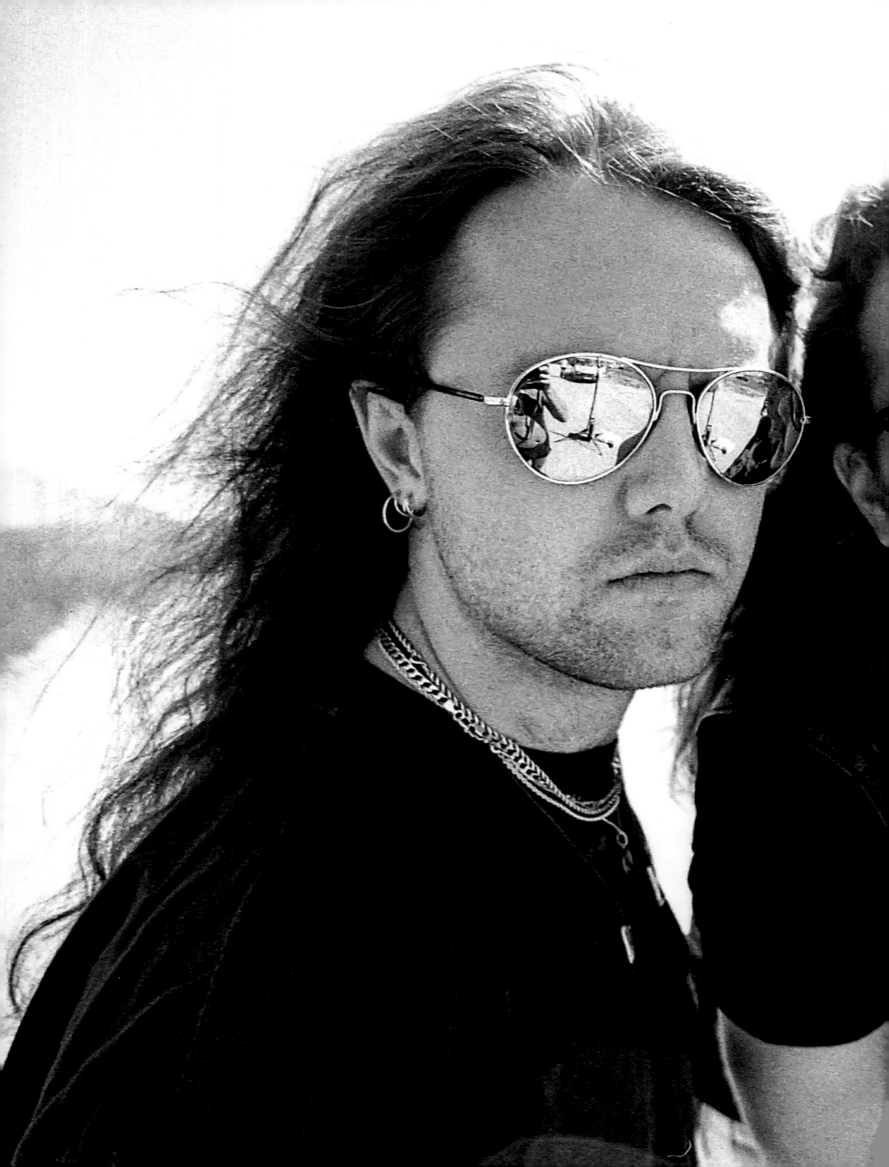

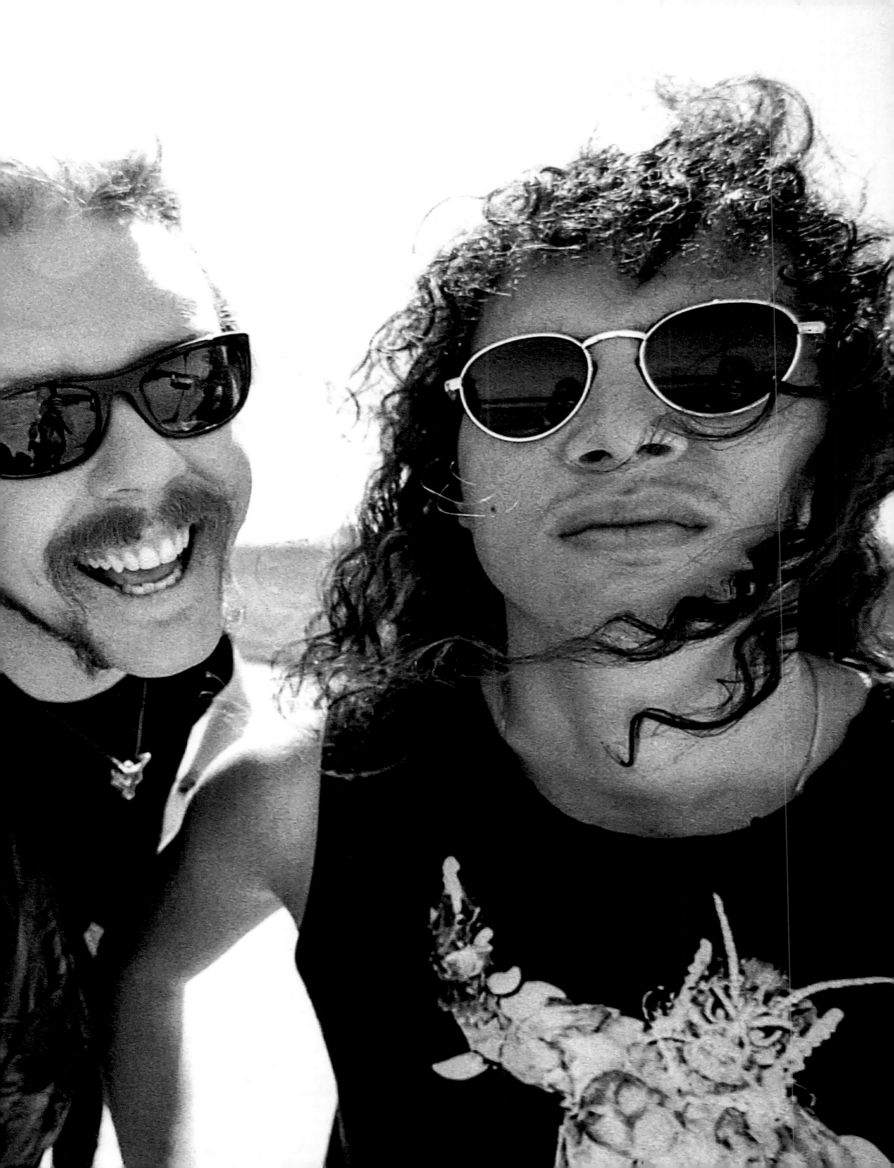

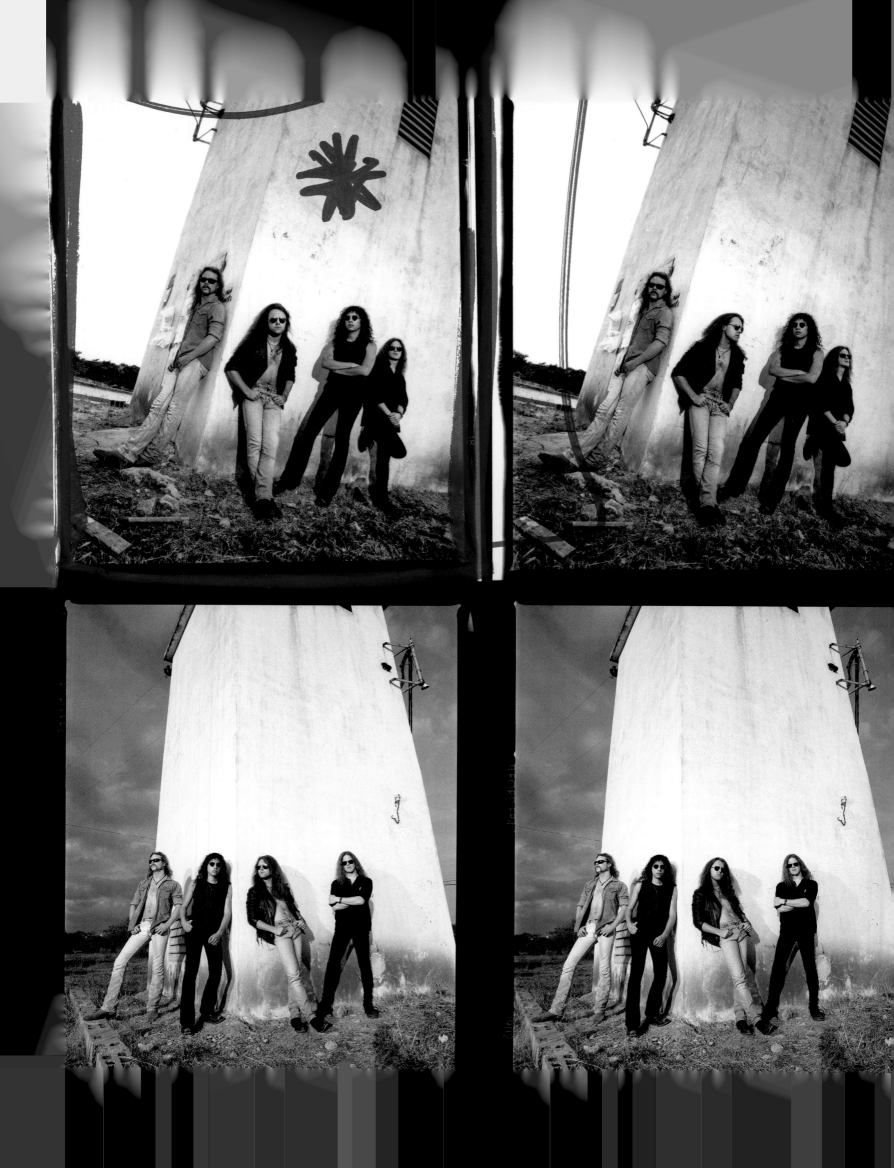

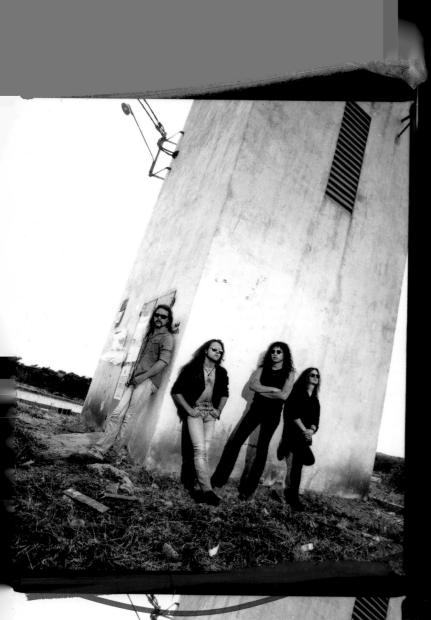
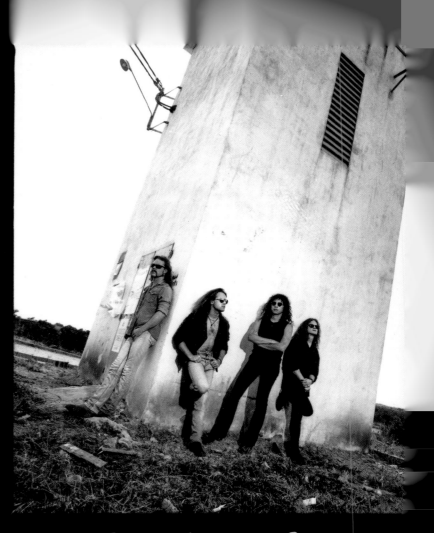

R160991-12

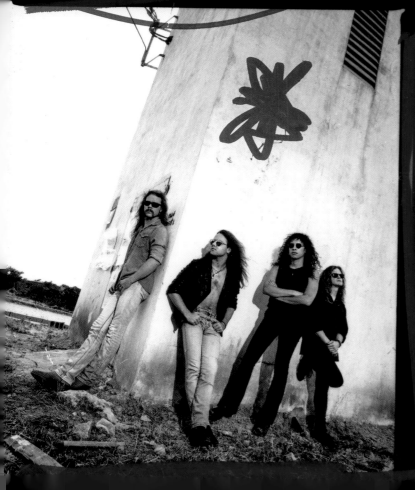
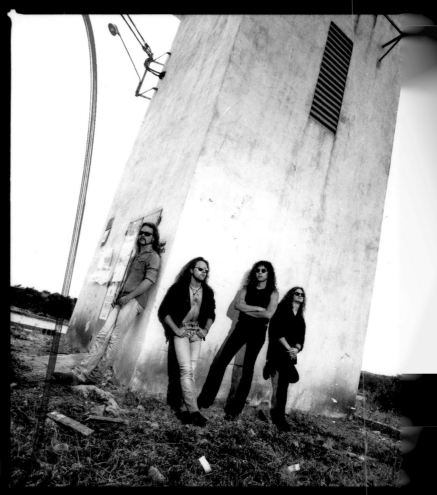

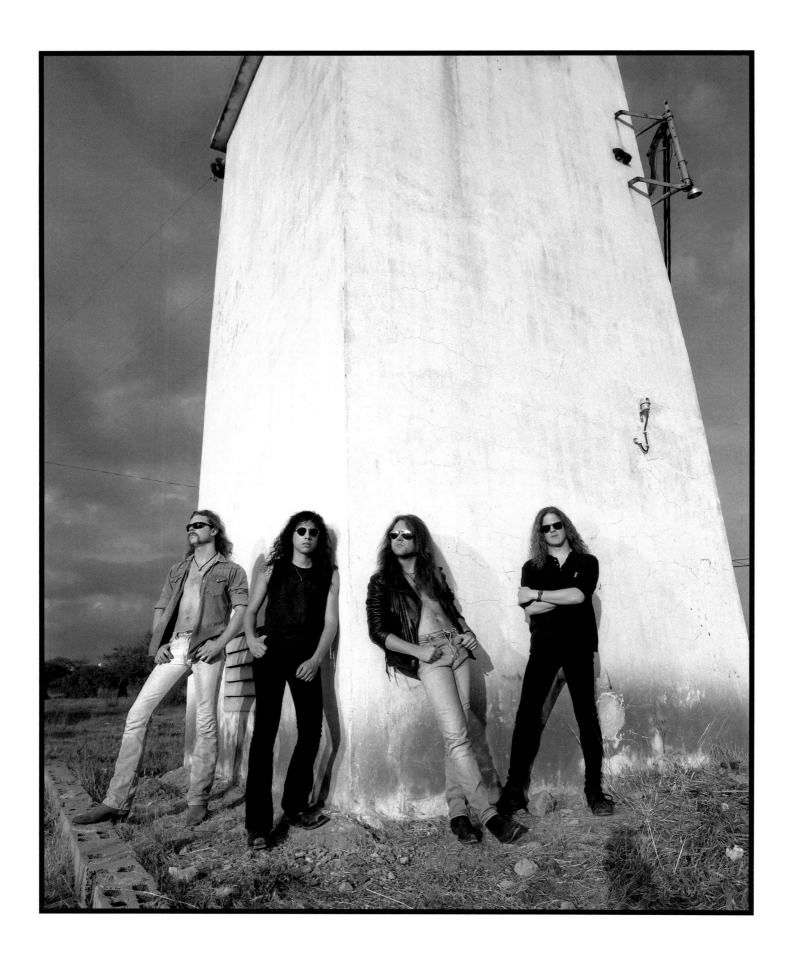

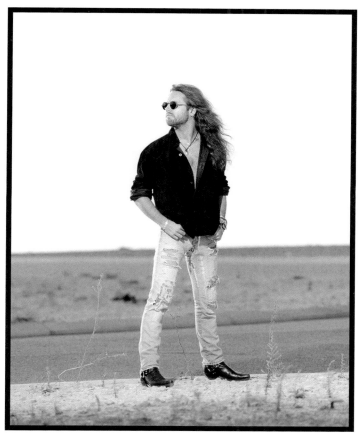
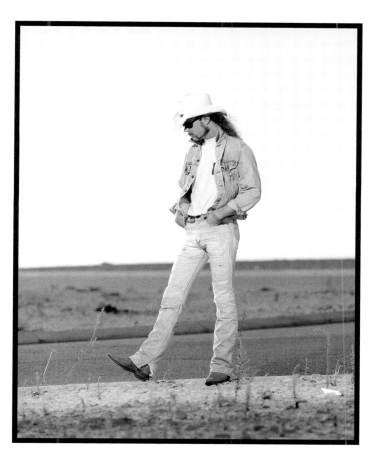
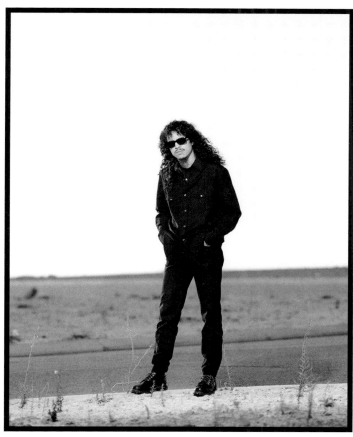
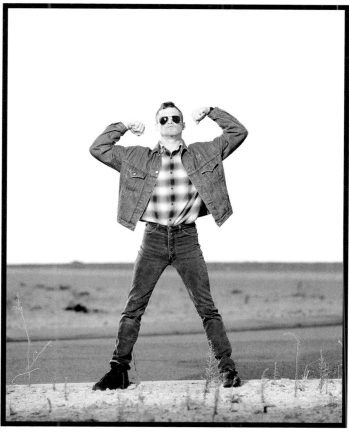

We would always go to places and do pictures and we would stop wherever we felt somewhere had a vibe . . . you have to realise with Metallica, it's always about the vibe.

ROSS

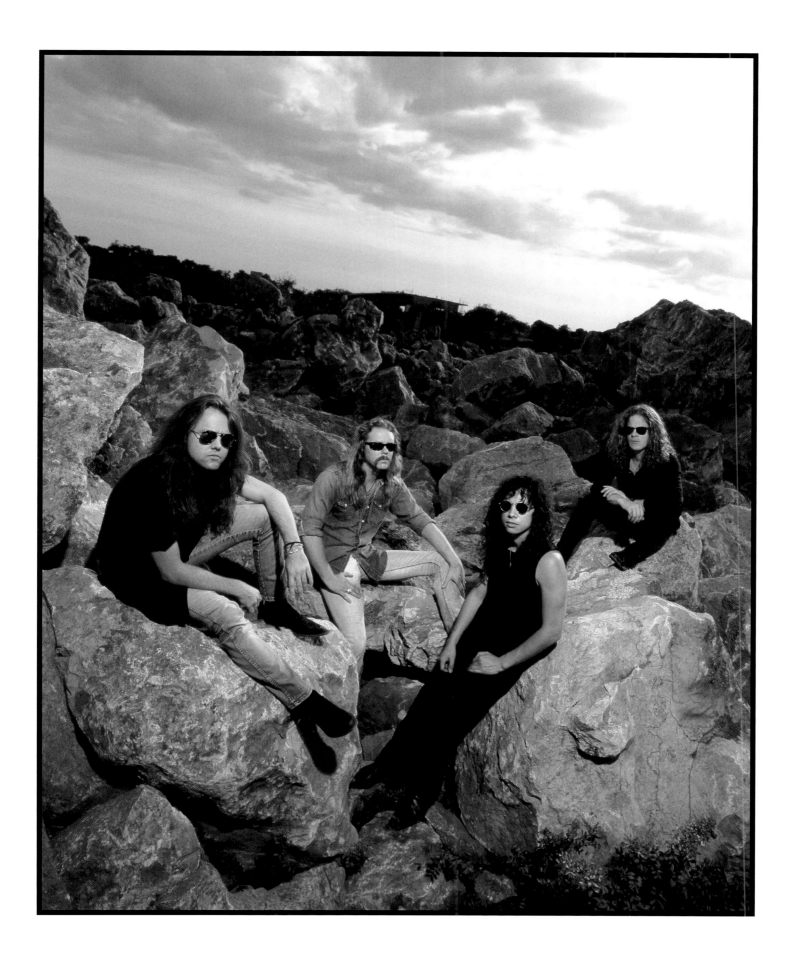

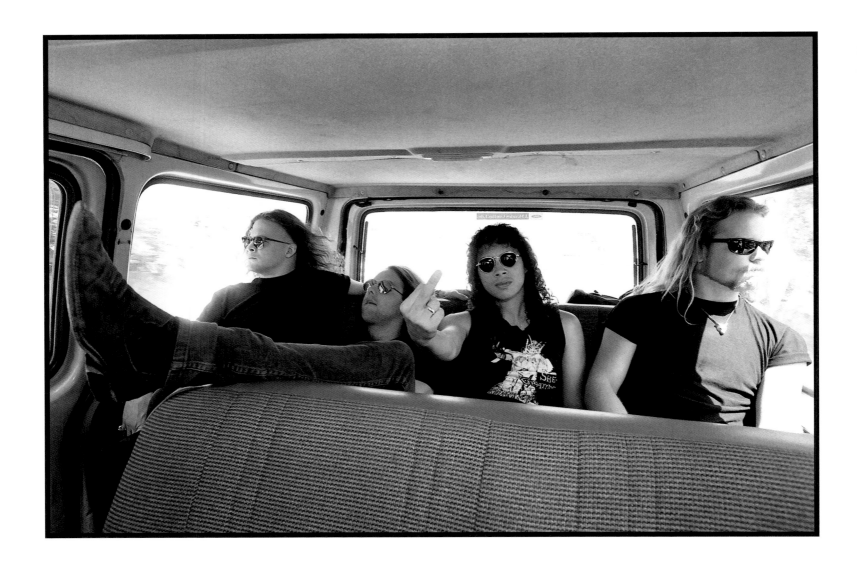

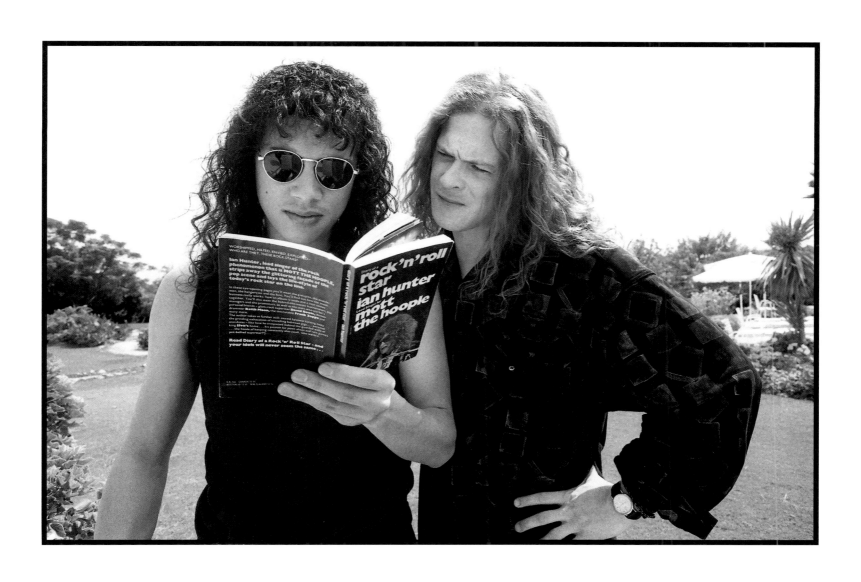

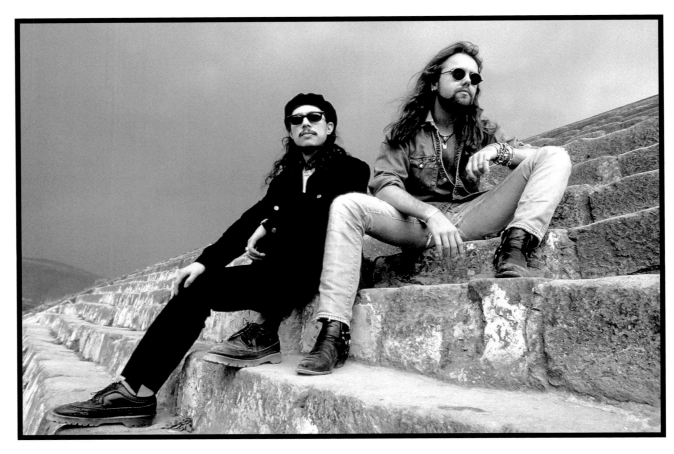

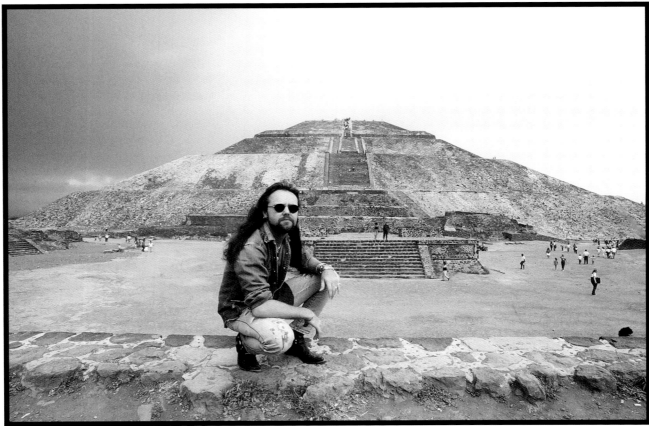

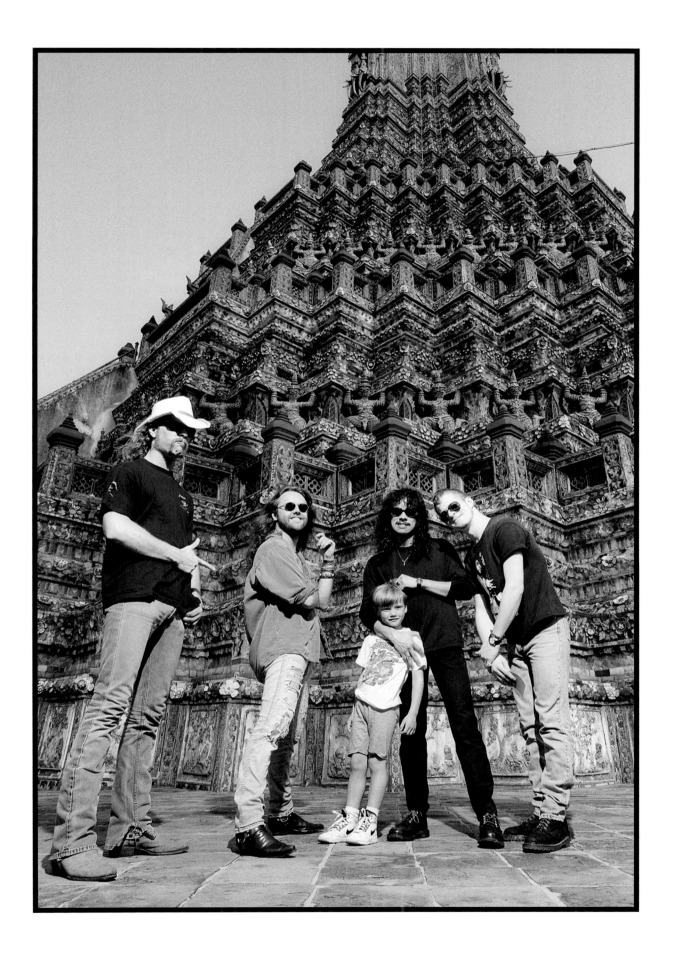

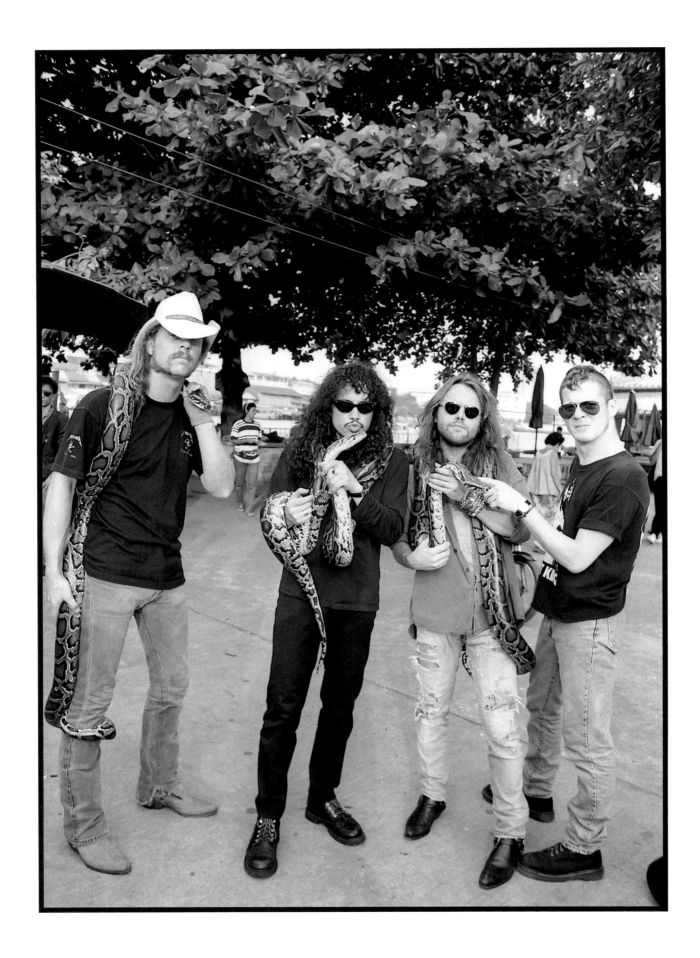

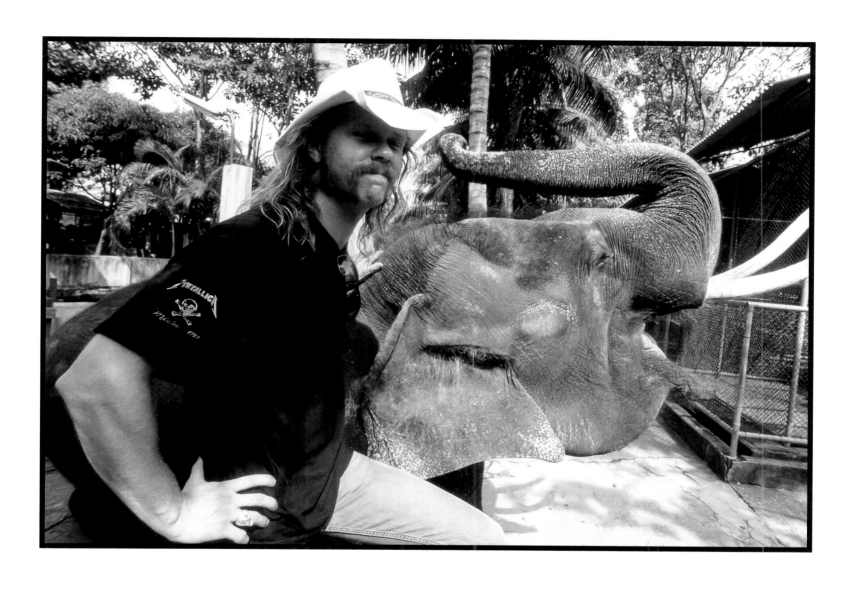

It all boils down
to one thing . . . being in the
right place at the right time.
Nothing more, nothing less.
Well, maybe some extra-tight rock
clothes, some extra-long hair with
an extra hairbrush or two, an extra
pair of rockstar shades, an extra
couple of raised middle fingers,
and a fuck load of attitude . . .
both from the subjects and
the photographer.

LARS

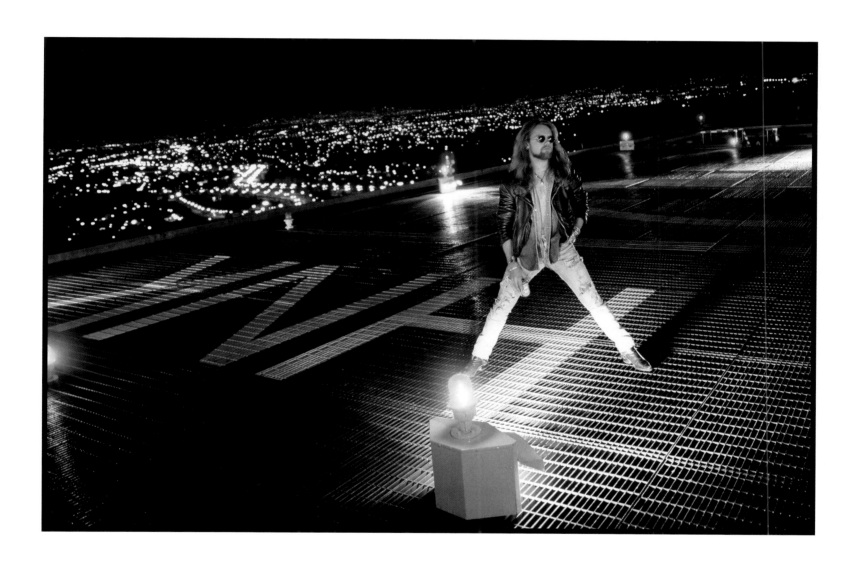

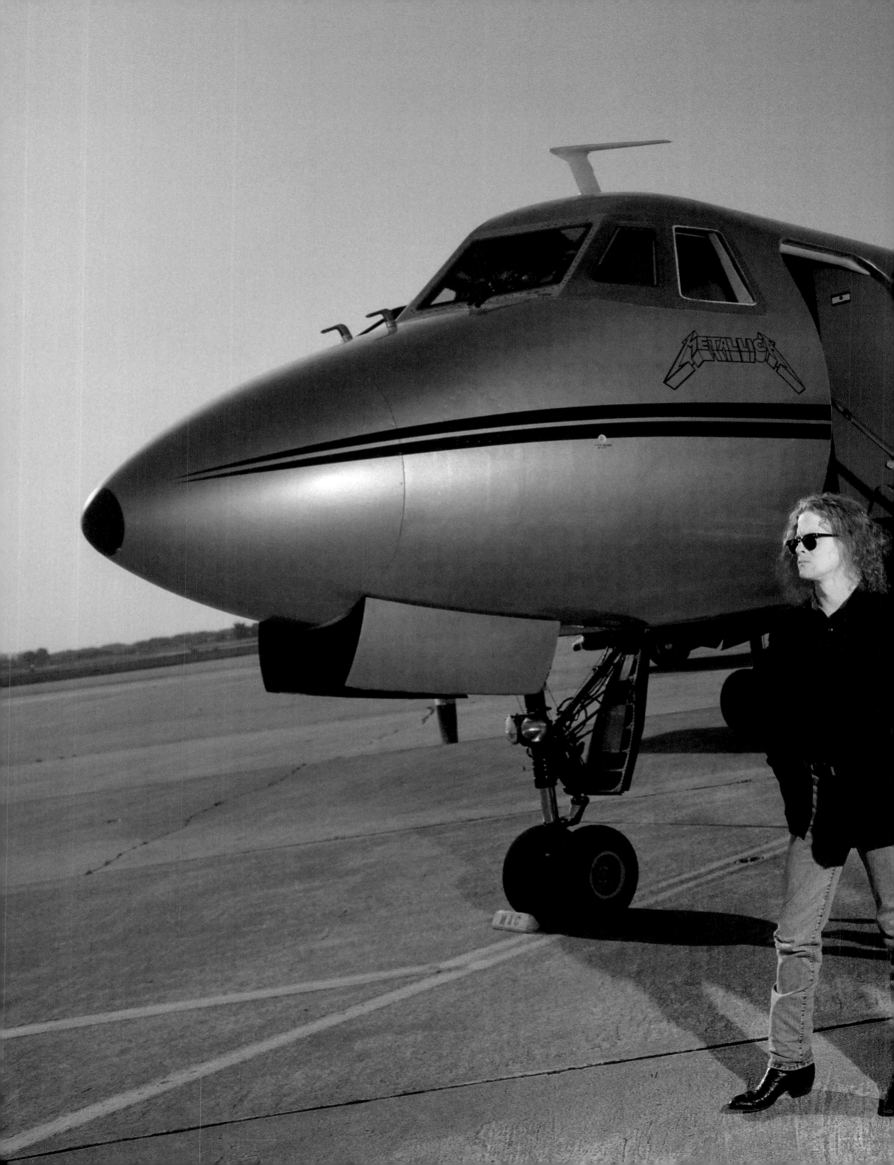

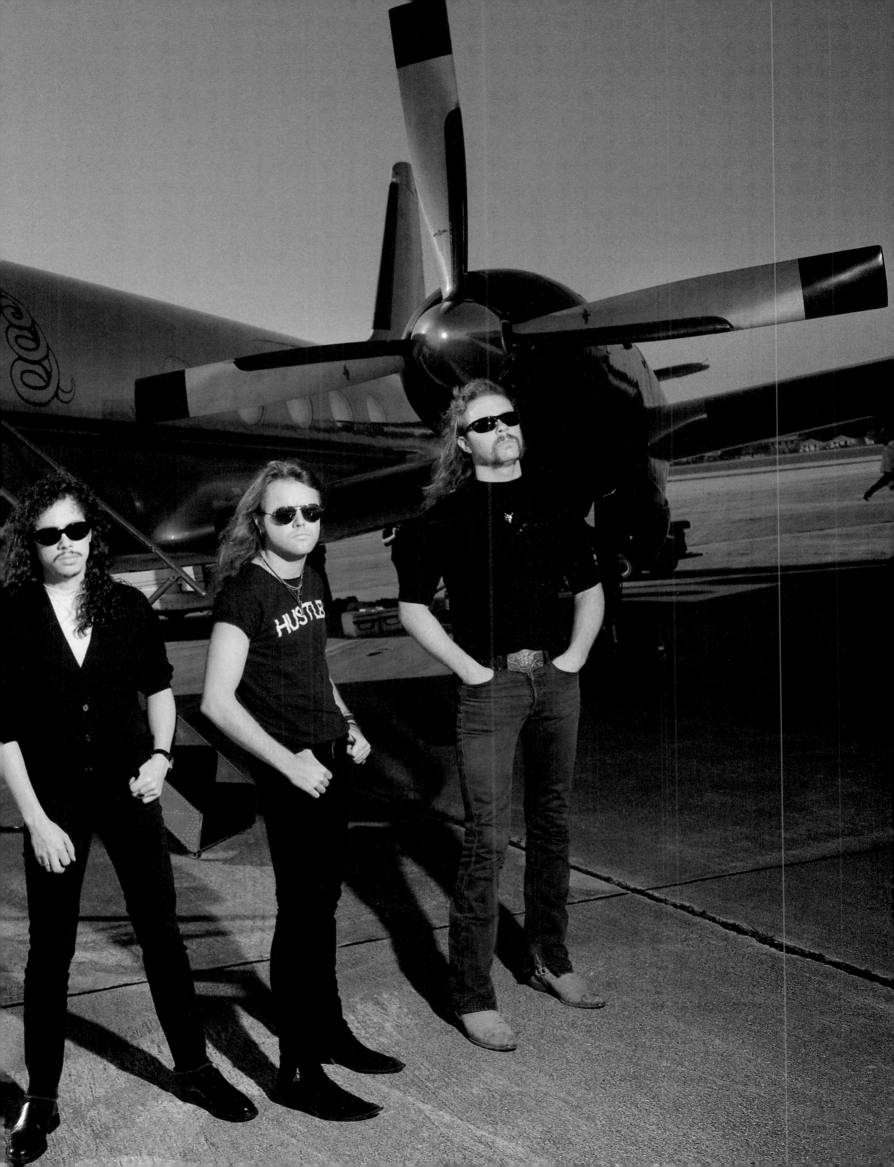

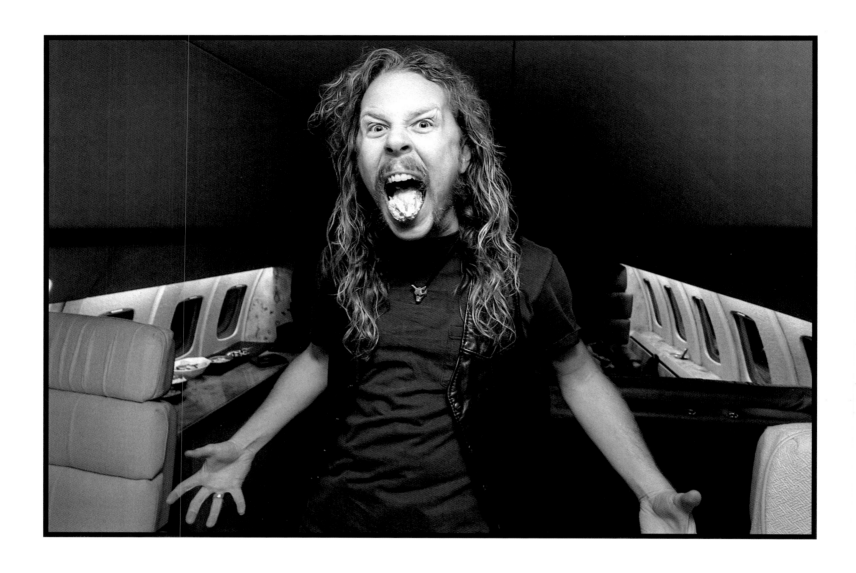

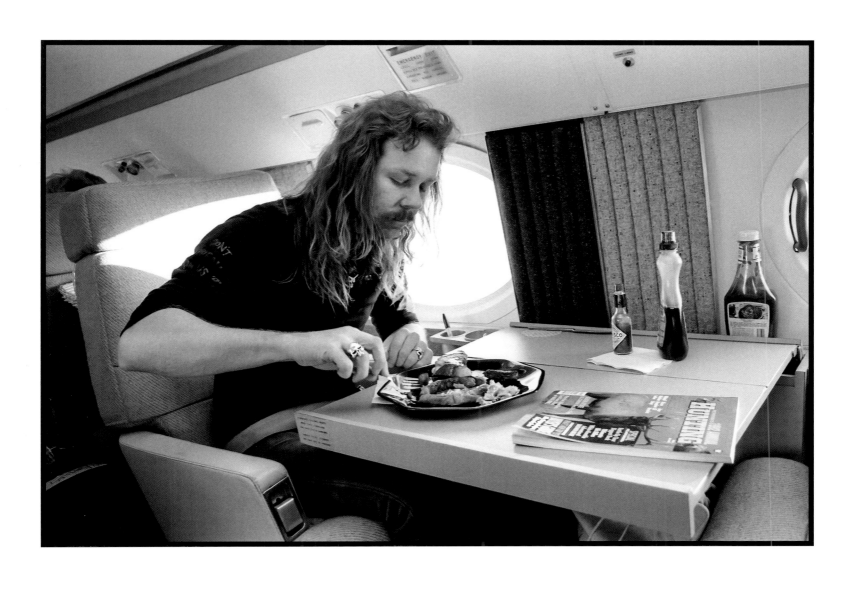

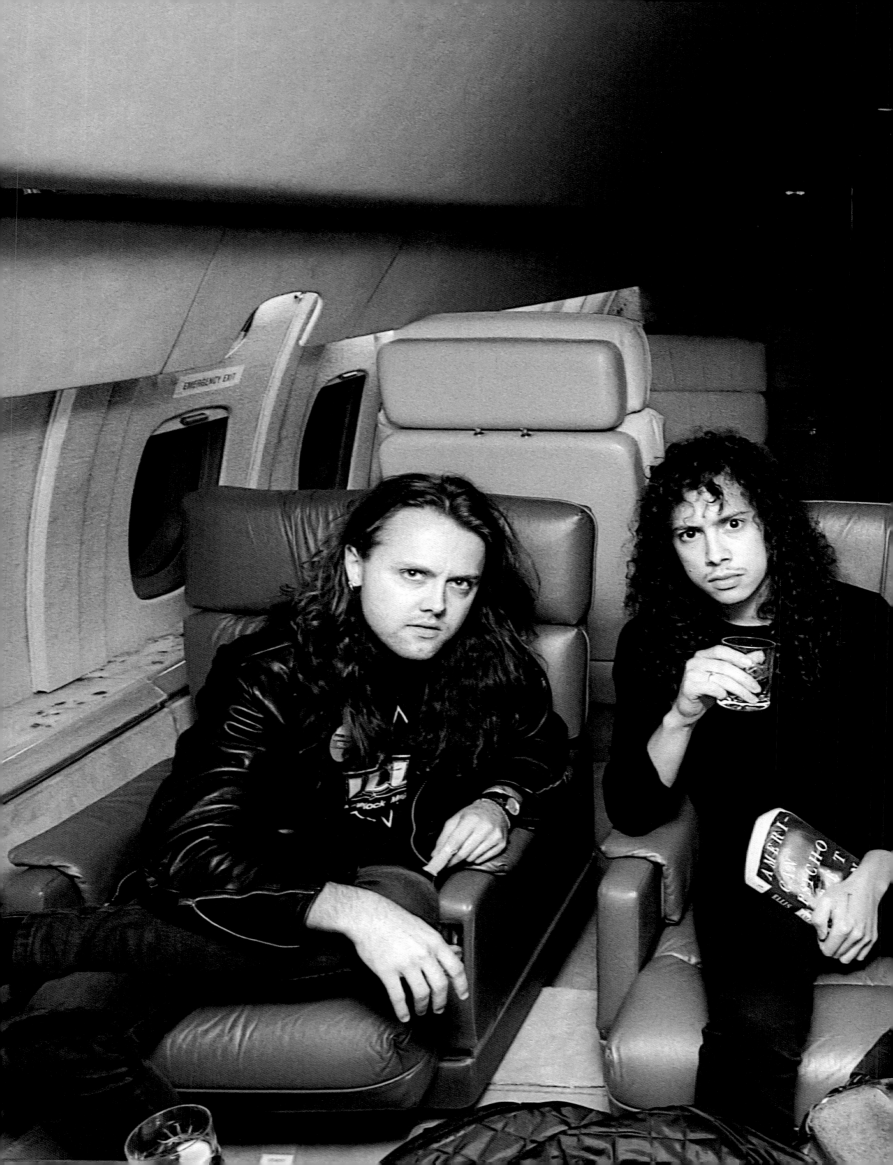

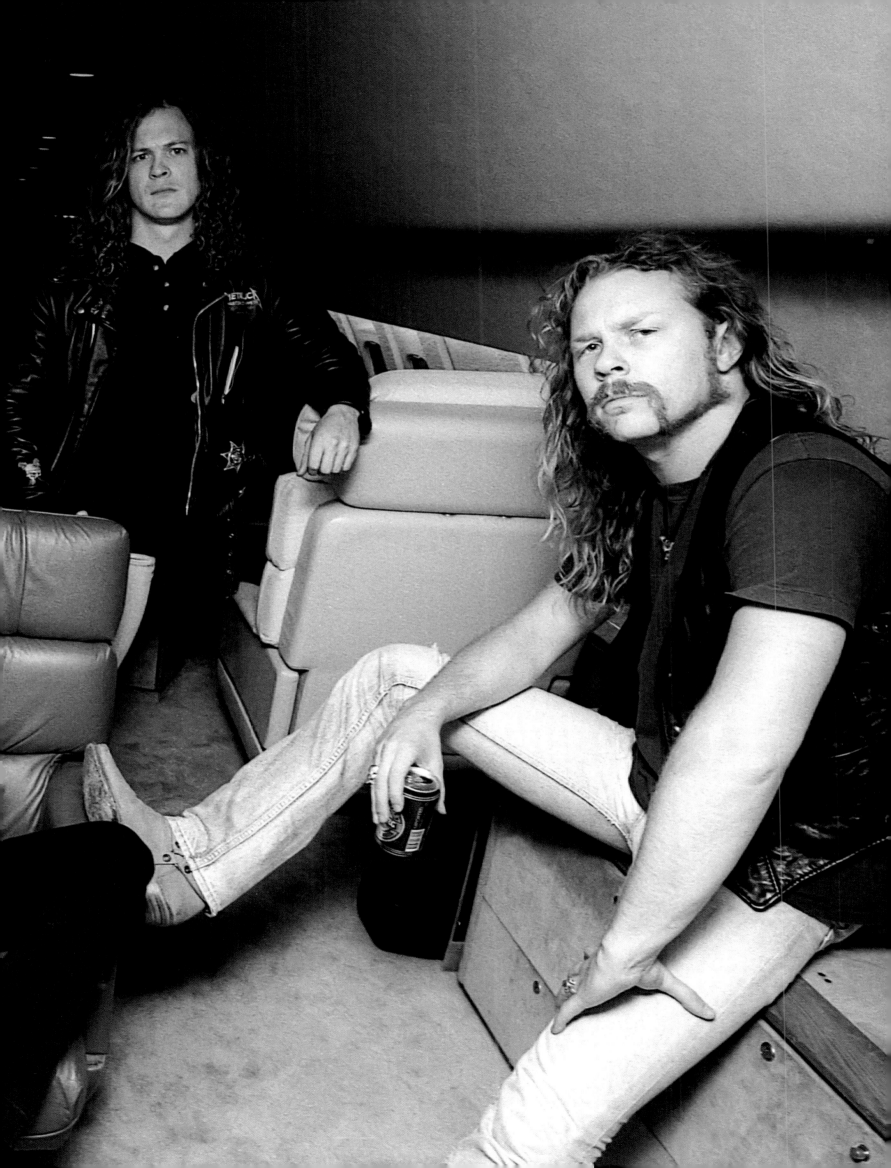

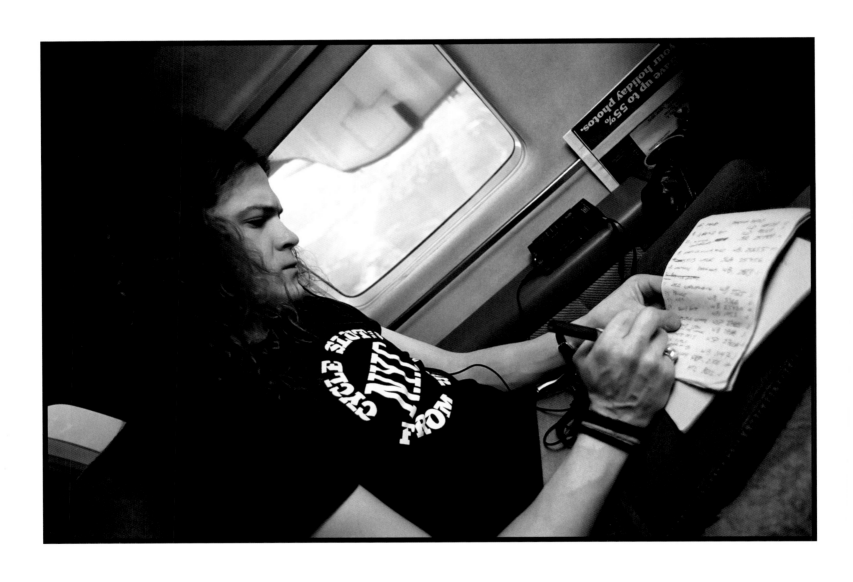

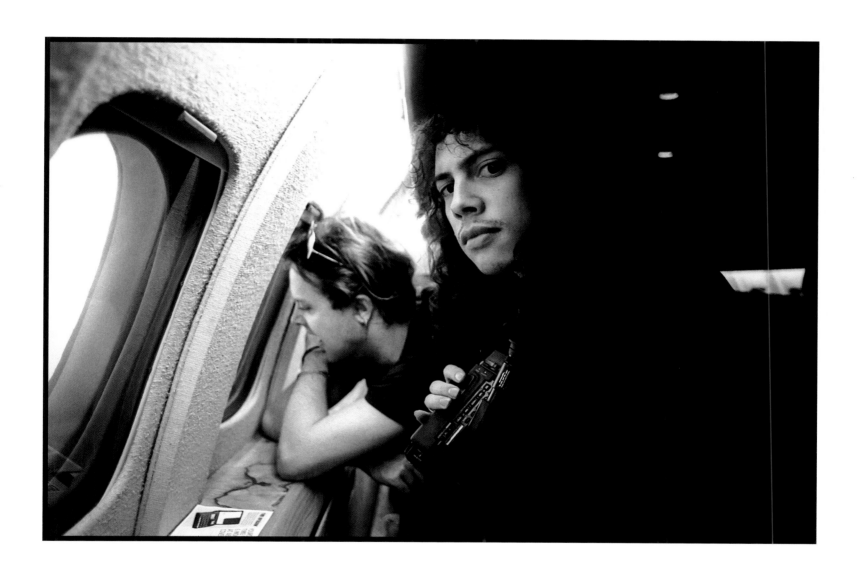

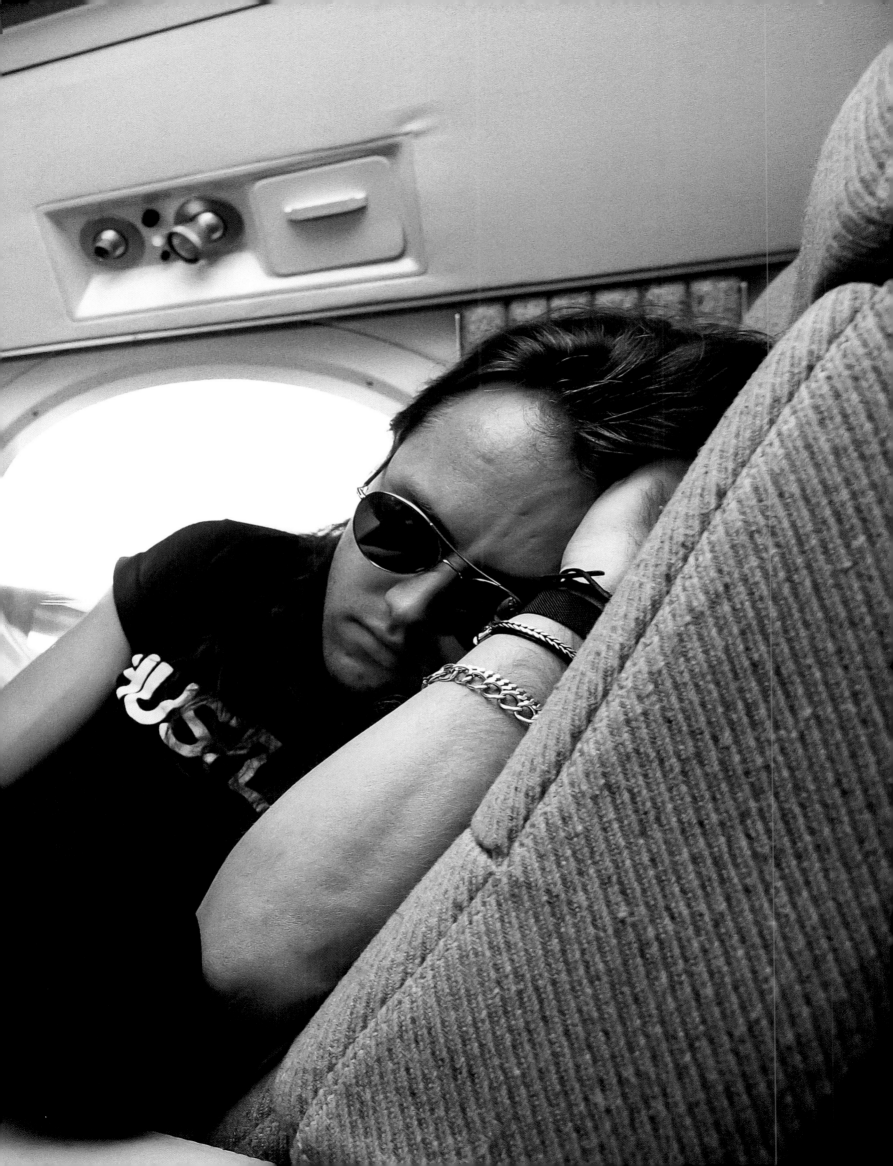

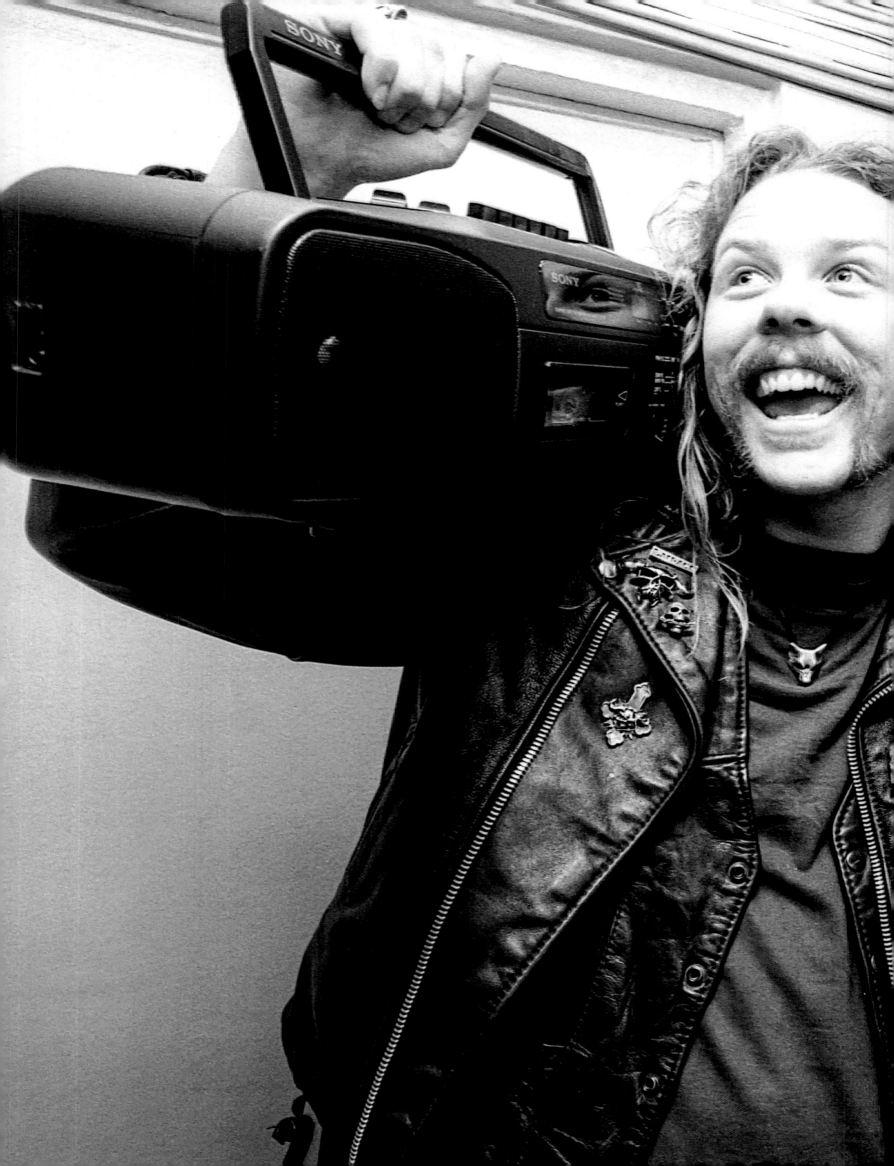

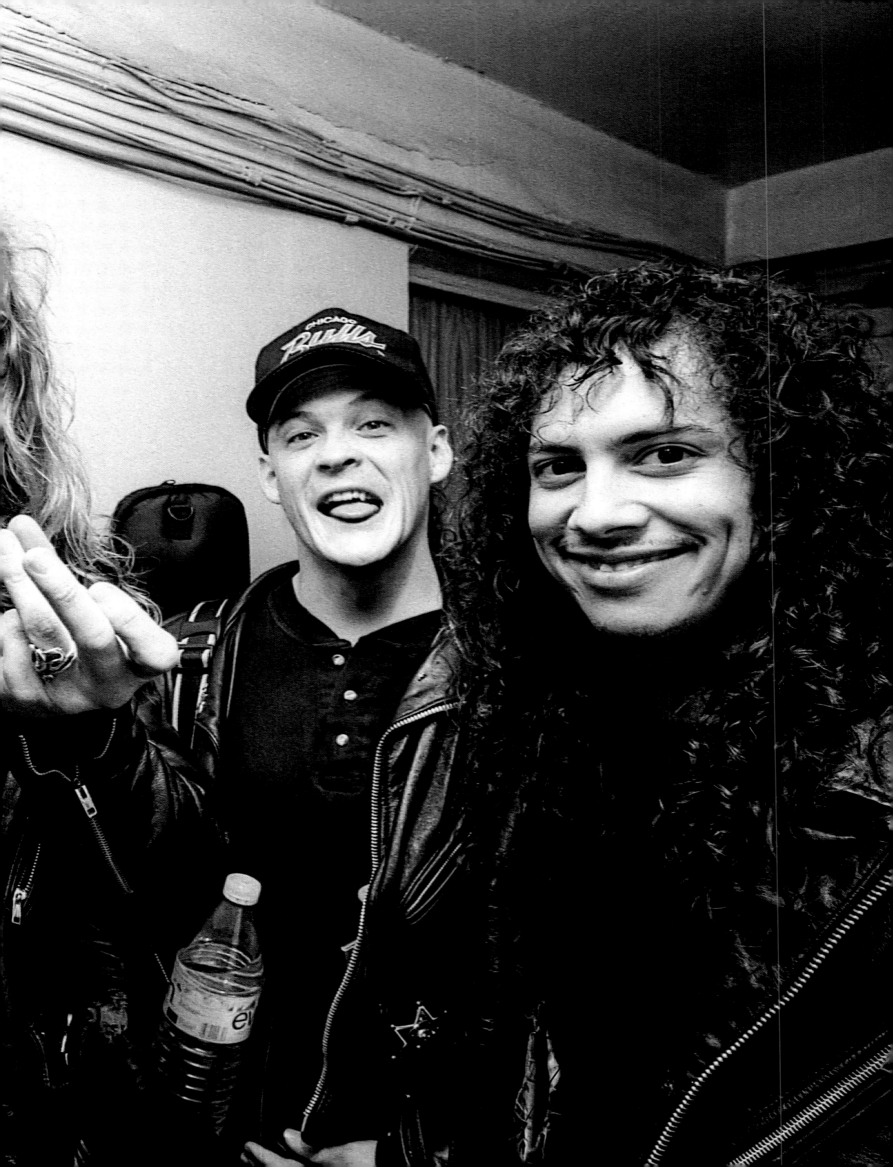

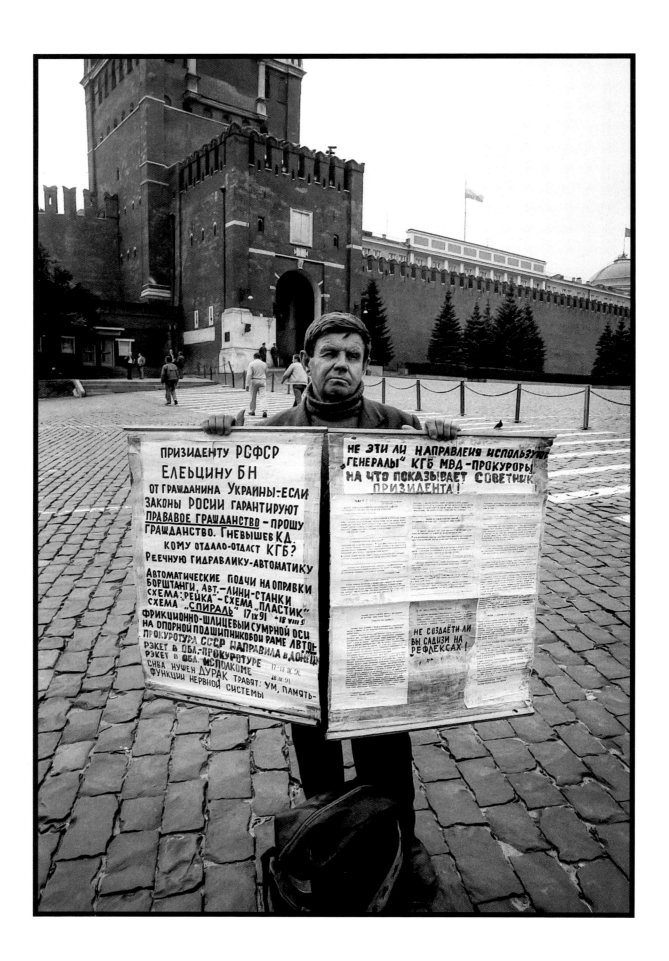

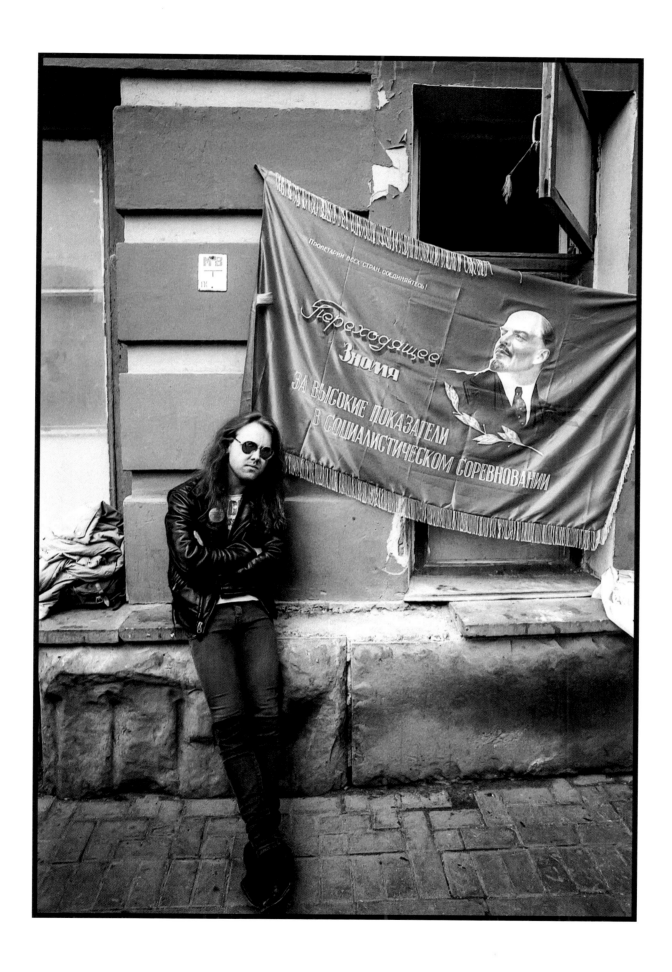

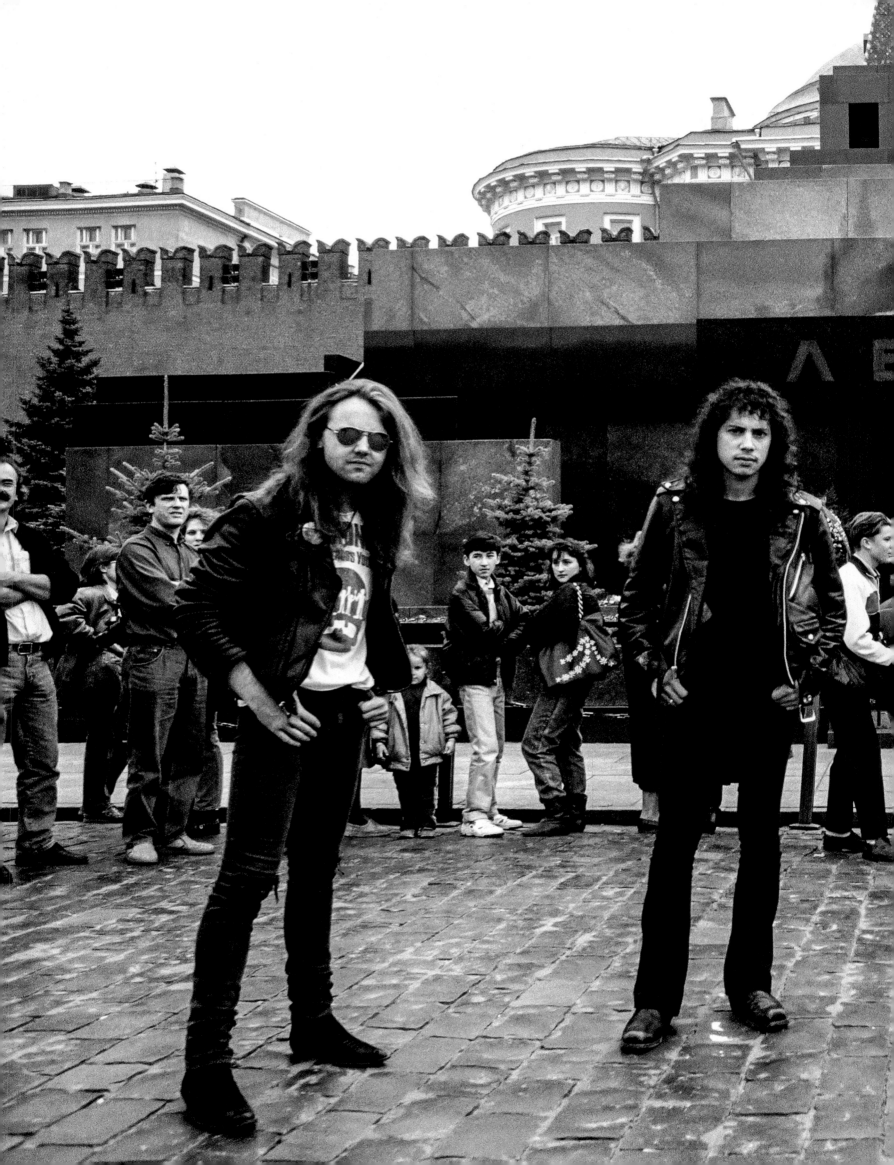

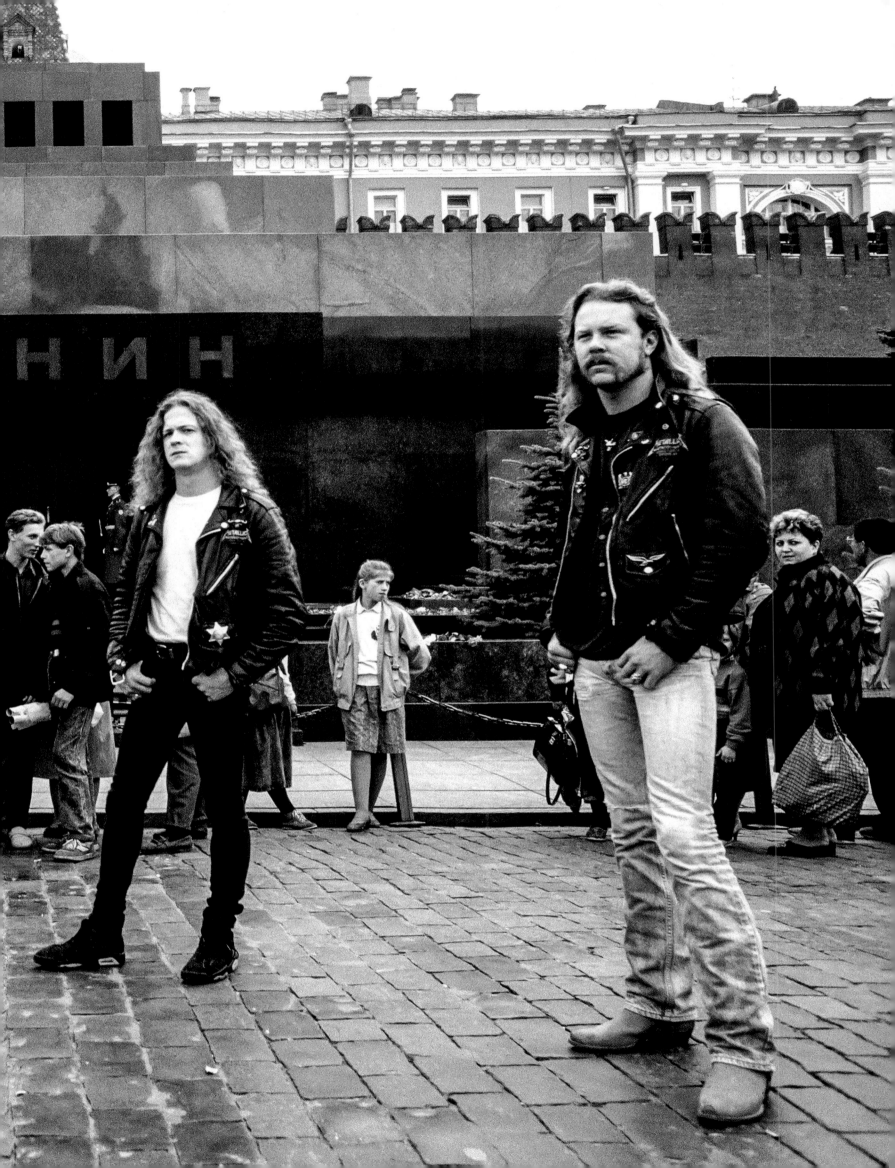

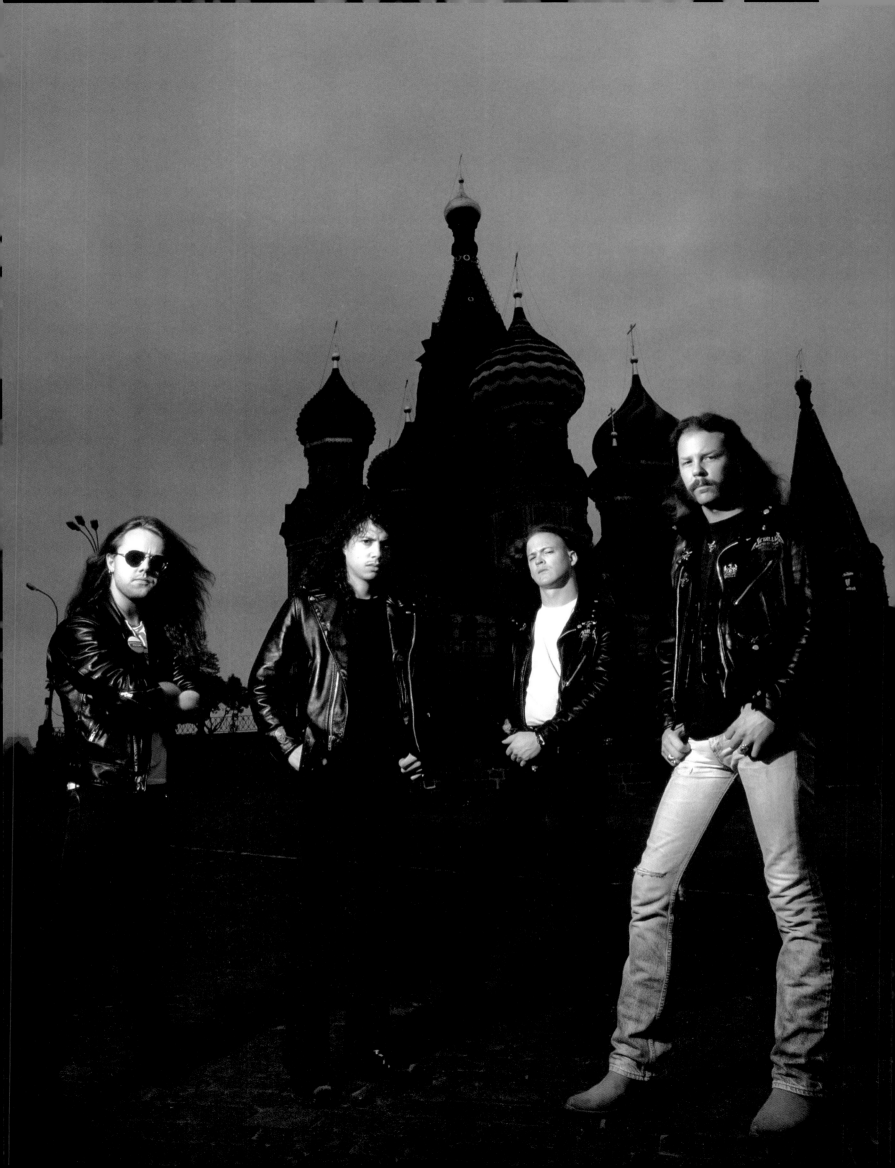

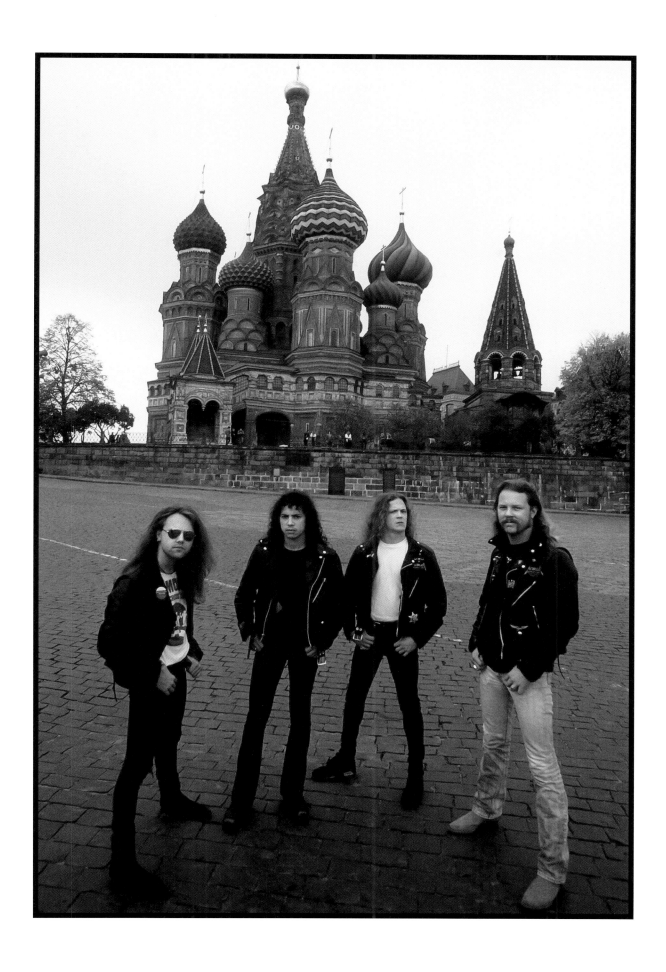

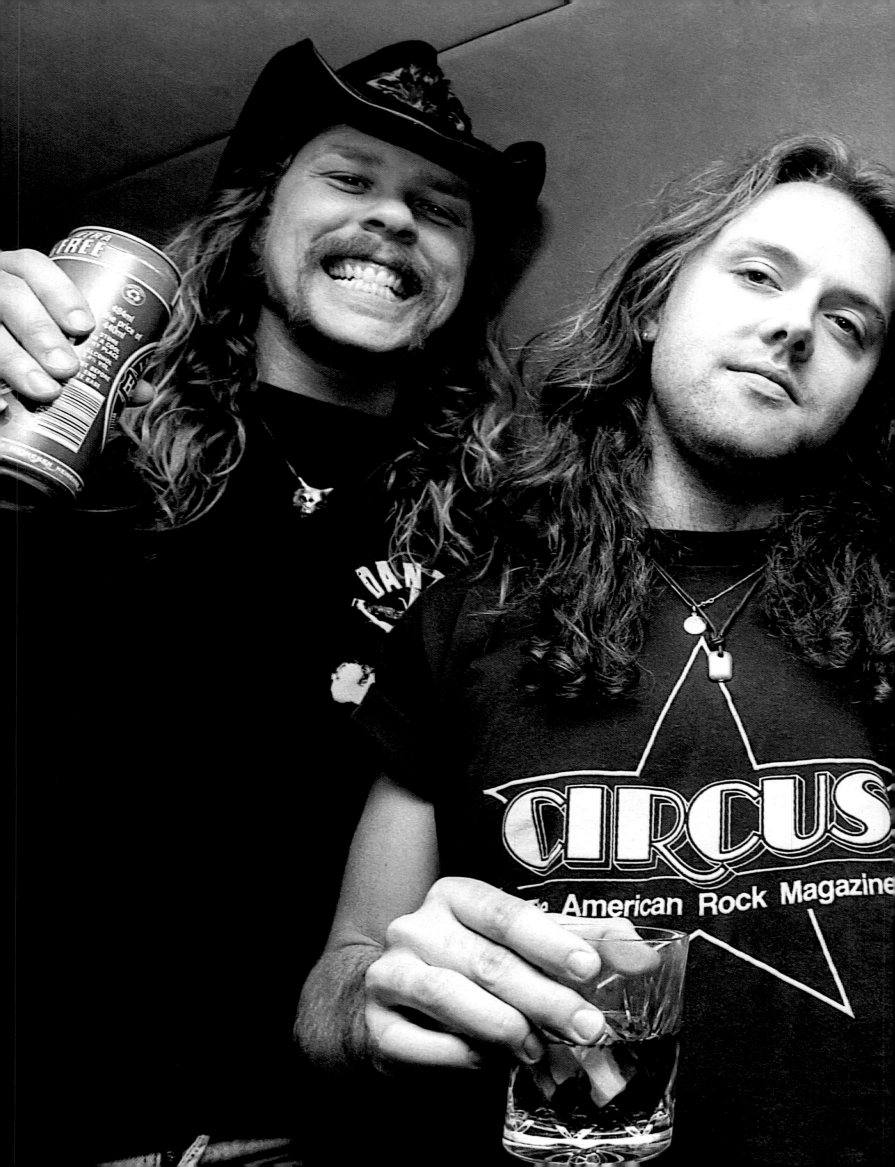

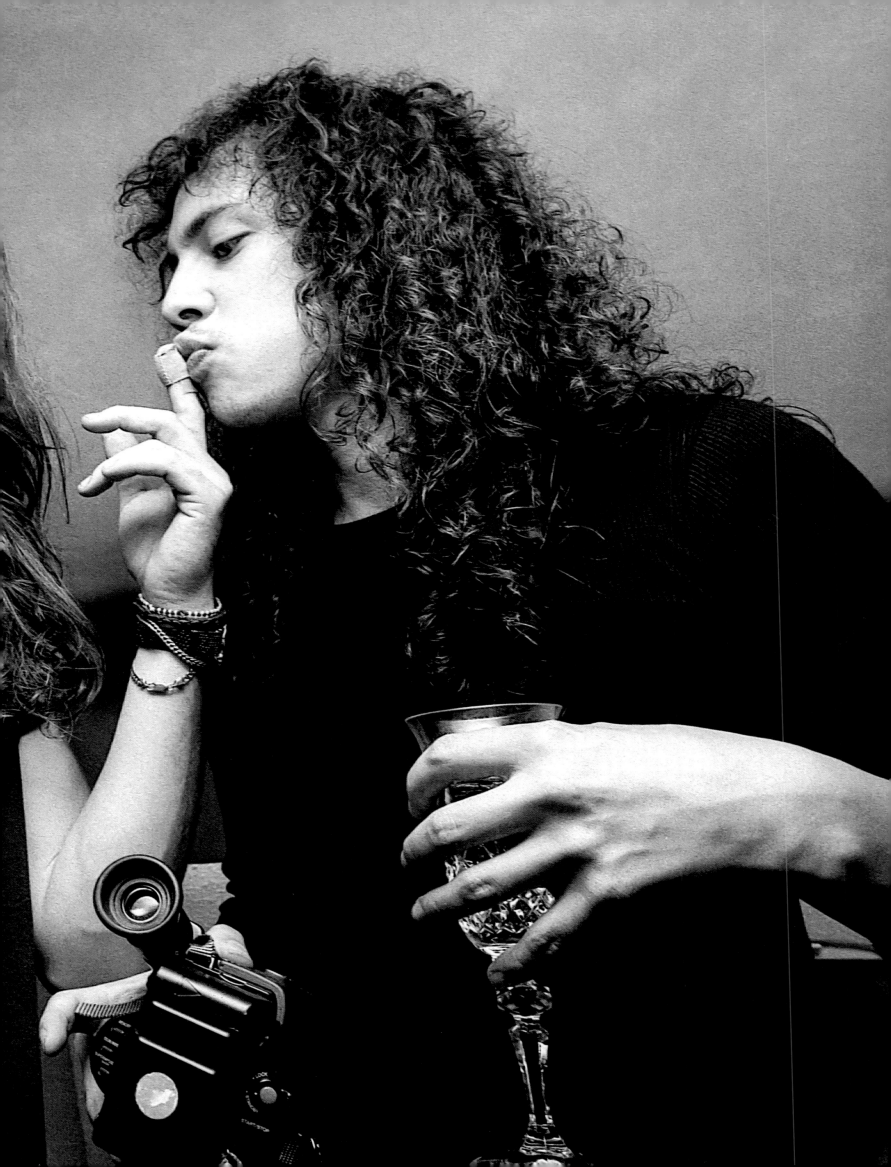

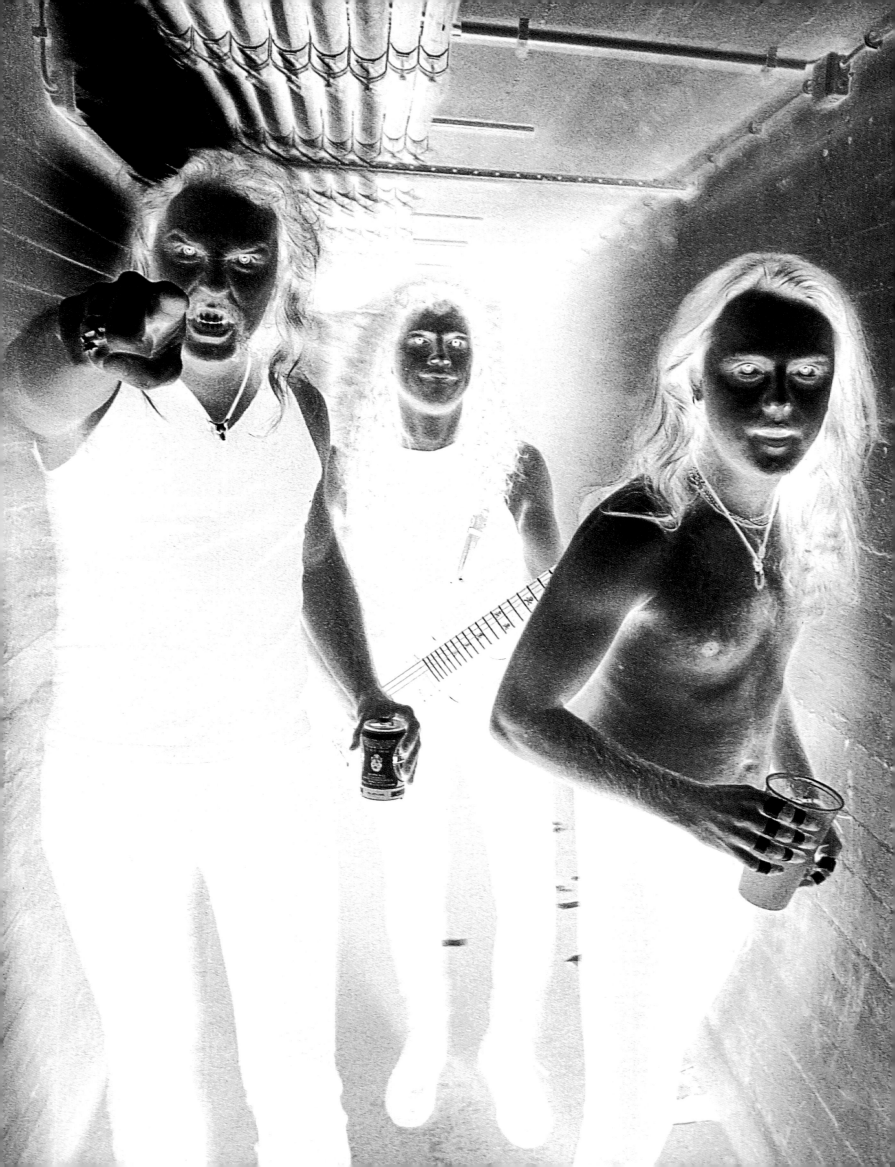

BACKSTAGE

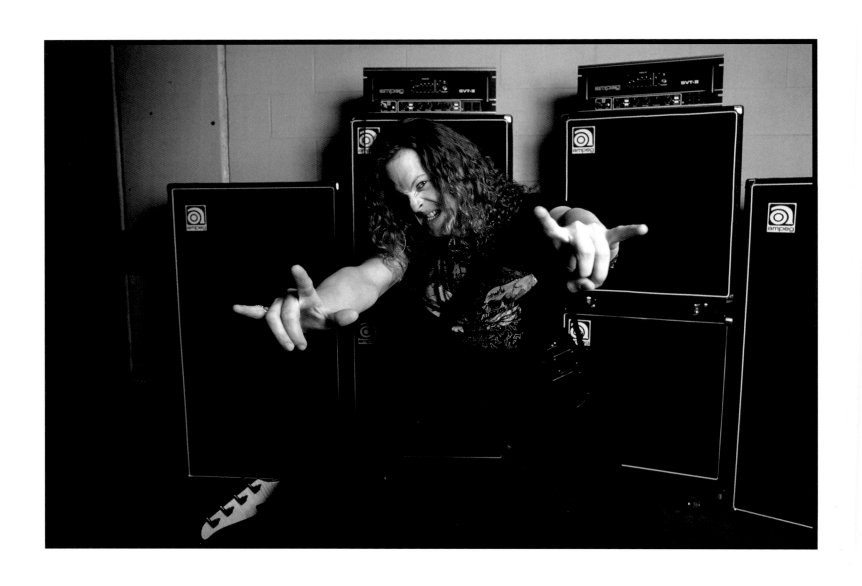

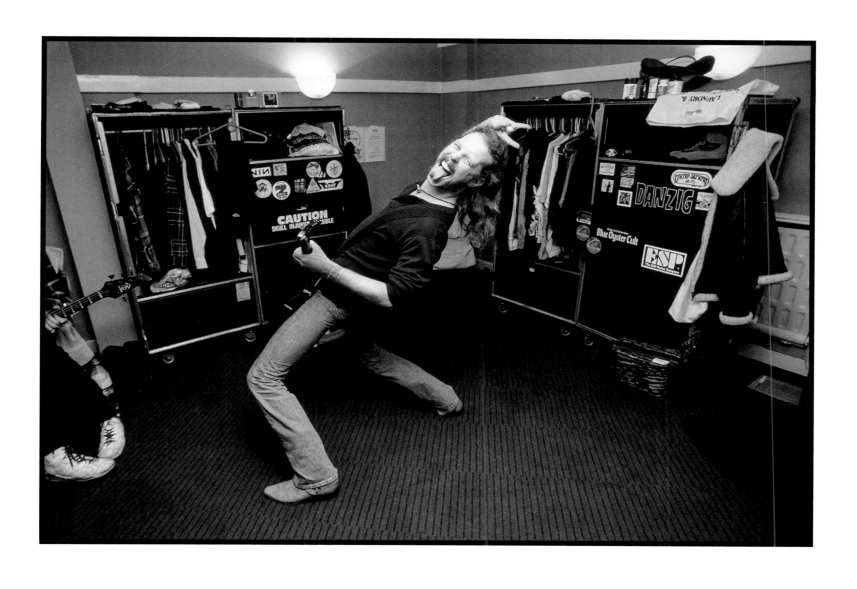

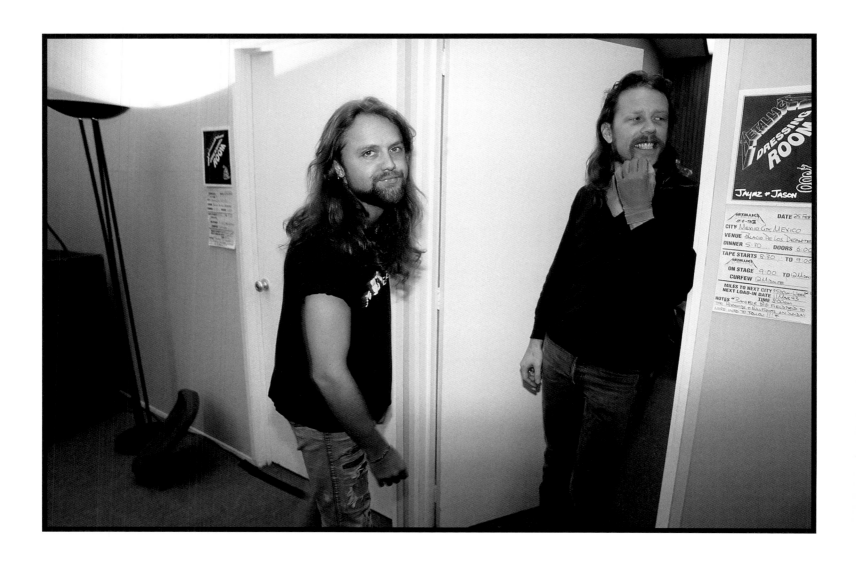

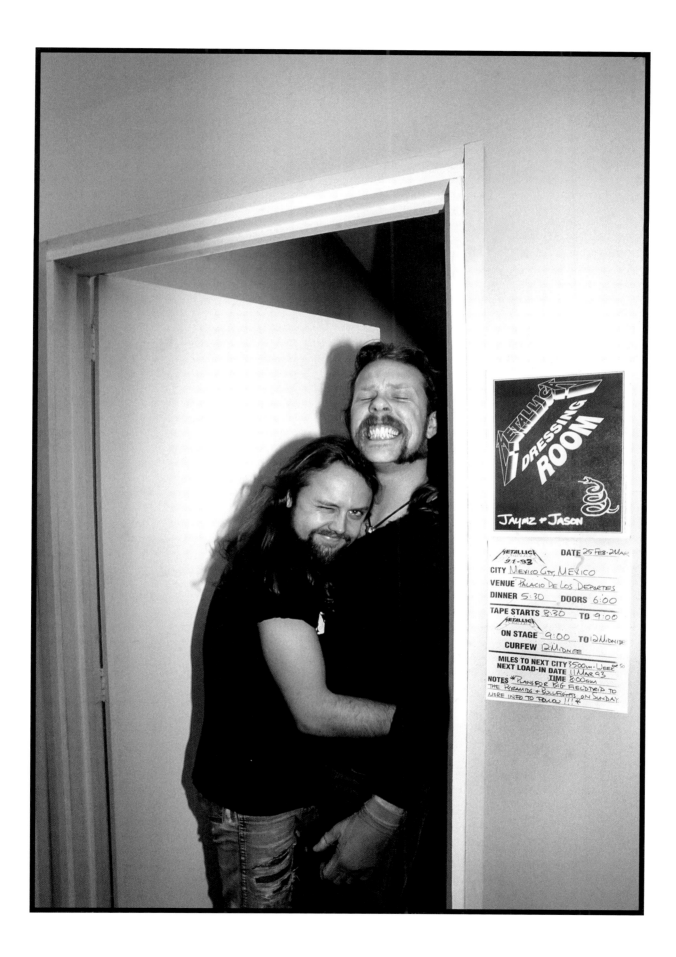

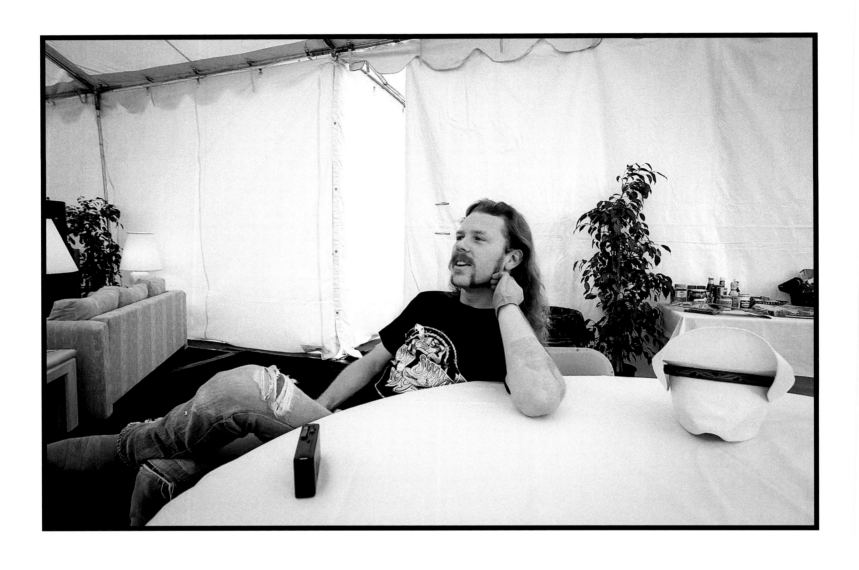

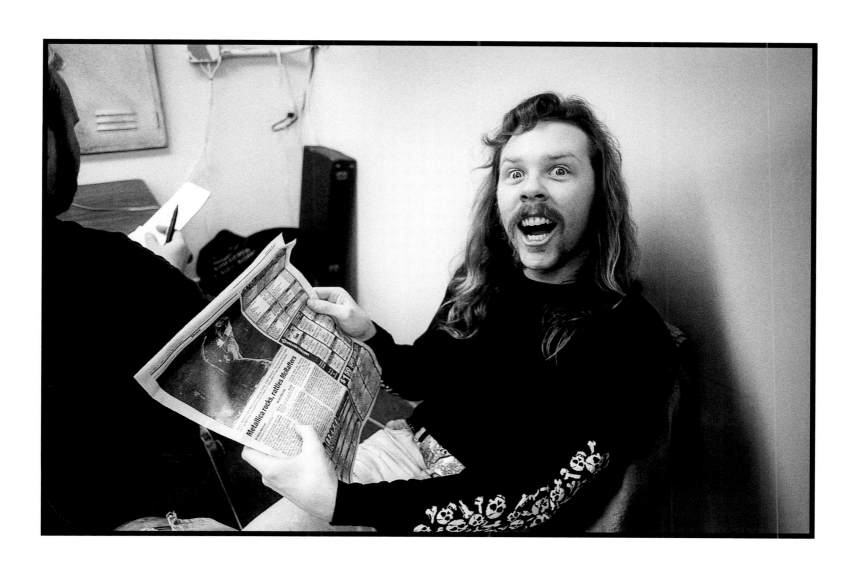

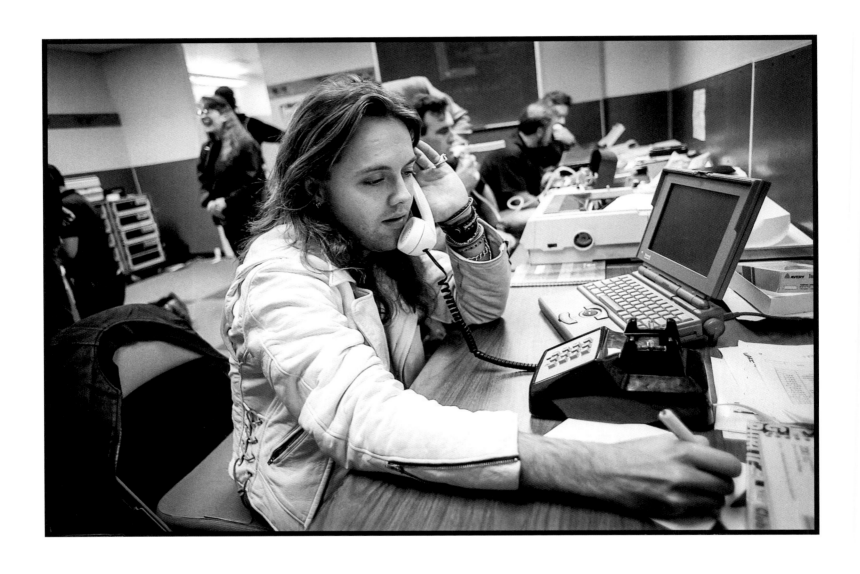

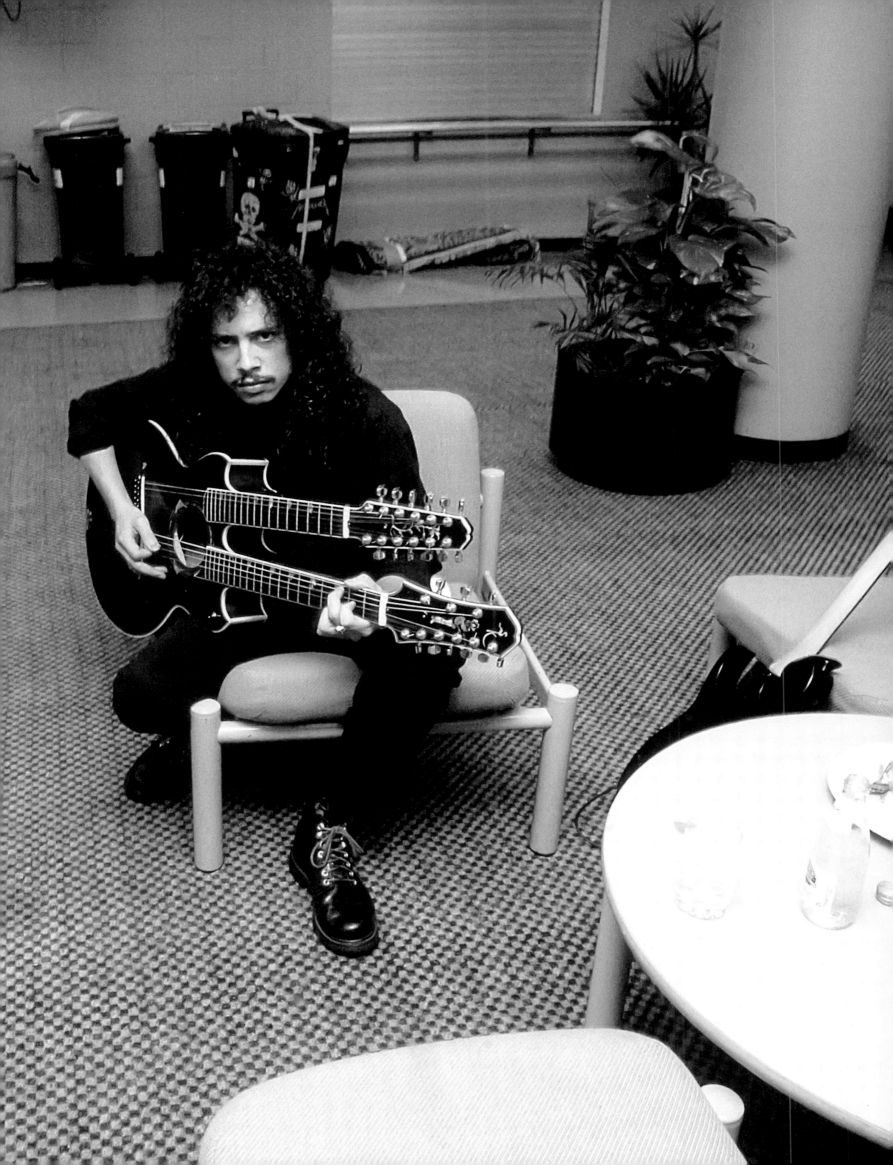

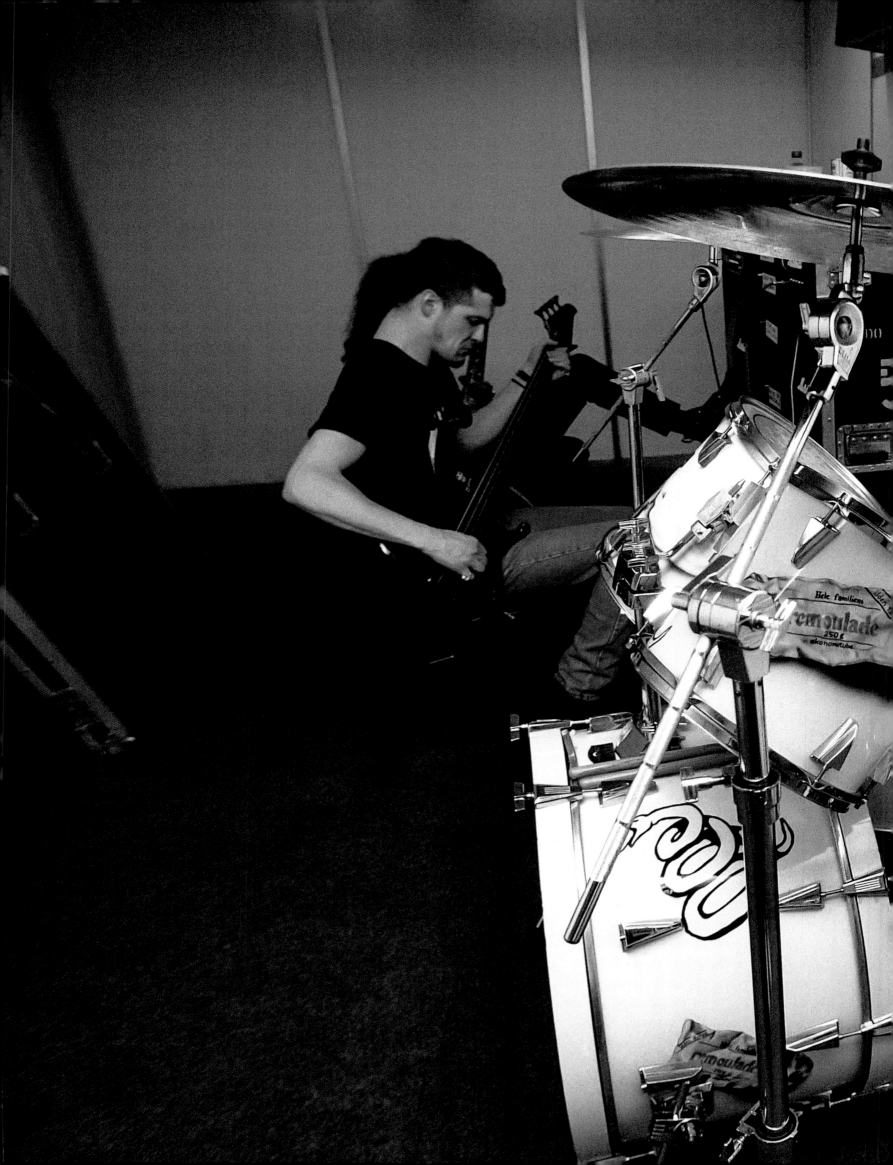

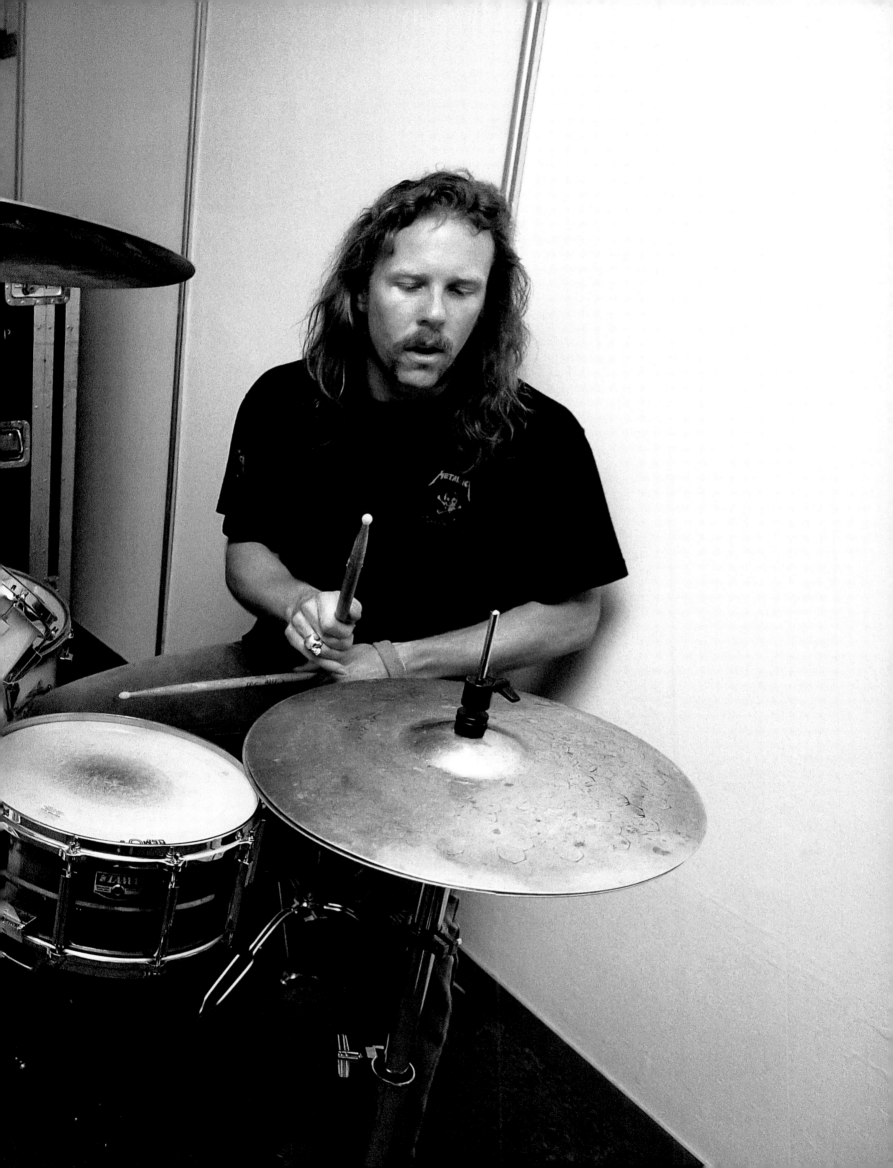

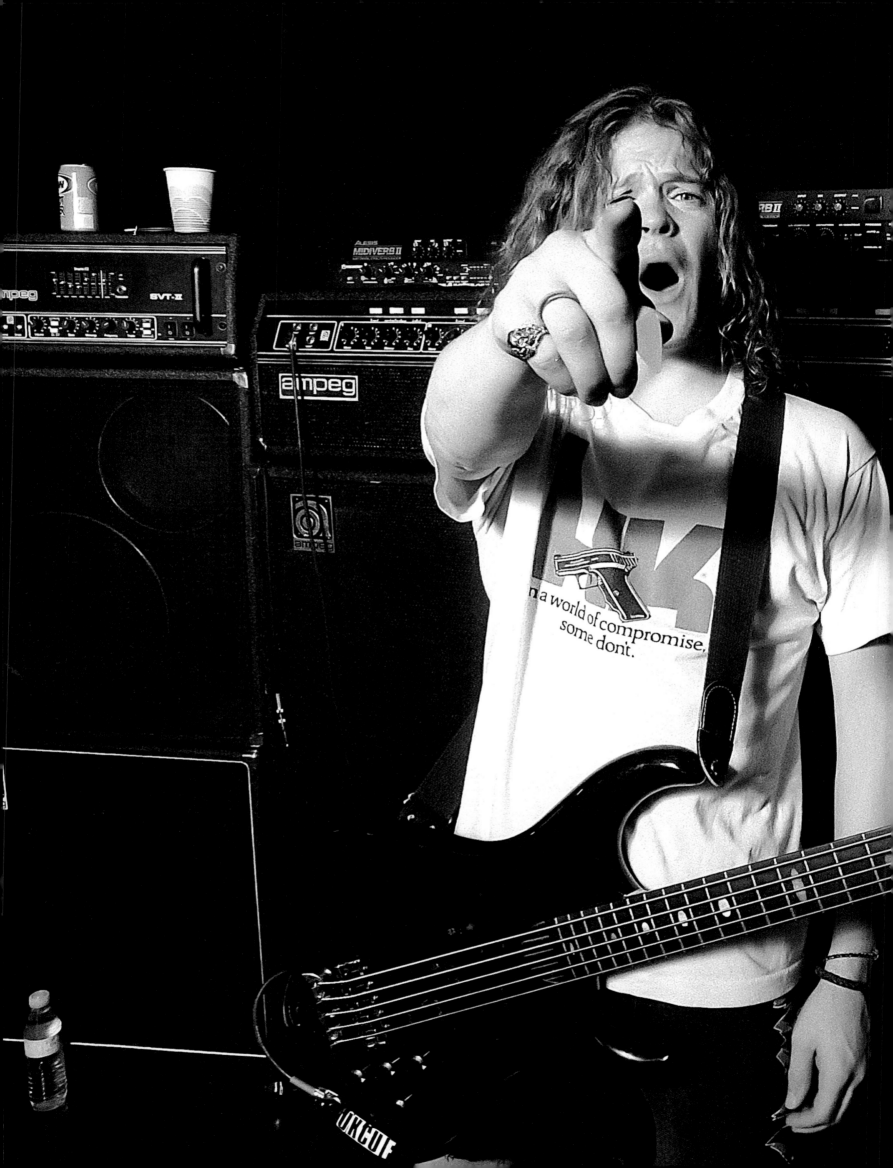

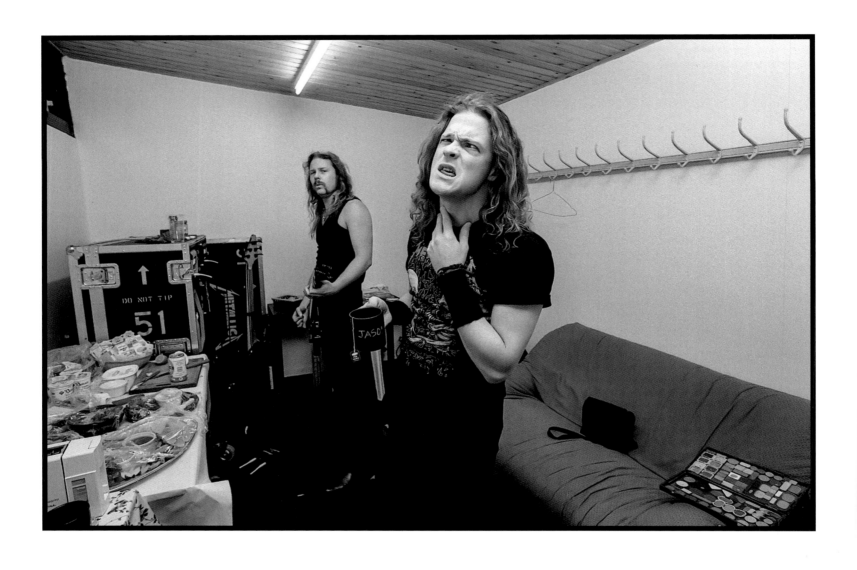

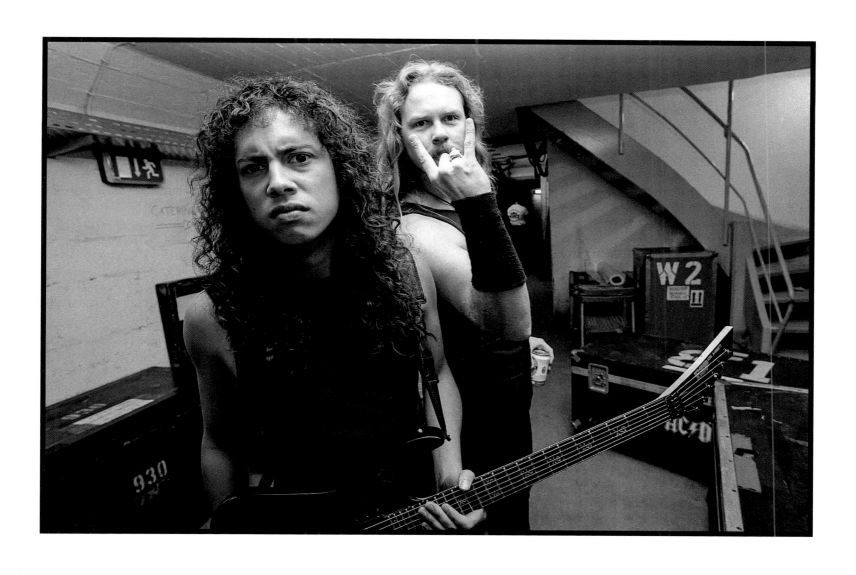

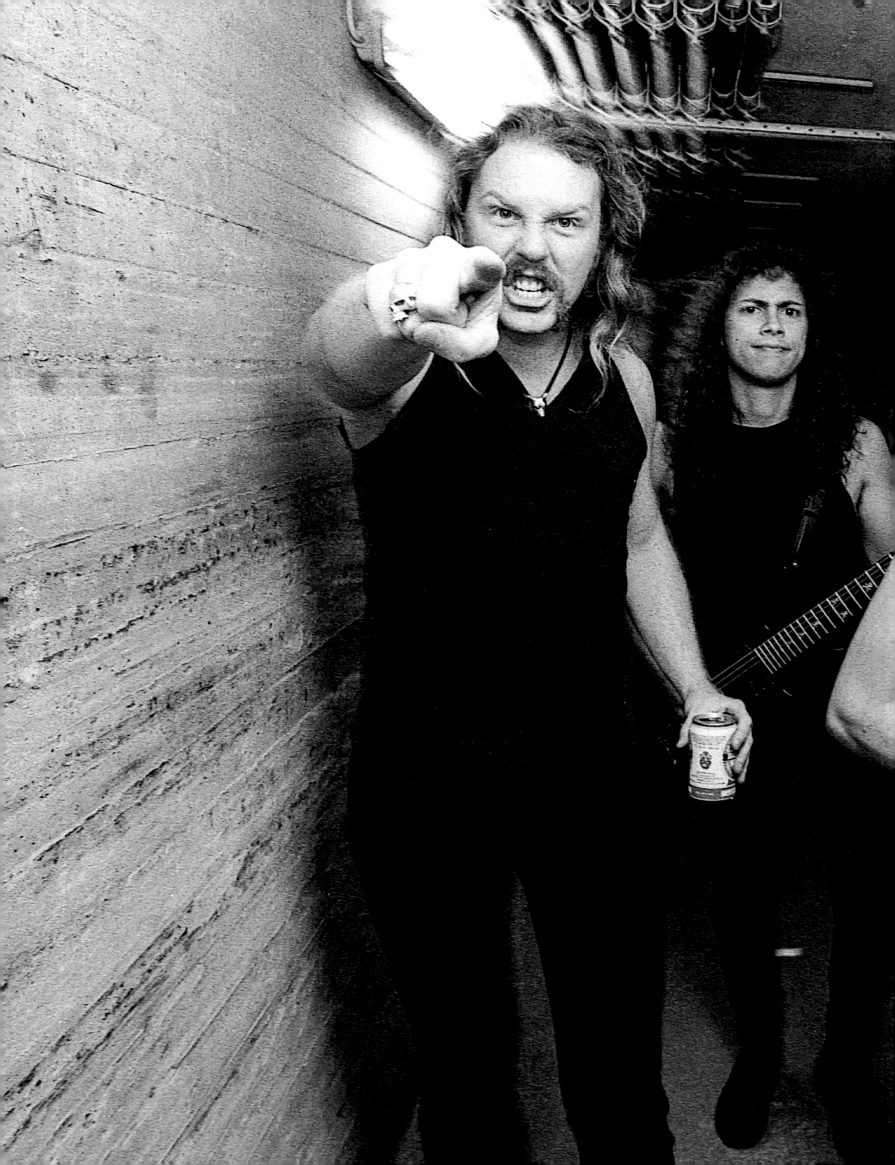

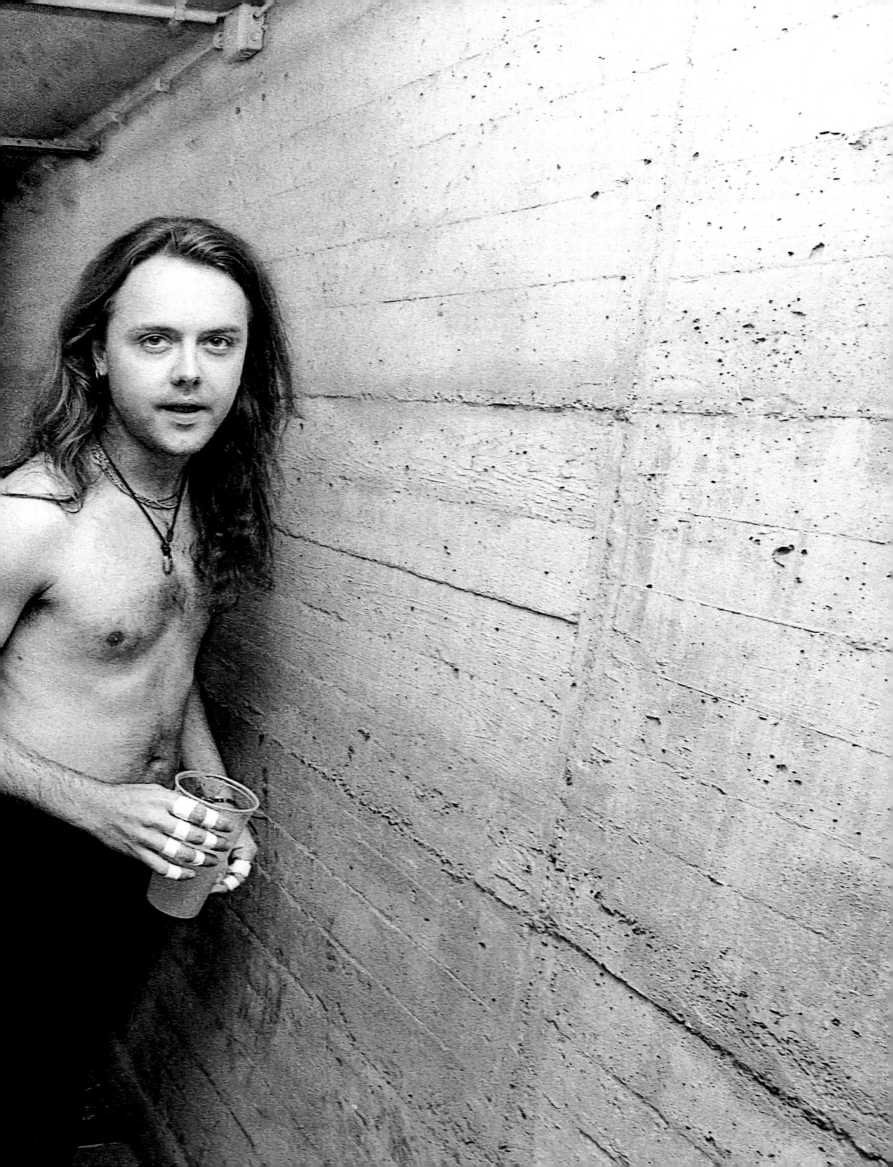

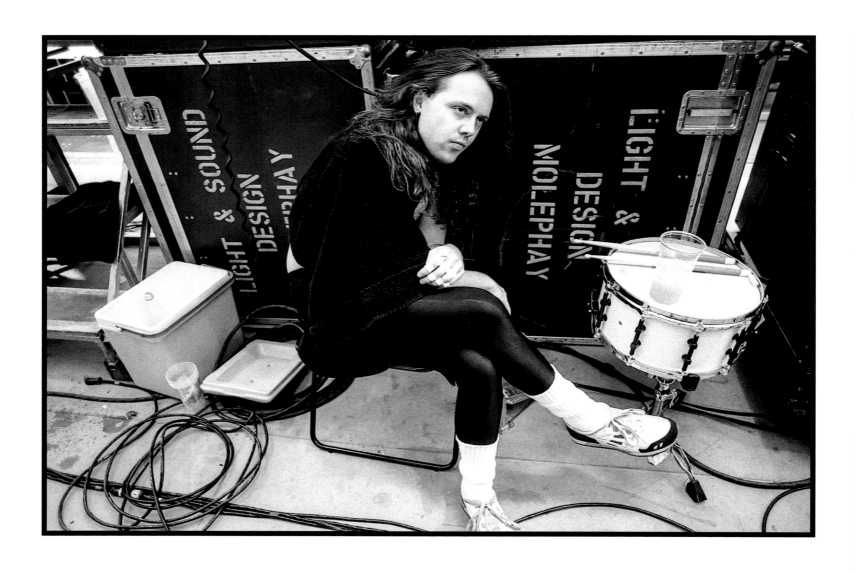

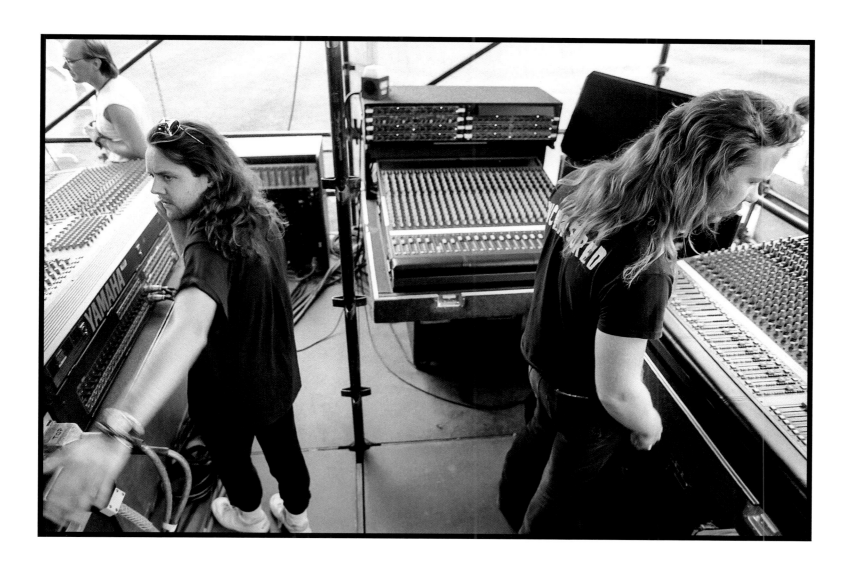

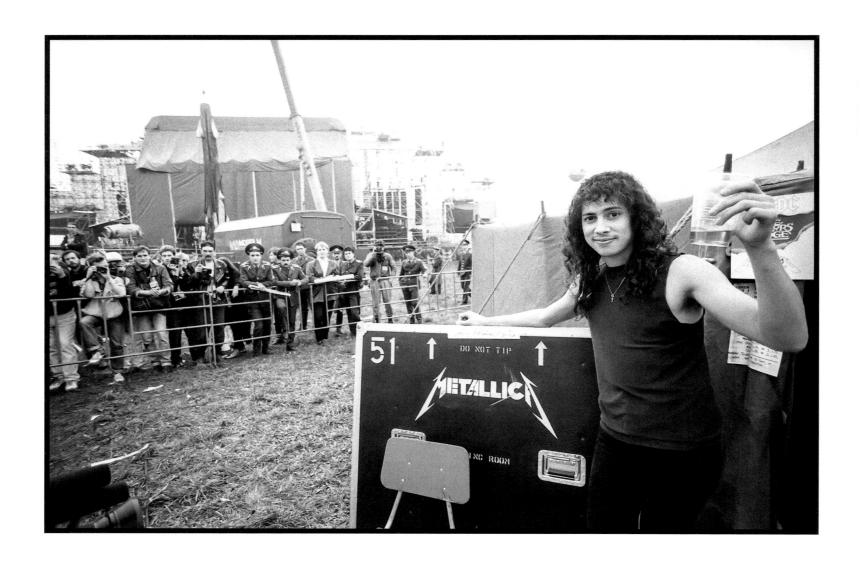

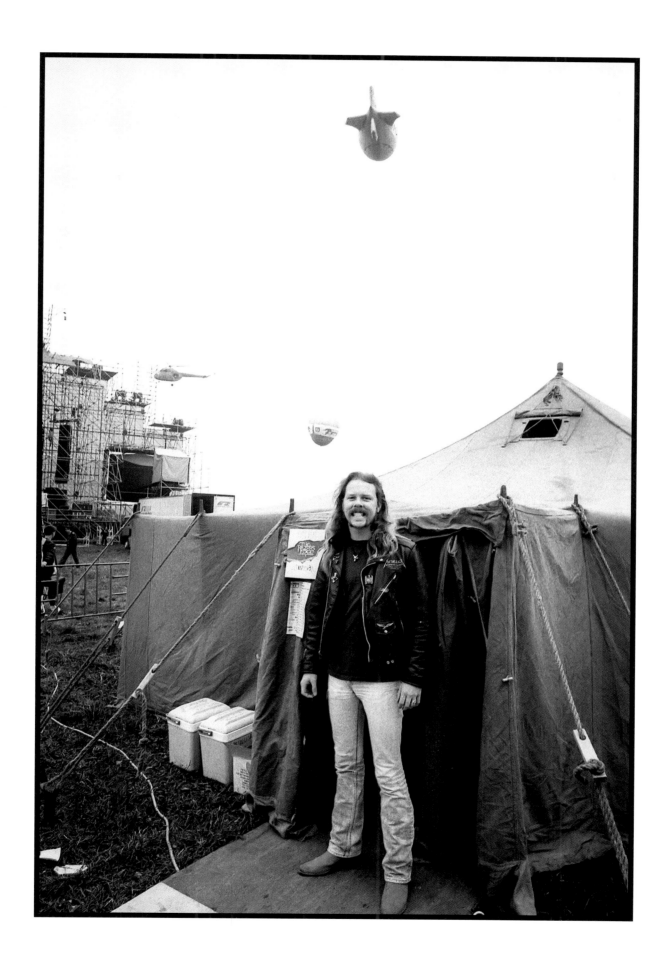

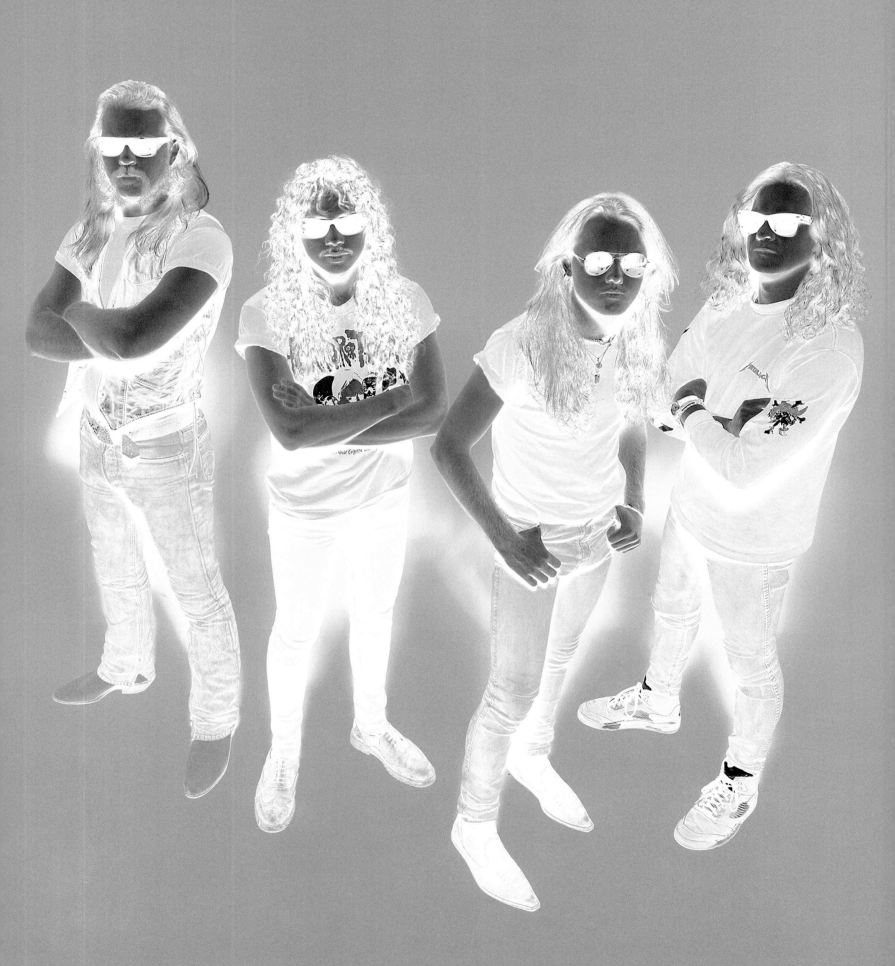

PORTRAITS

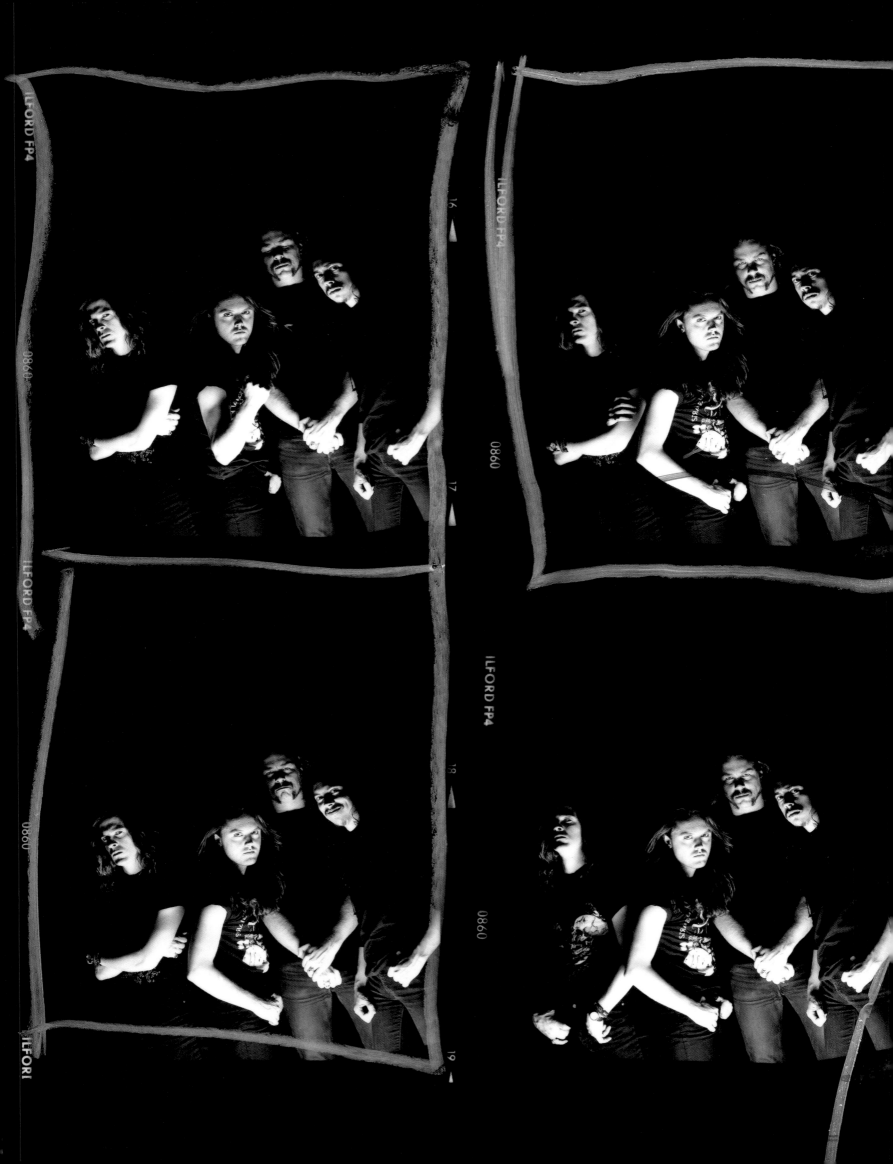

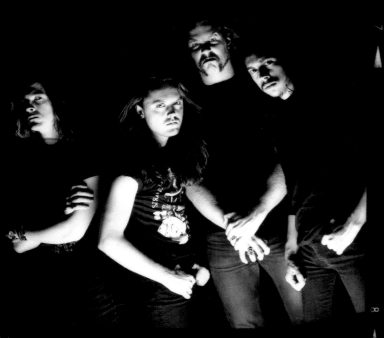

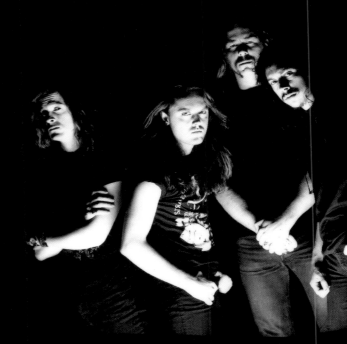

ILFORD FP4

0860

0860

CSSIGCSS1 2

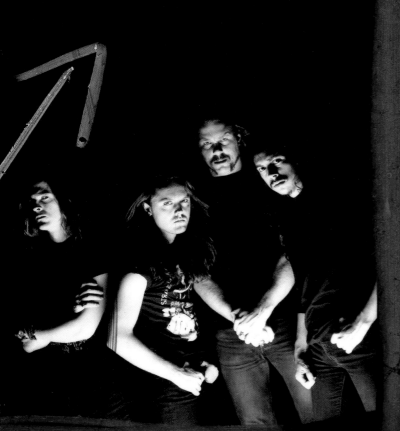

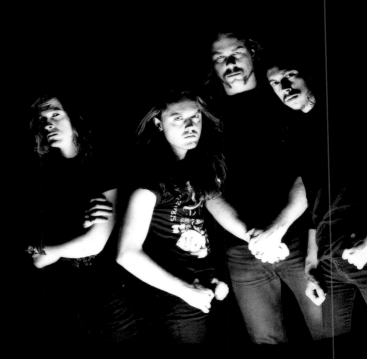

ILFORD FP4

**That was Ross's idea.
He had heard we were
calling it the *Black Album*
and he said, *Well, if it's going
to be the Black Album,
let's do black portrait shots.*
So that's how those
came about.**

KIRK

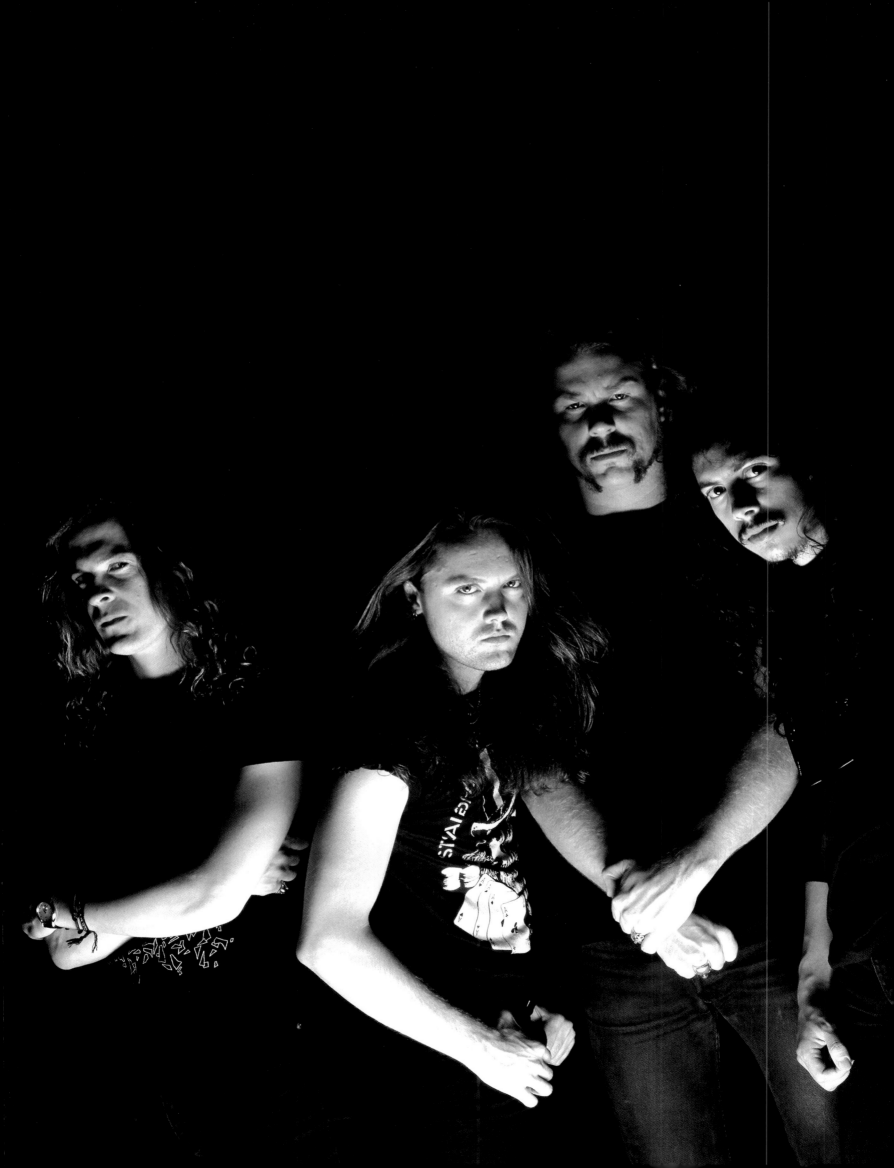

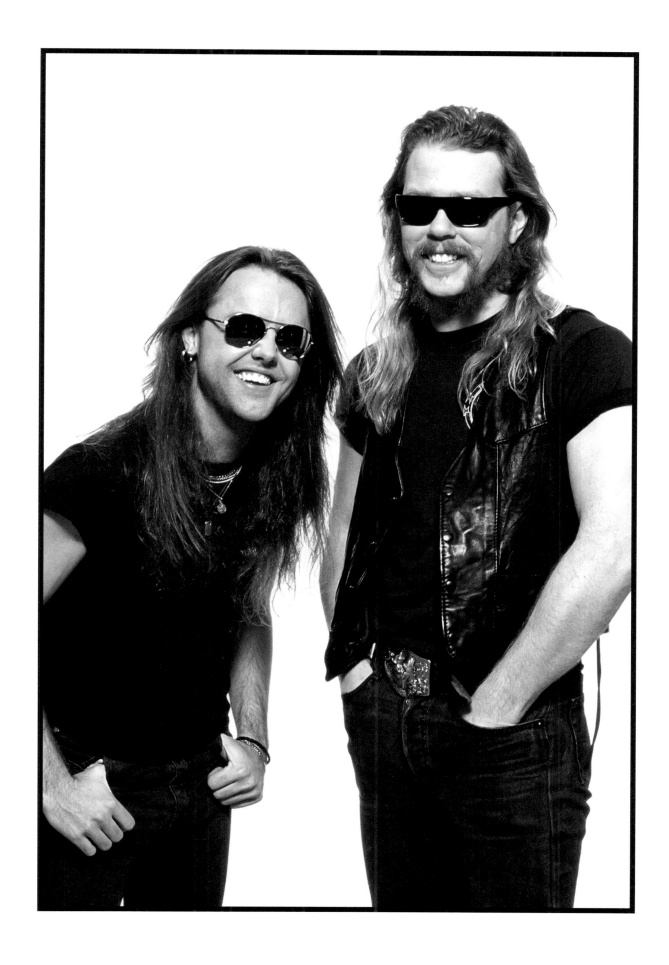

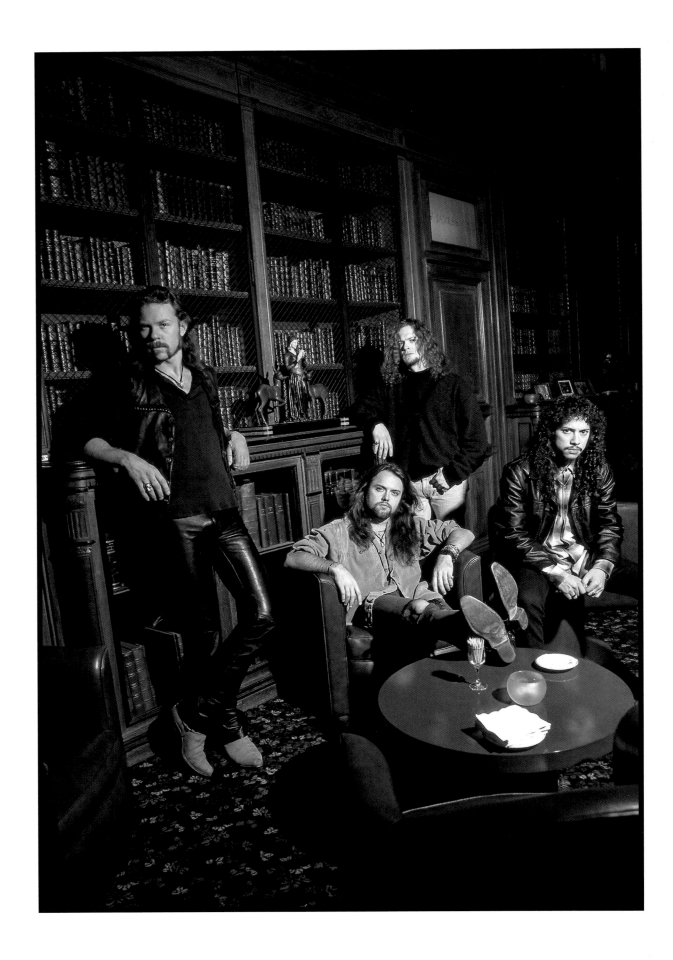

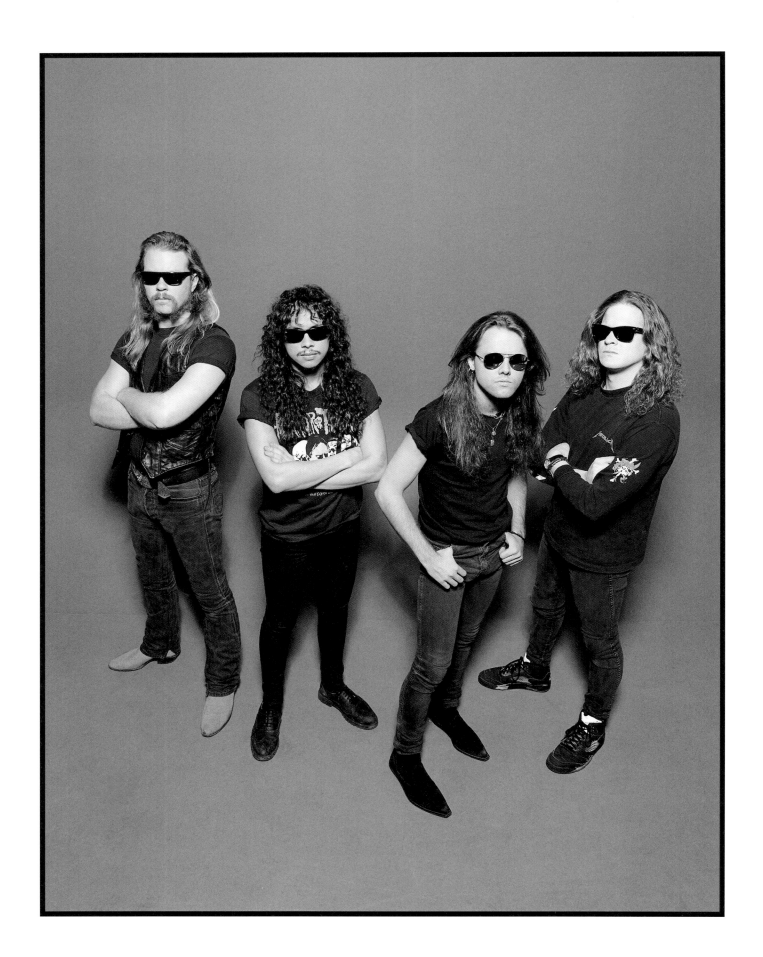

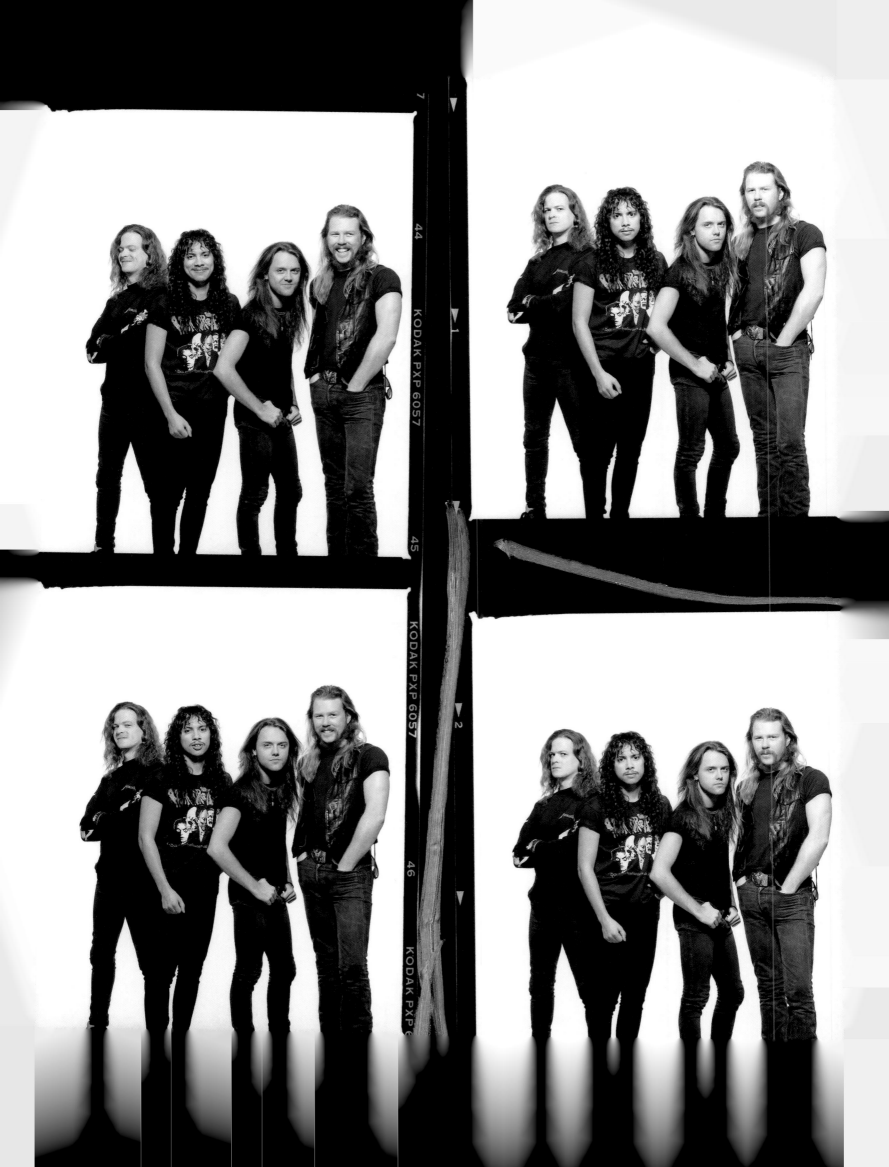

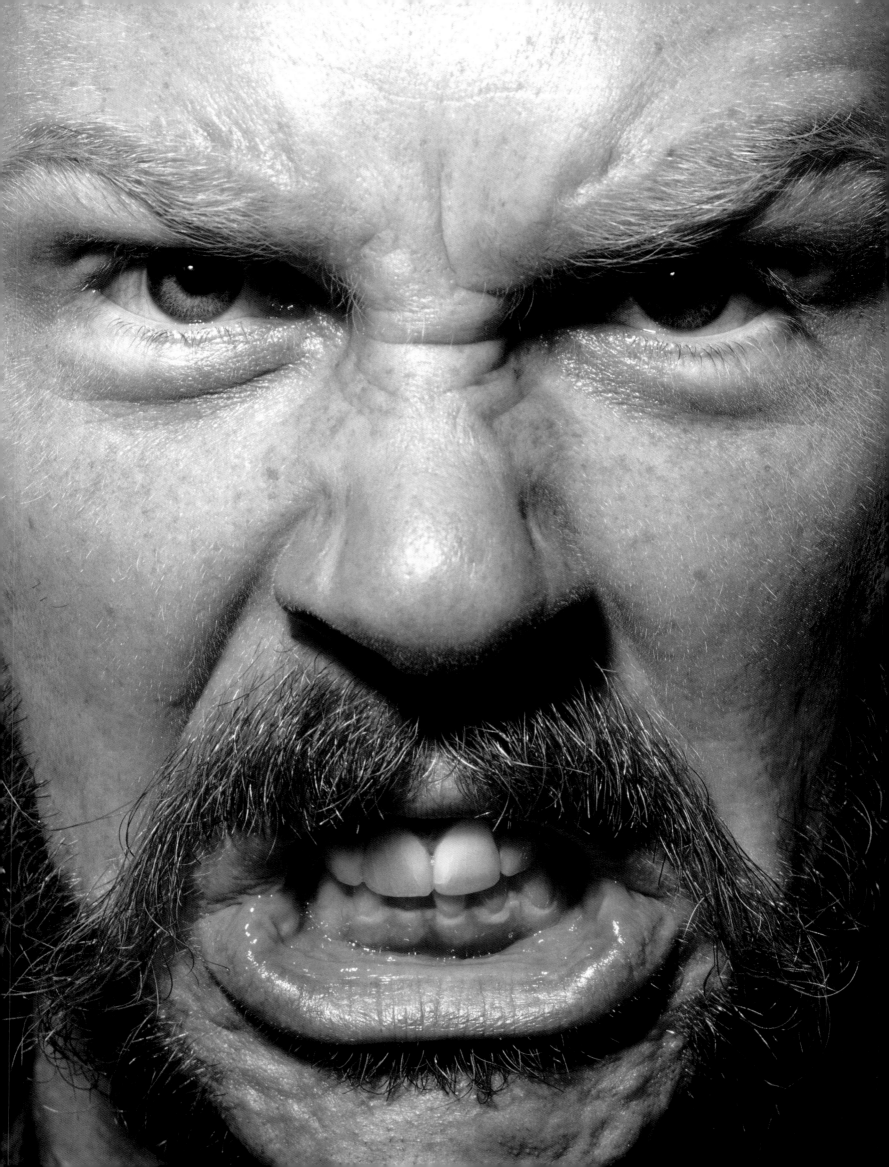

So many things changed for us externally after the *Black Album*'s release. The perception of the importance of Metallica changed greatly.

JAMES

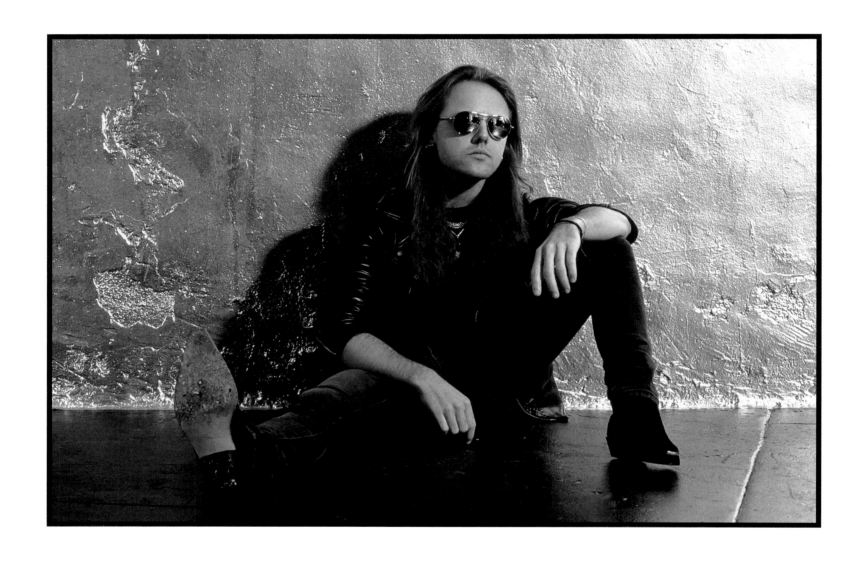

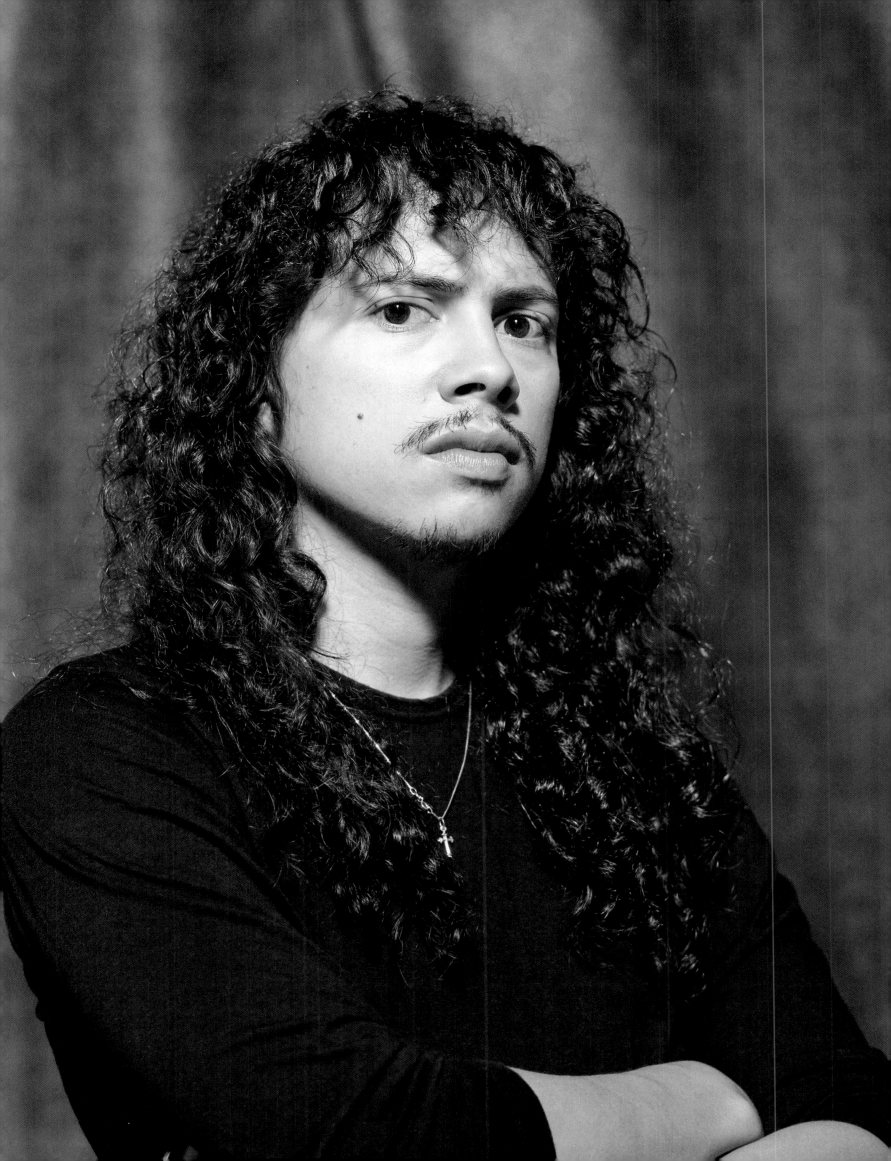

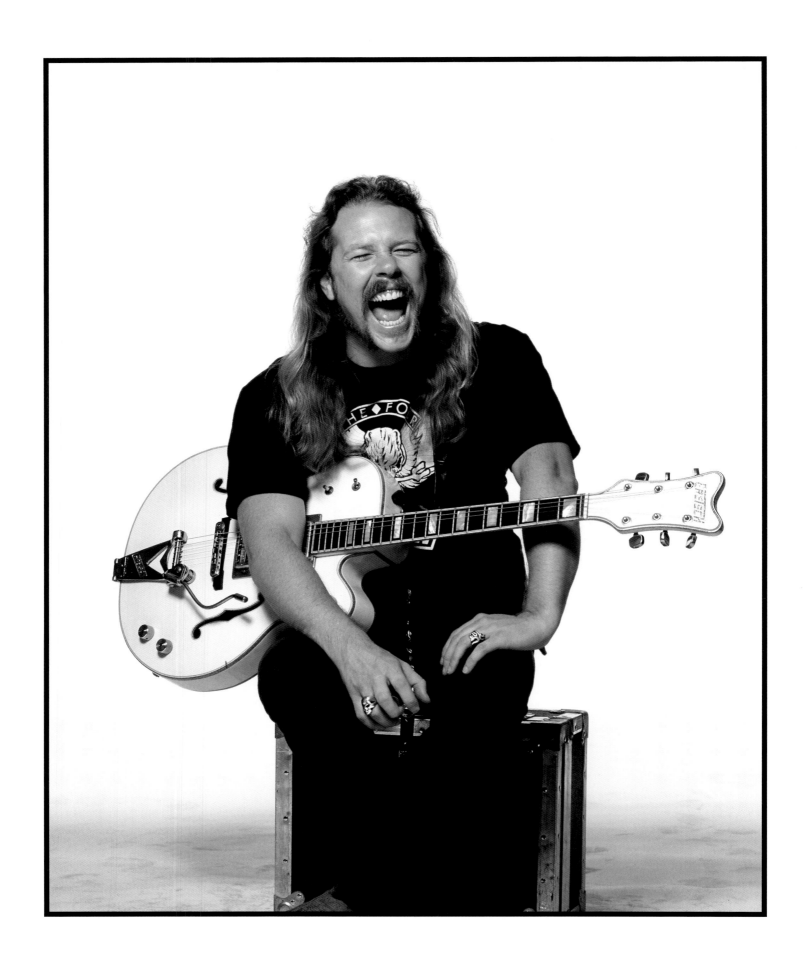

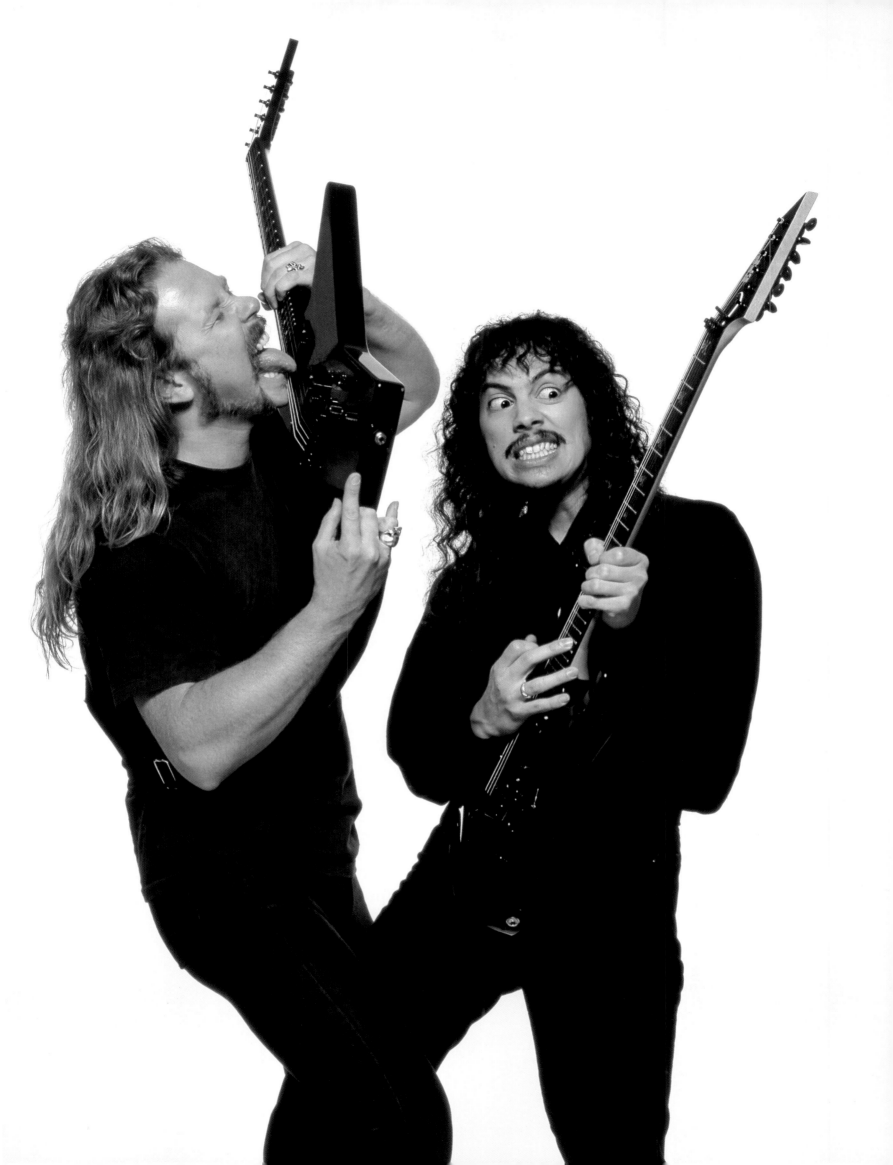

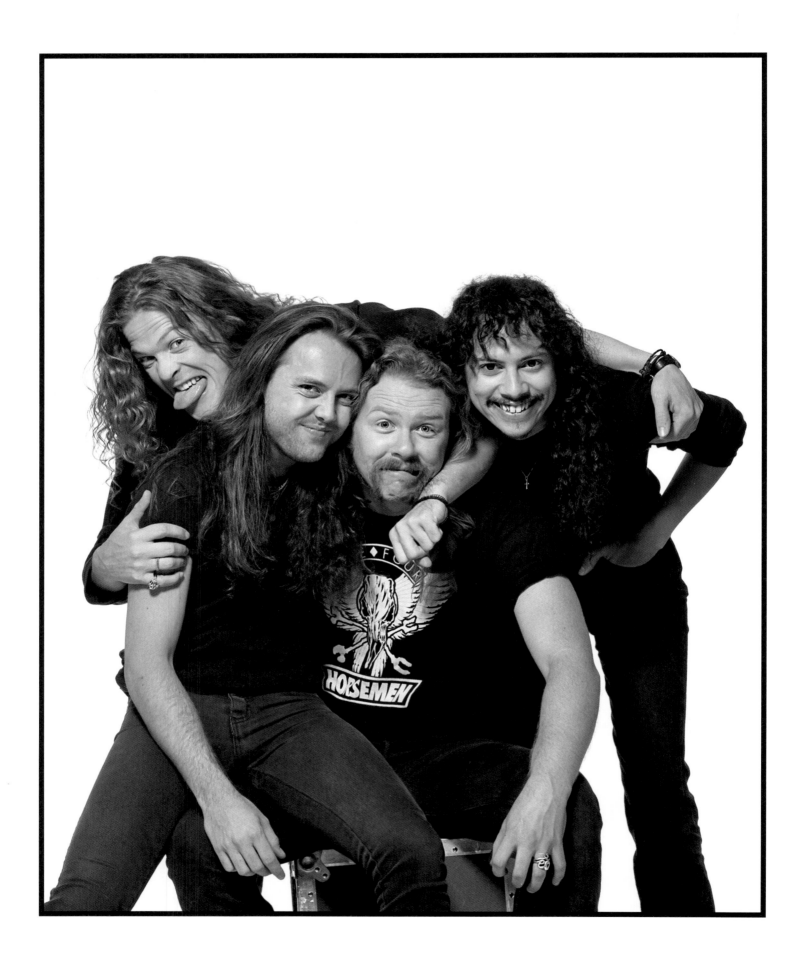

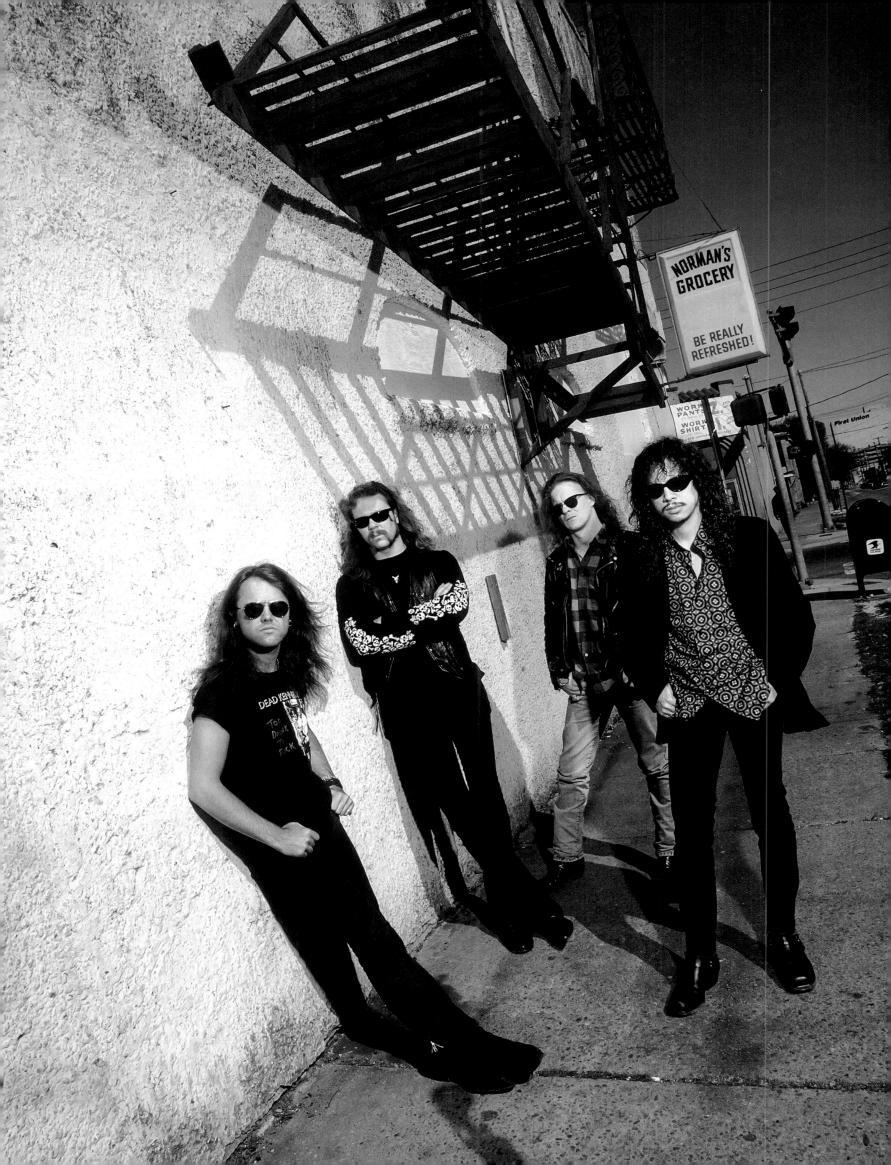

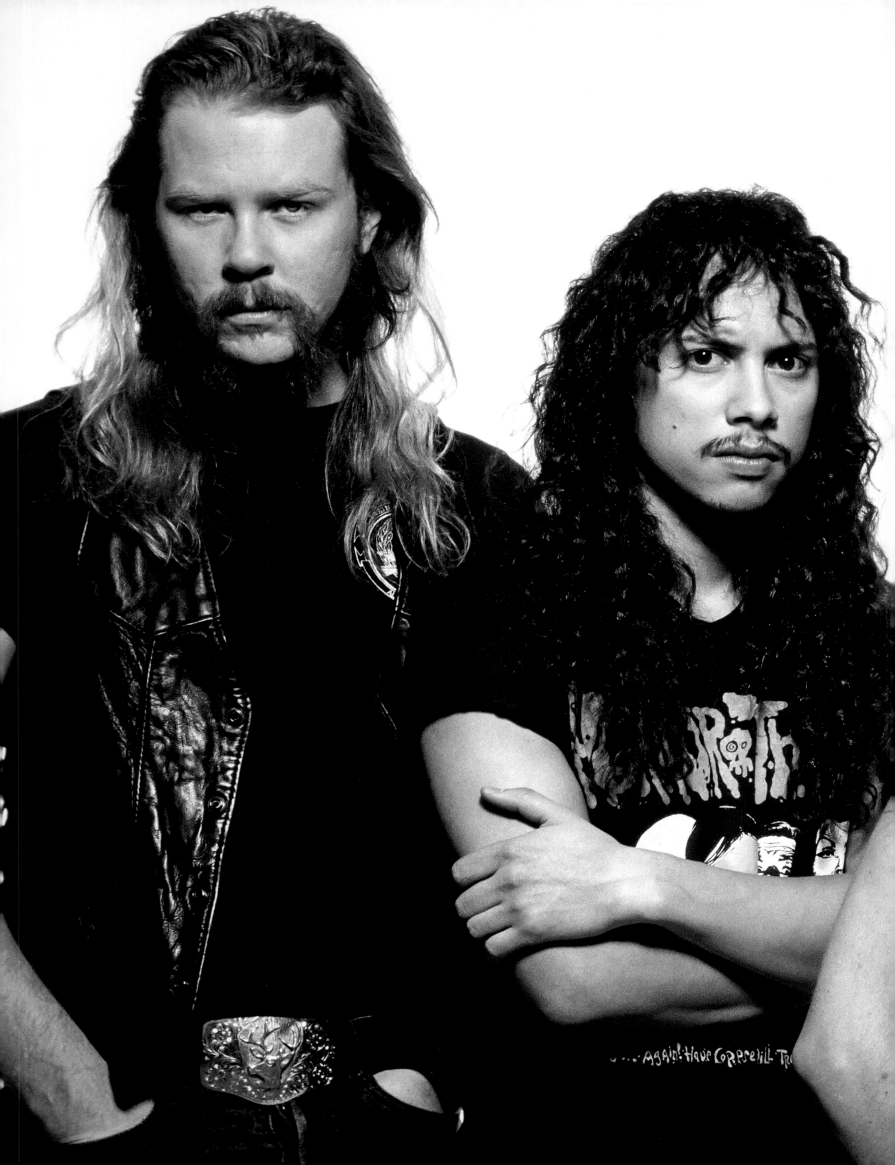

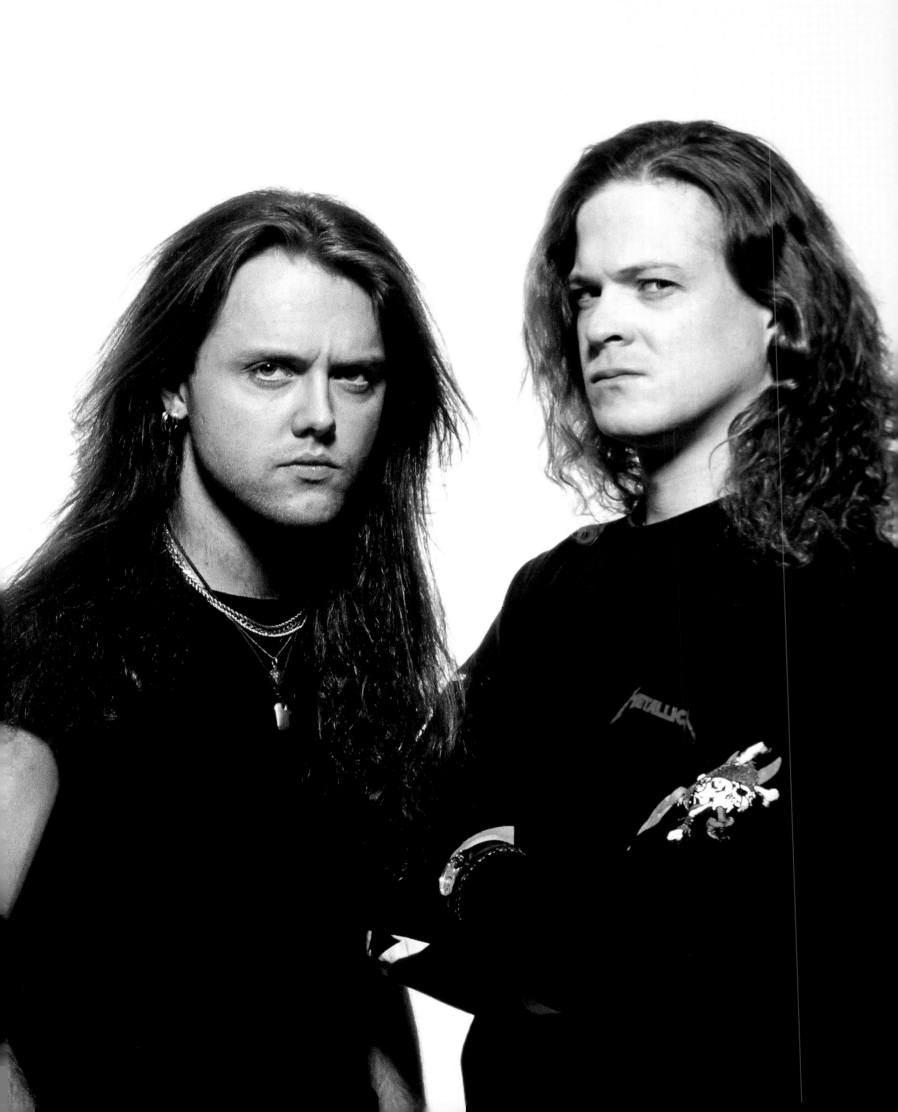

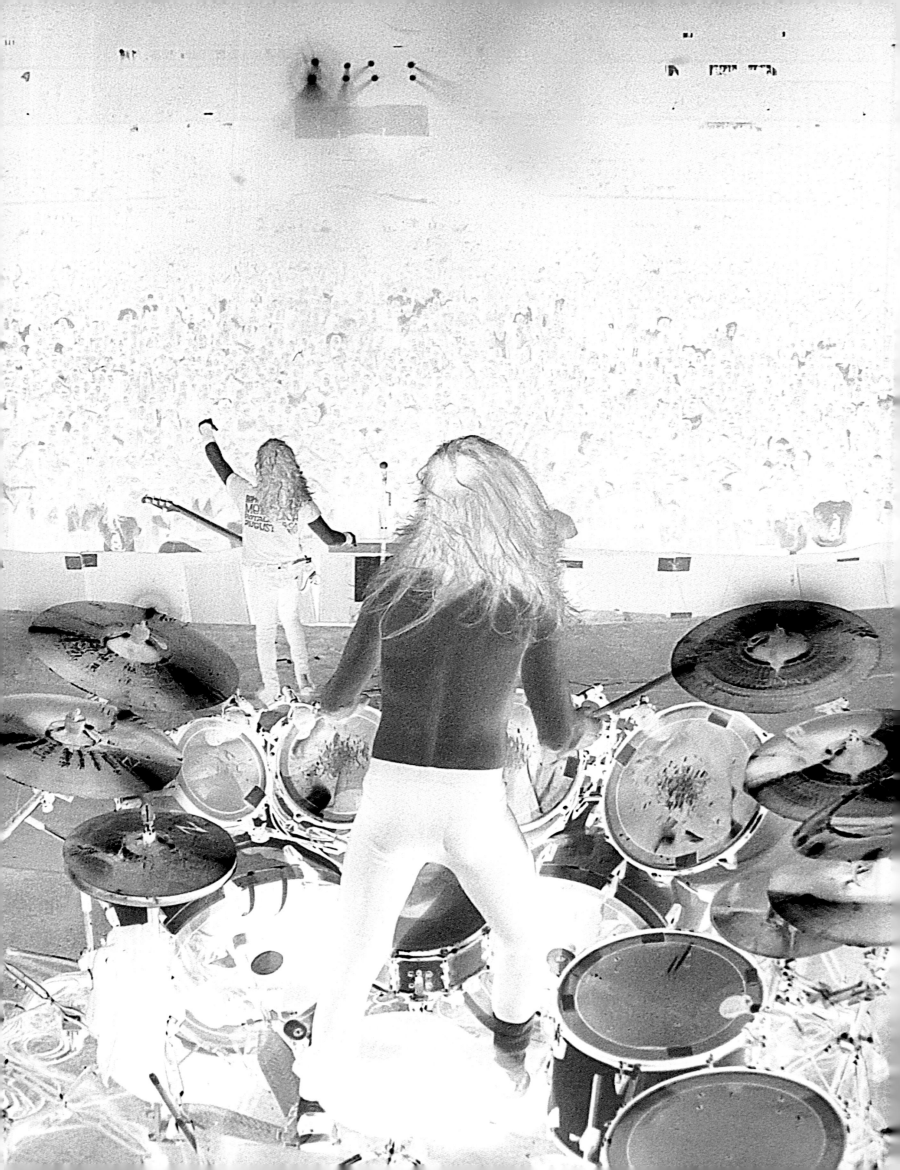

ON TOUR

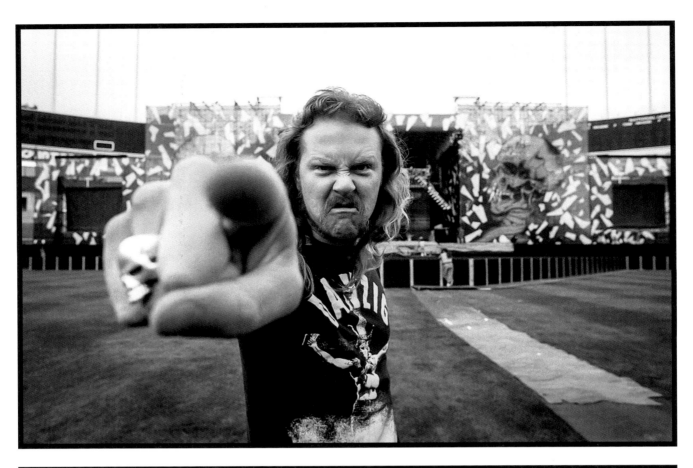

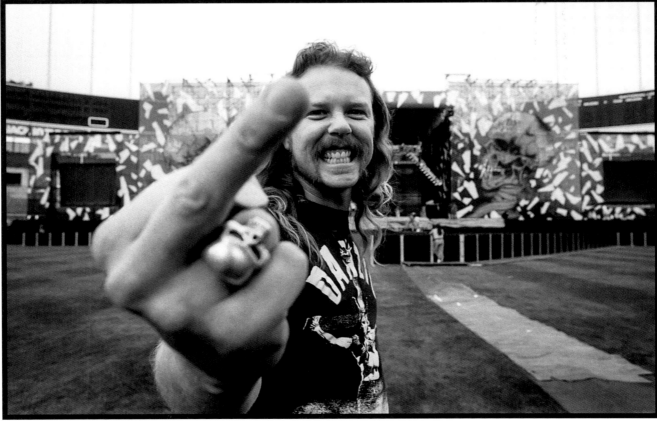

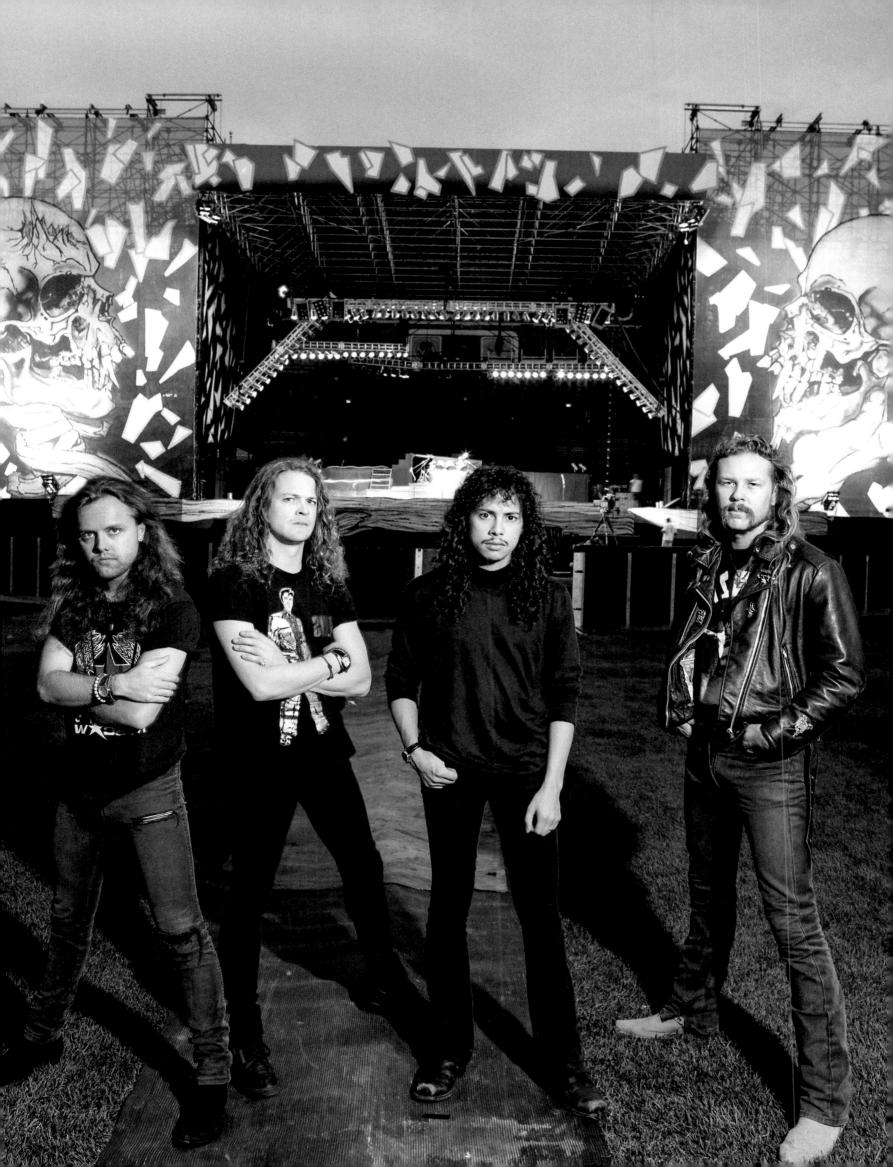

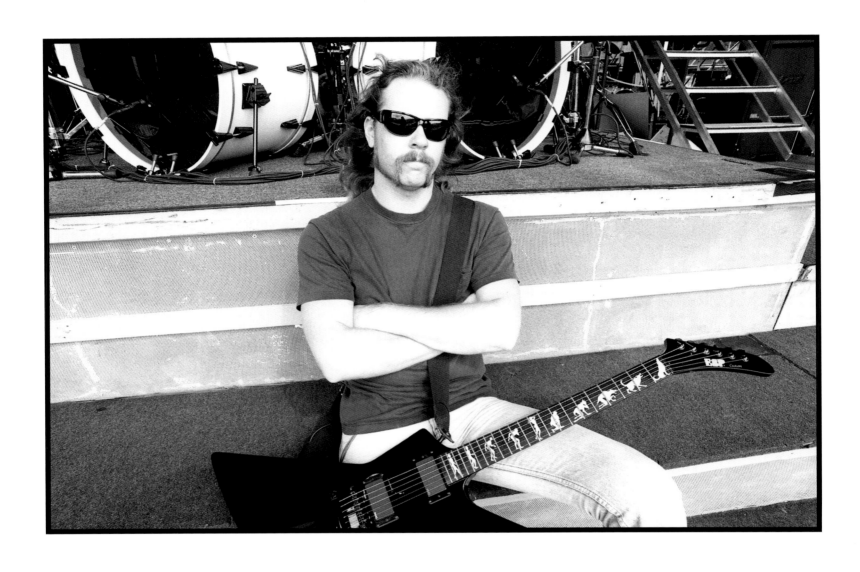

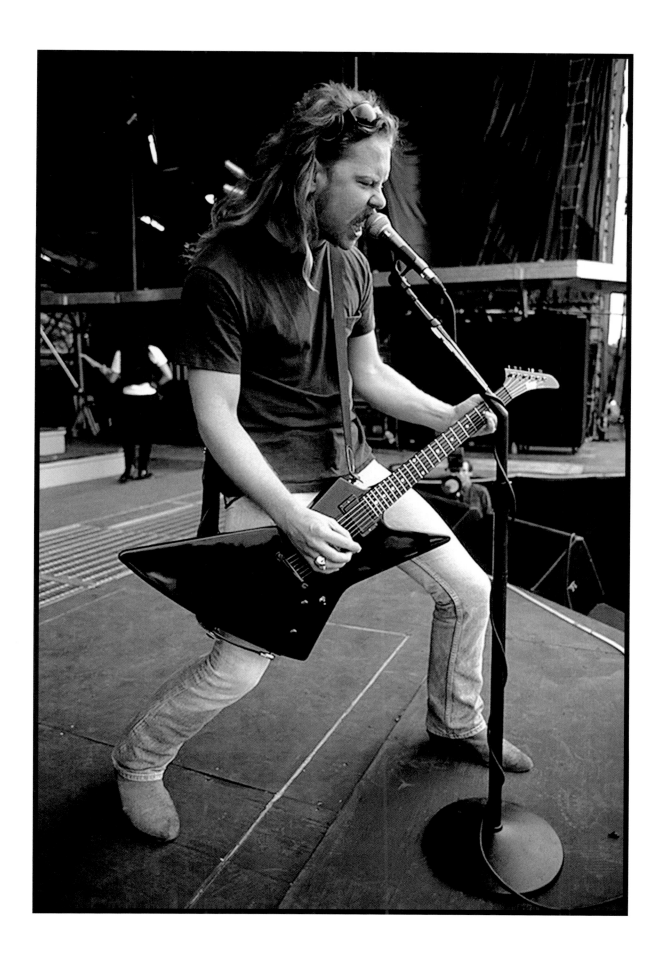

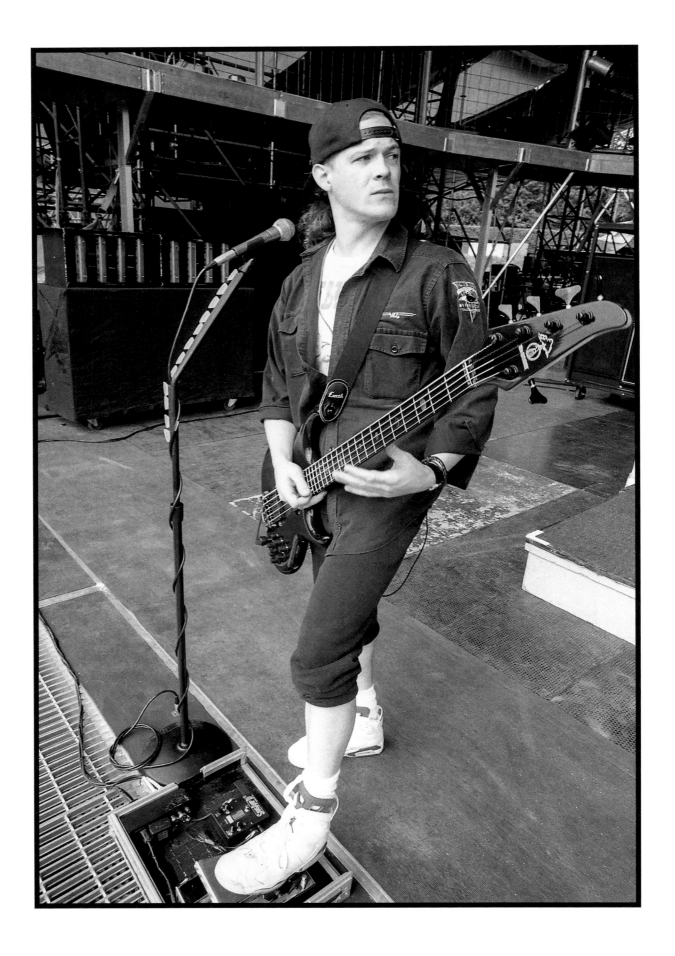

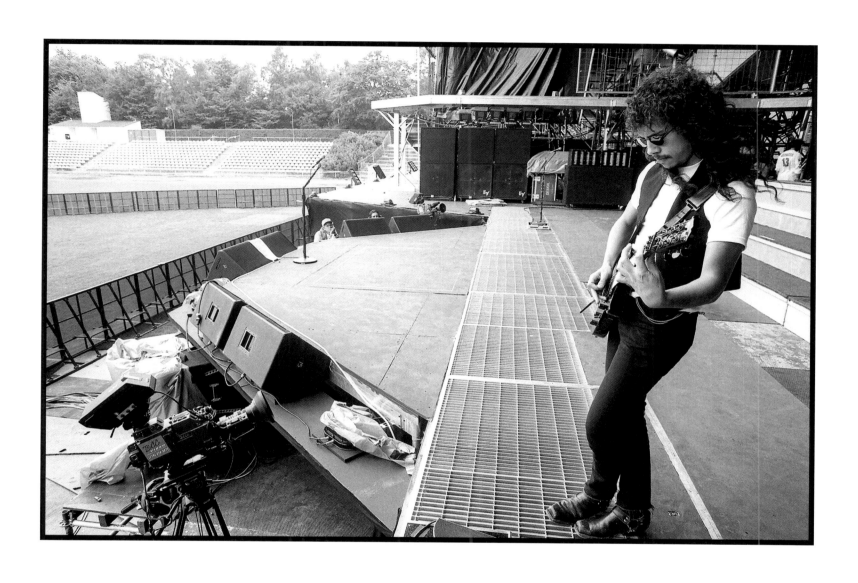

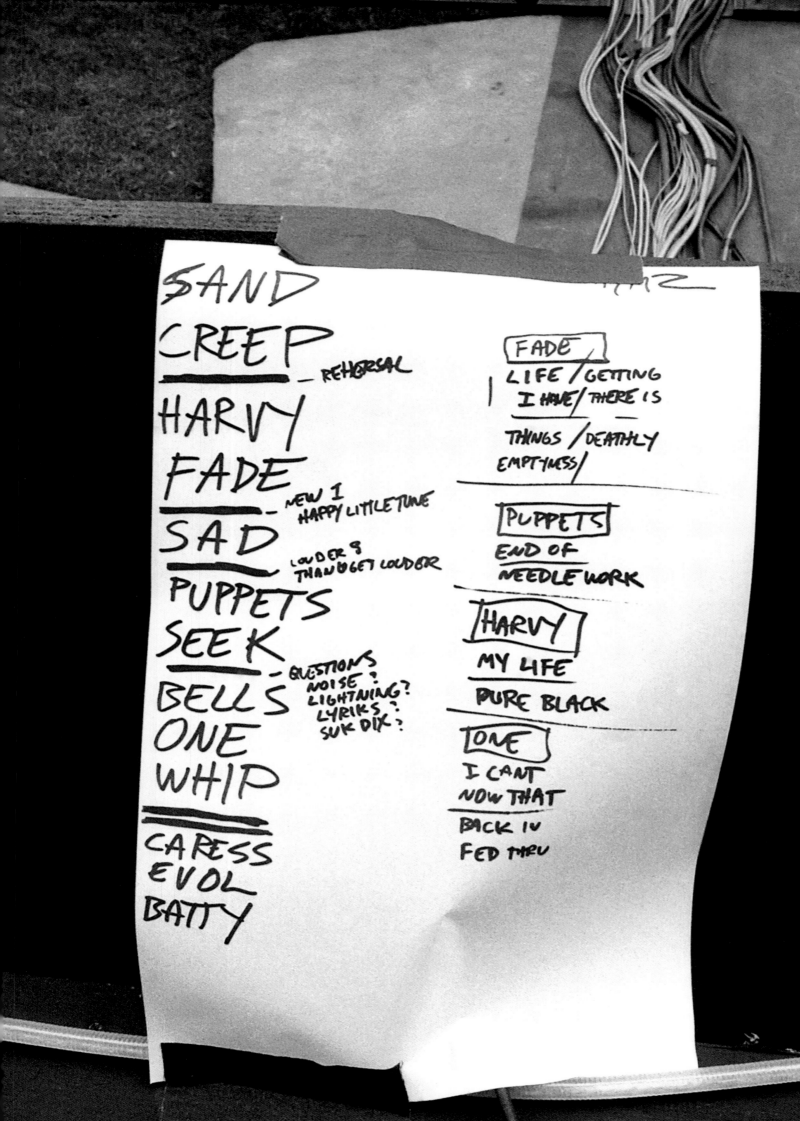

The *Black Album* is the statement record that propelled this amazing band to a whole new height of creative and commercial success, achieving a certain incredible balance of melody, kick ass riffage, and dynamics.

ROBERT

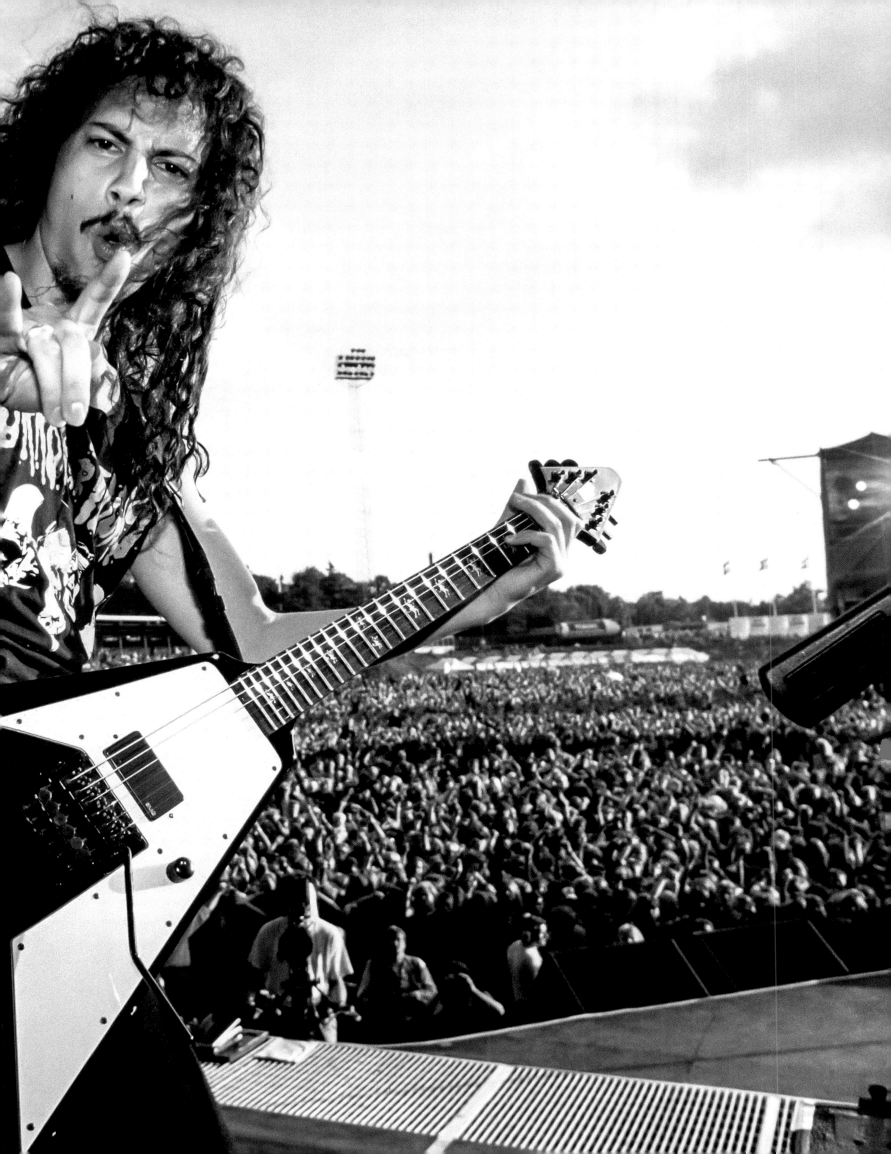

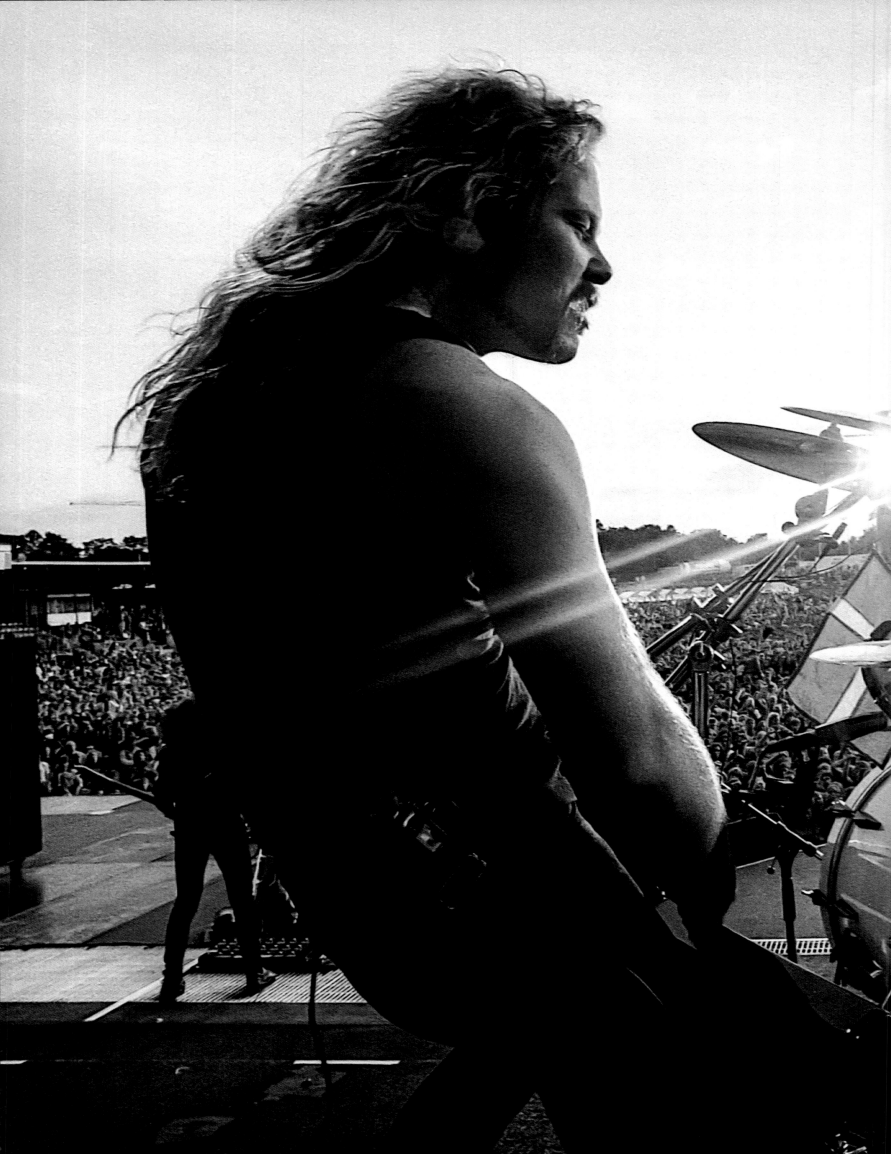

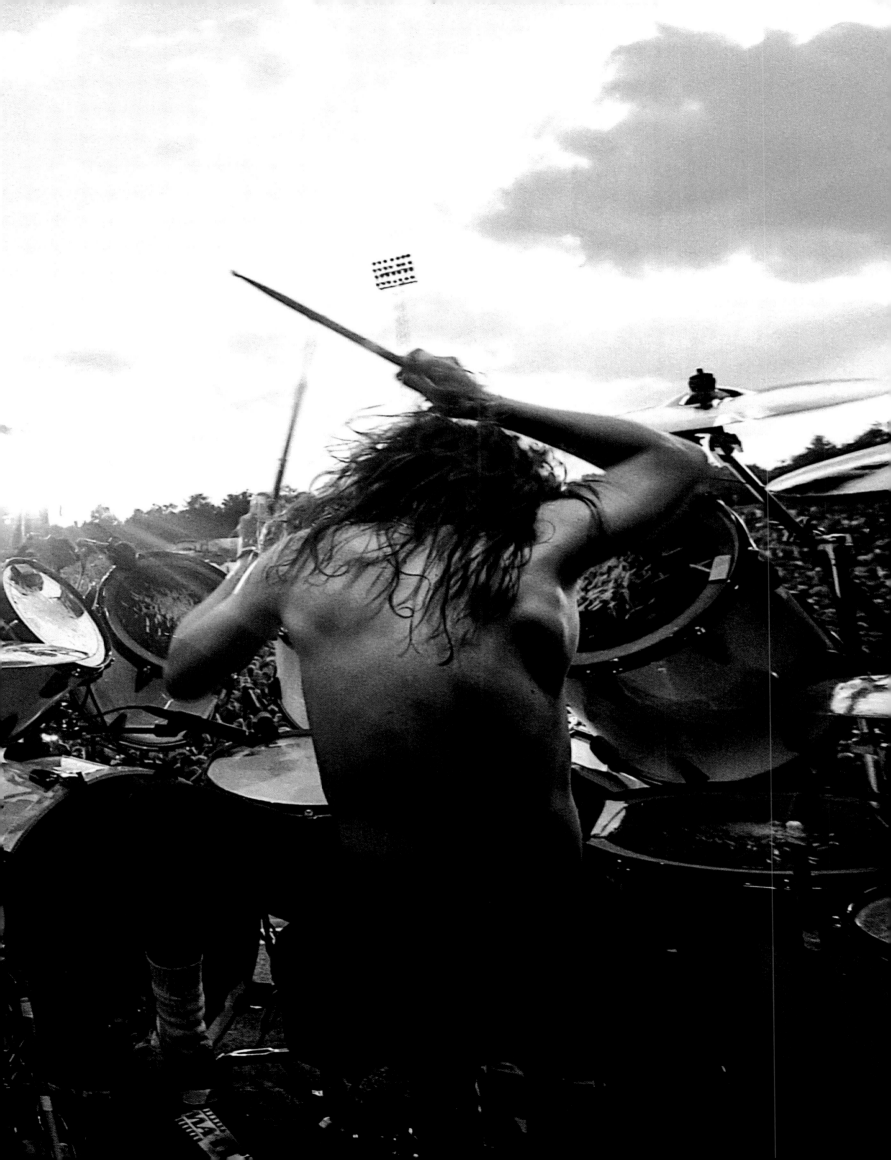

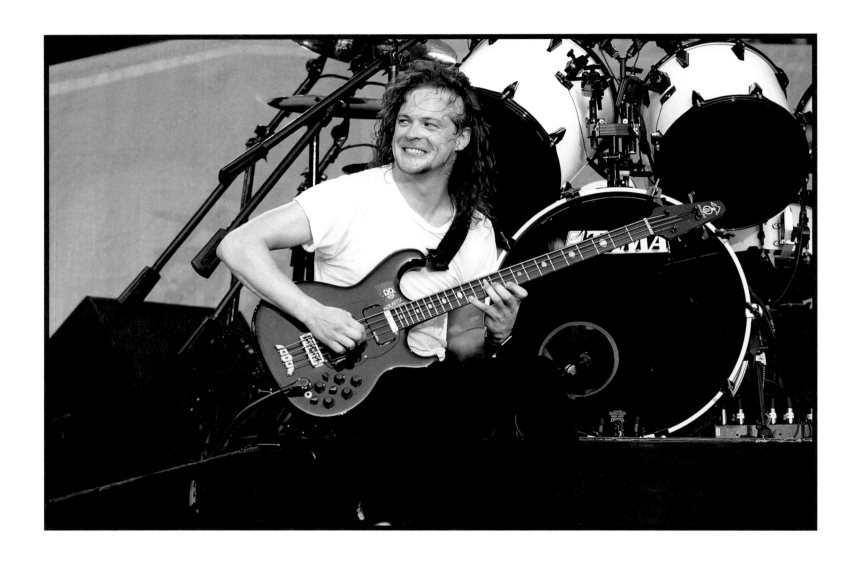

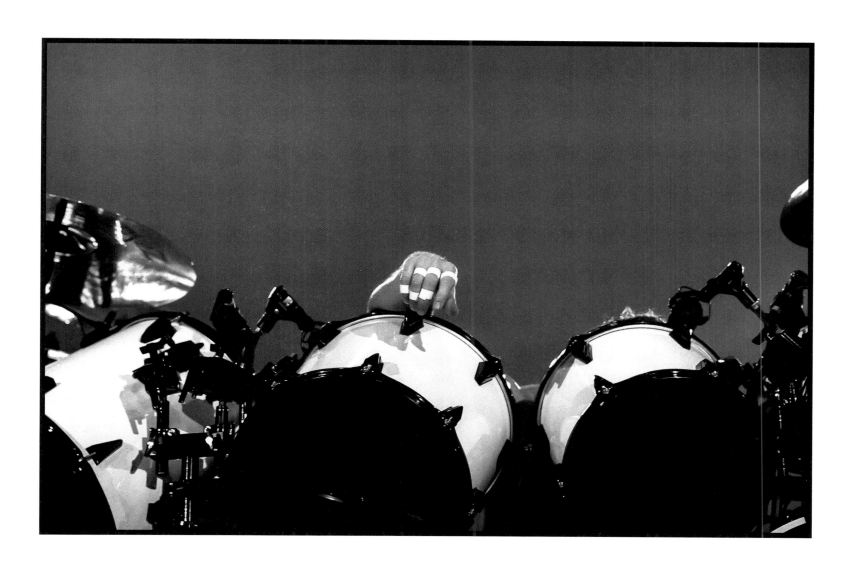

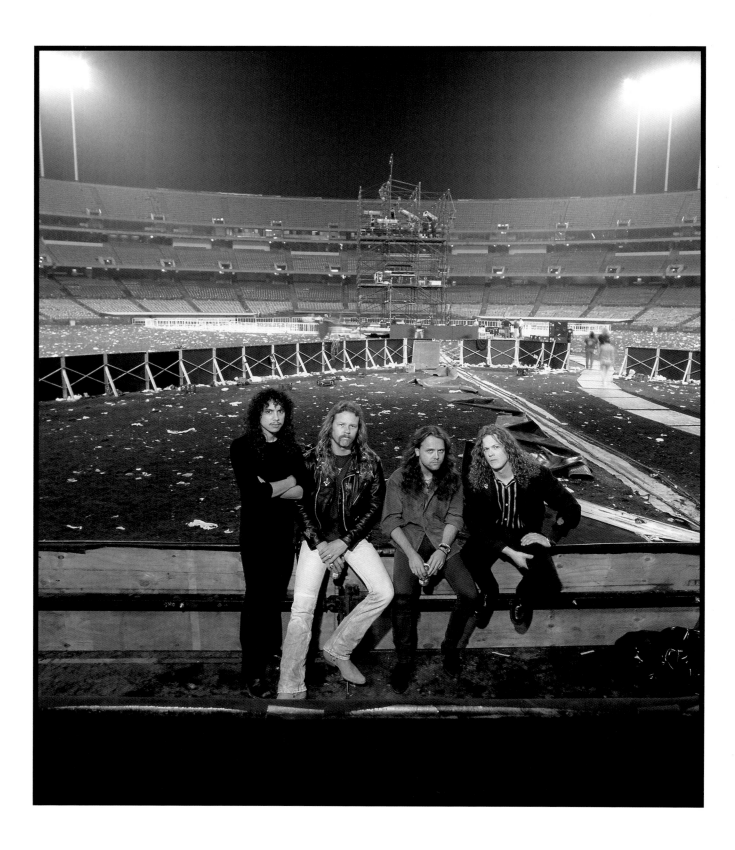

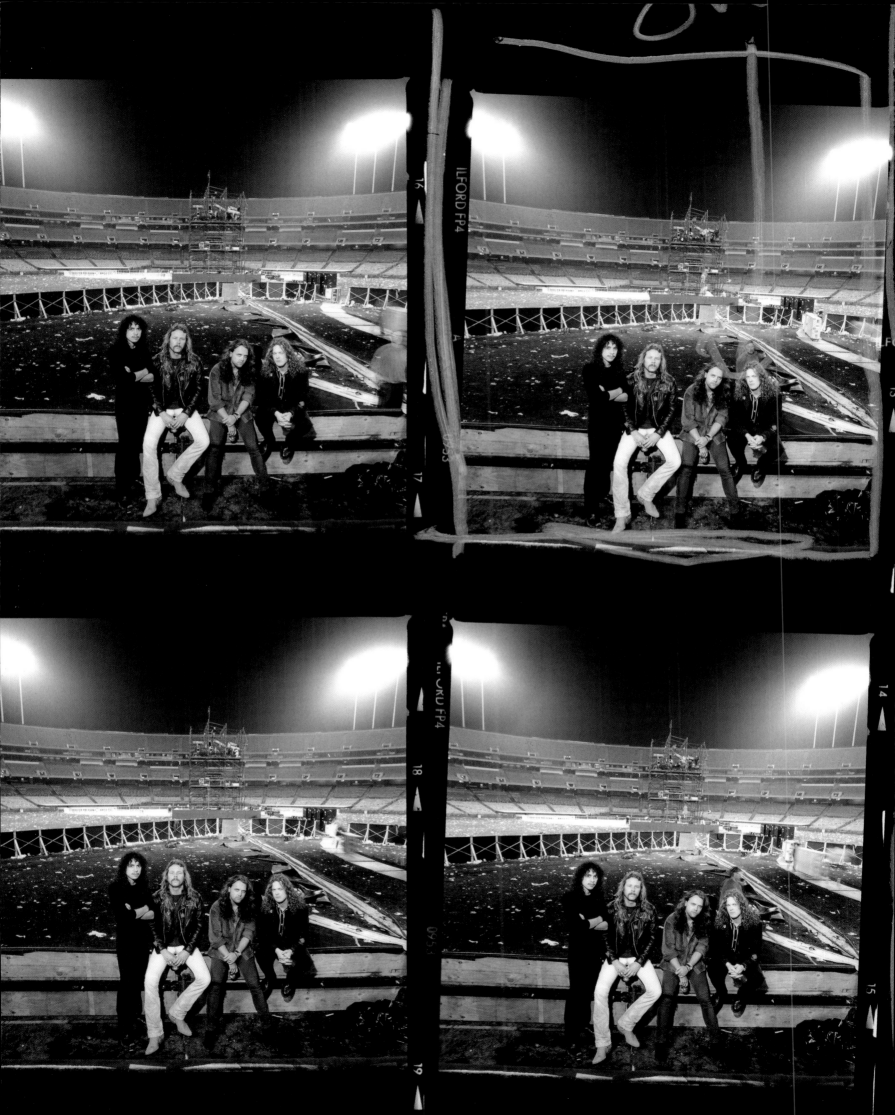

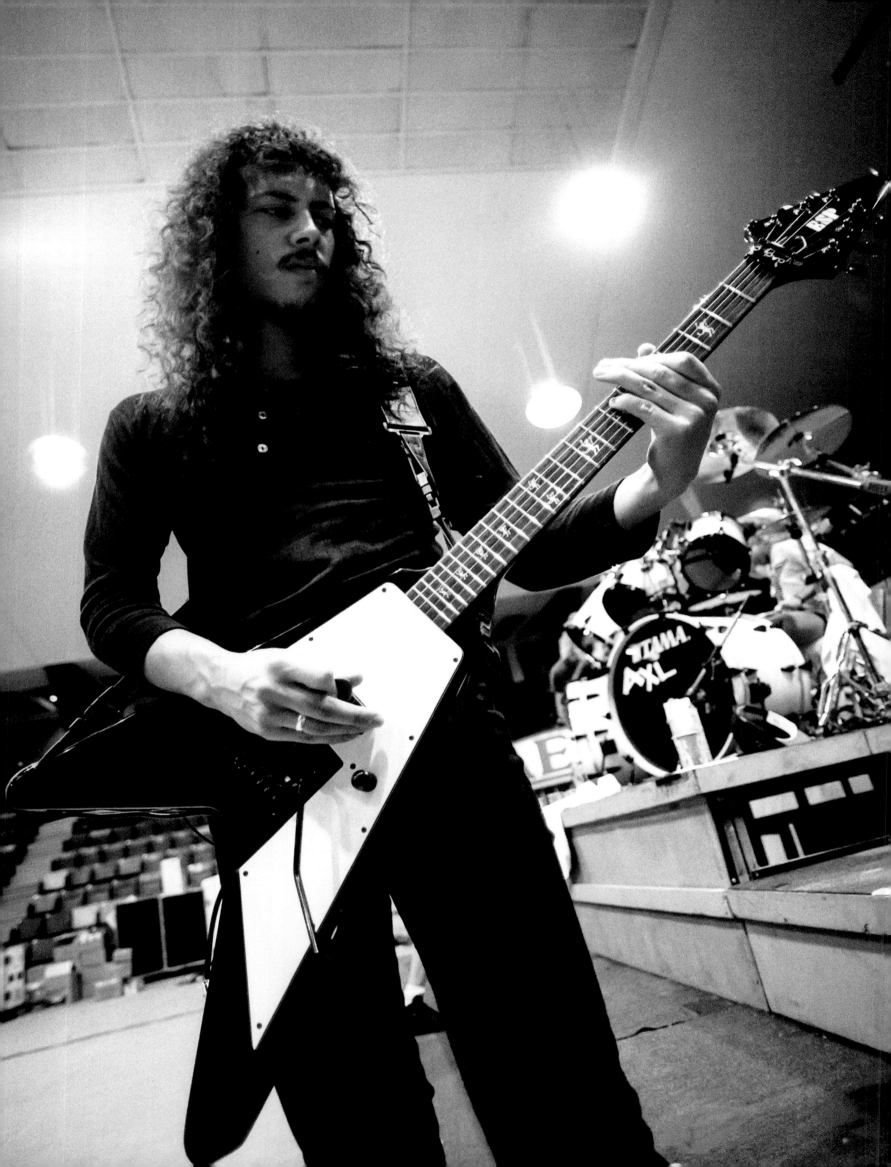

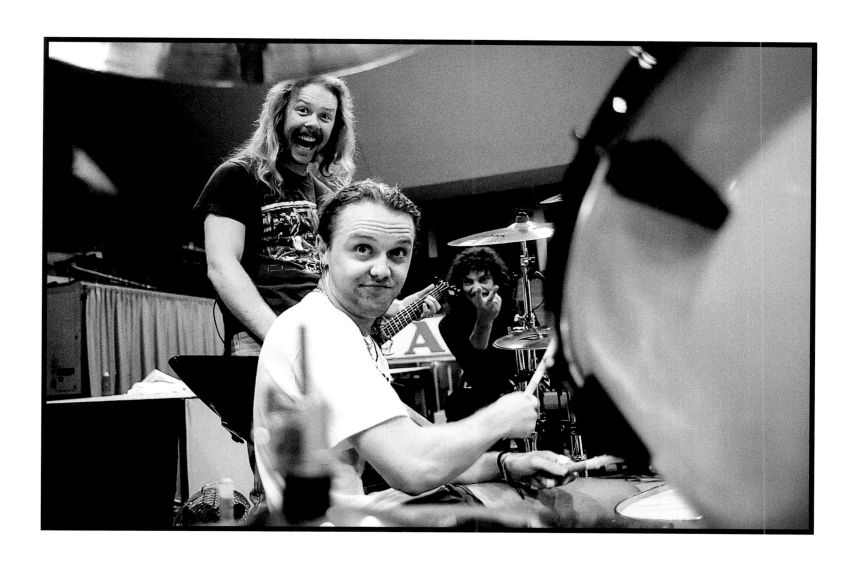

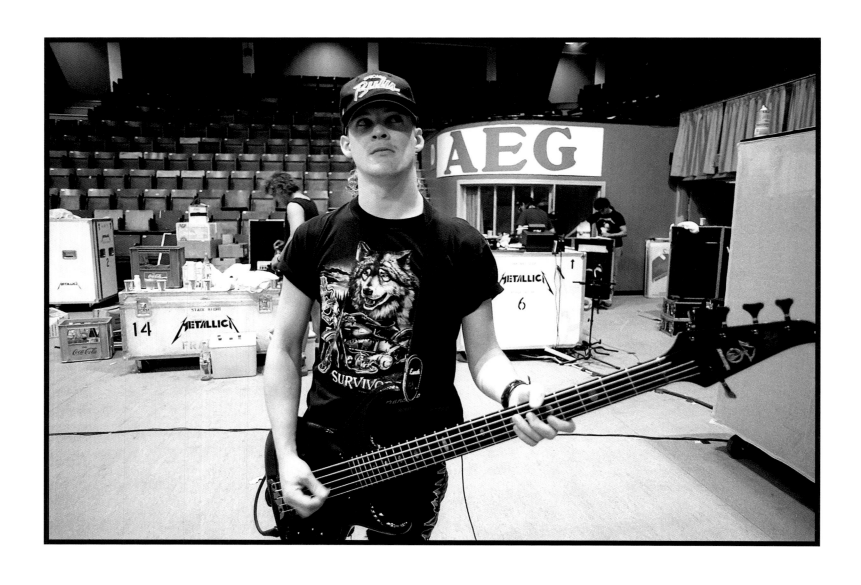

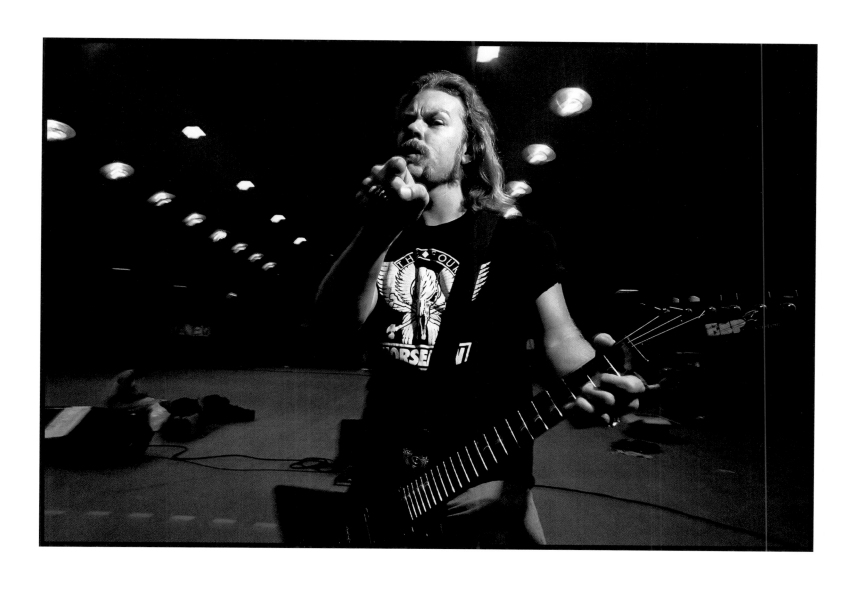

All of the miles, sacrifice and hard work had prepared us for this monumental challenge, and we seemed to take it in stride, at each other's side and otherwise.

JASON

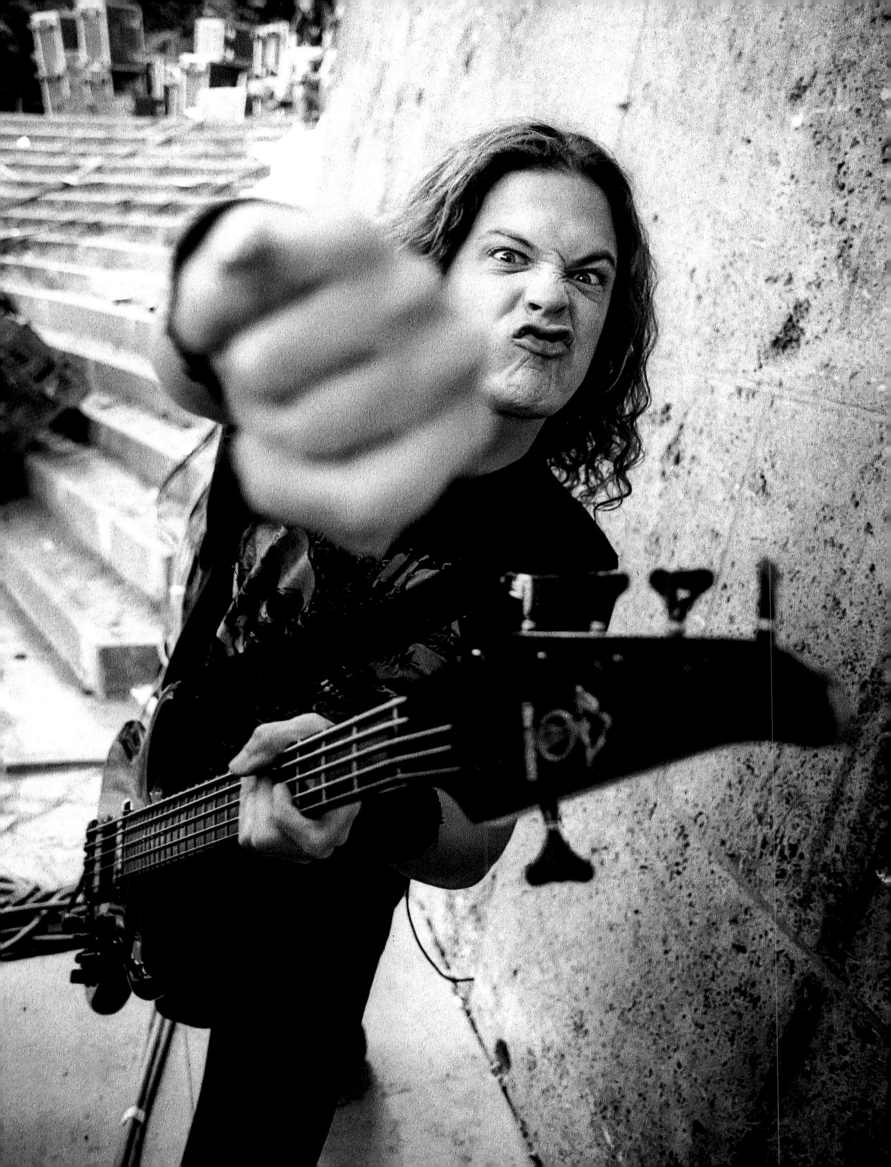

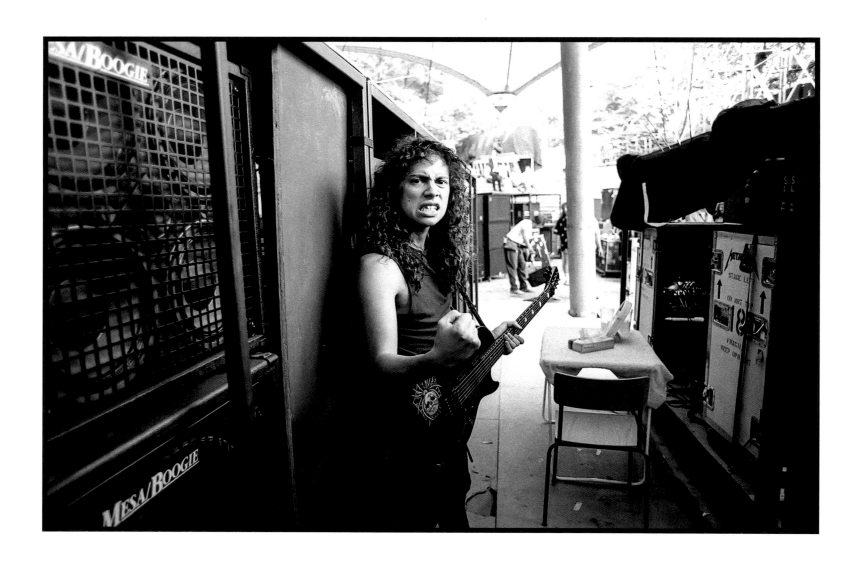

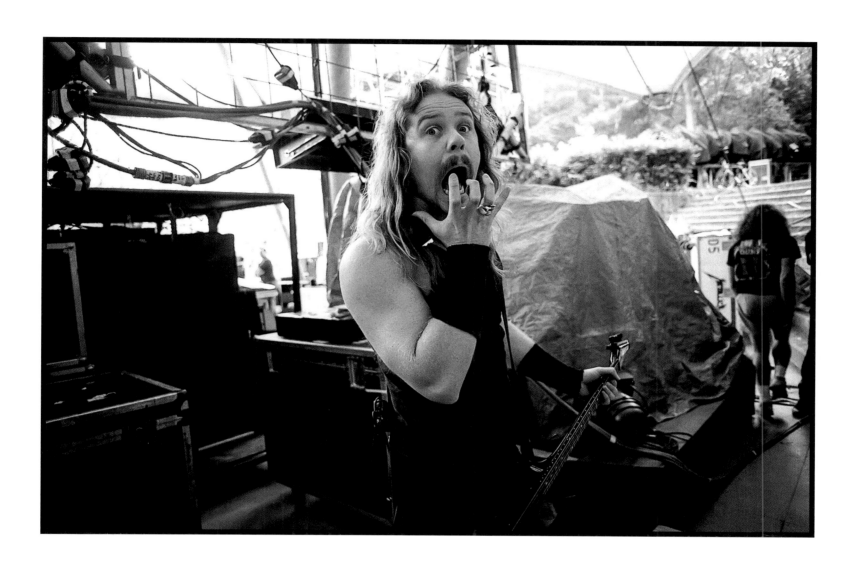

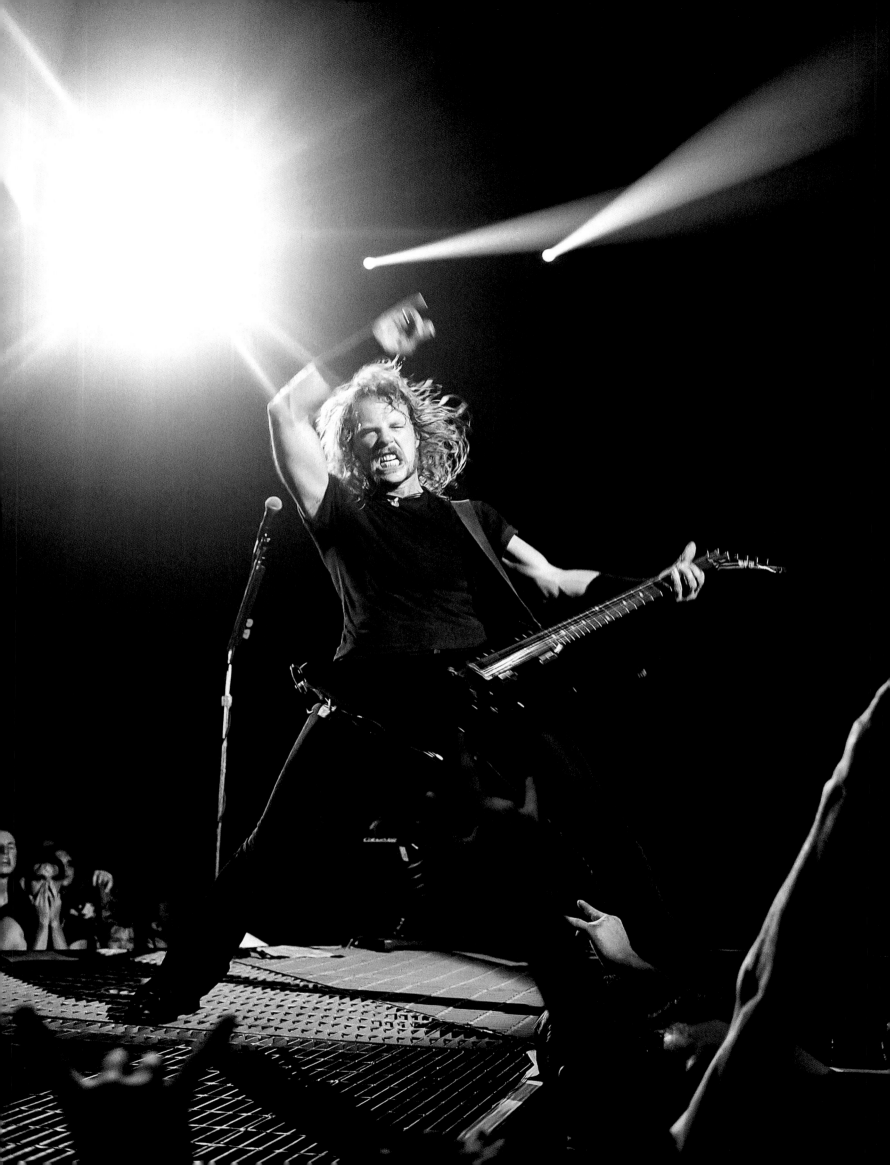

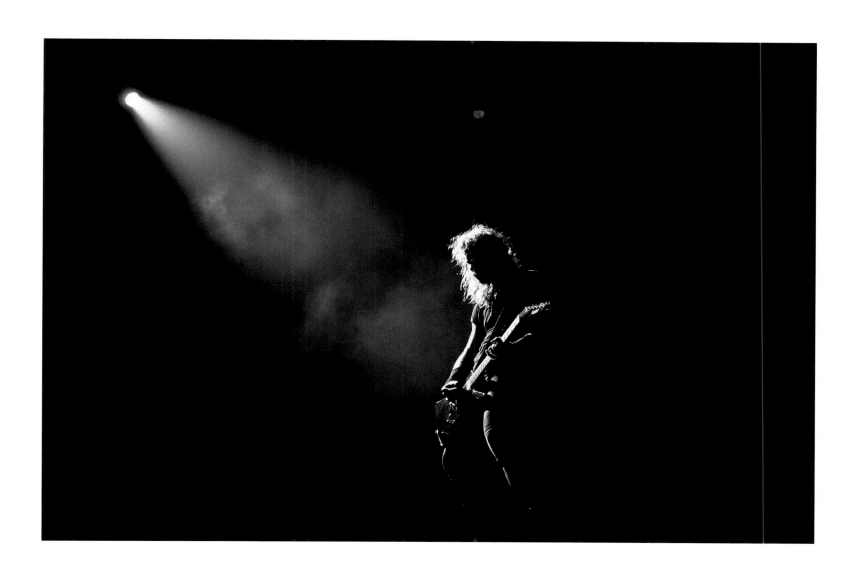

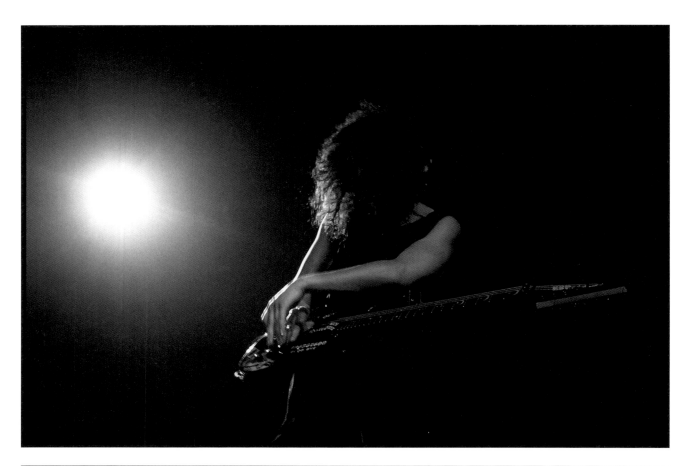

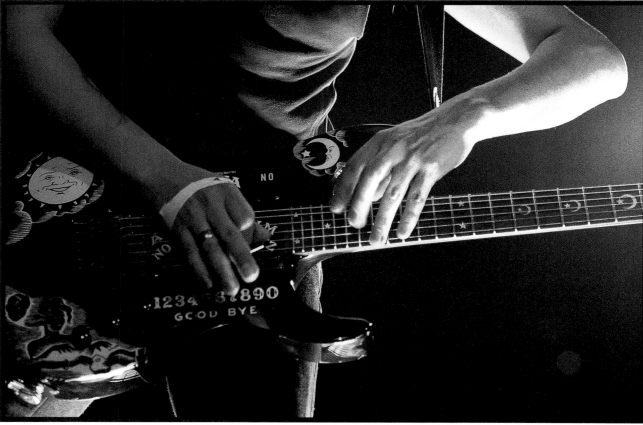

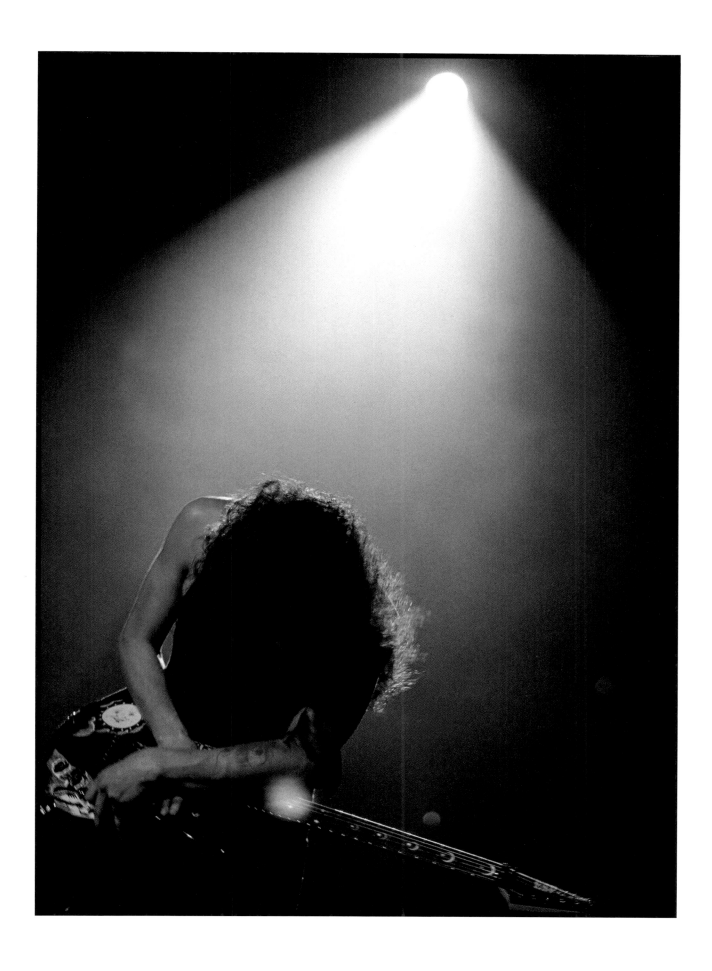

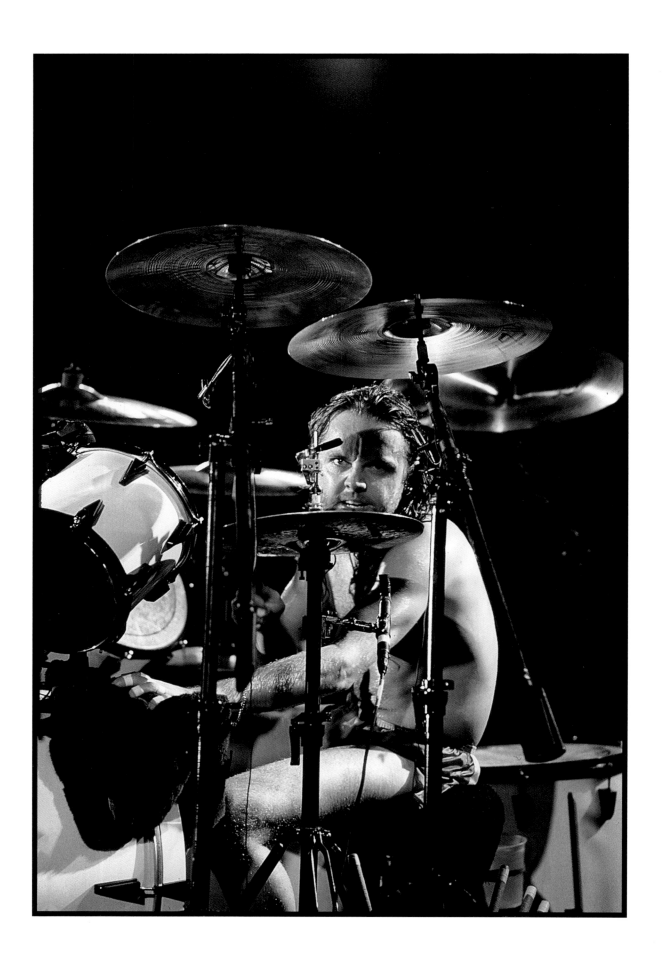

I want to give you, the audience, the idea that you are there and what it's like to really be there.

ROSS

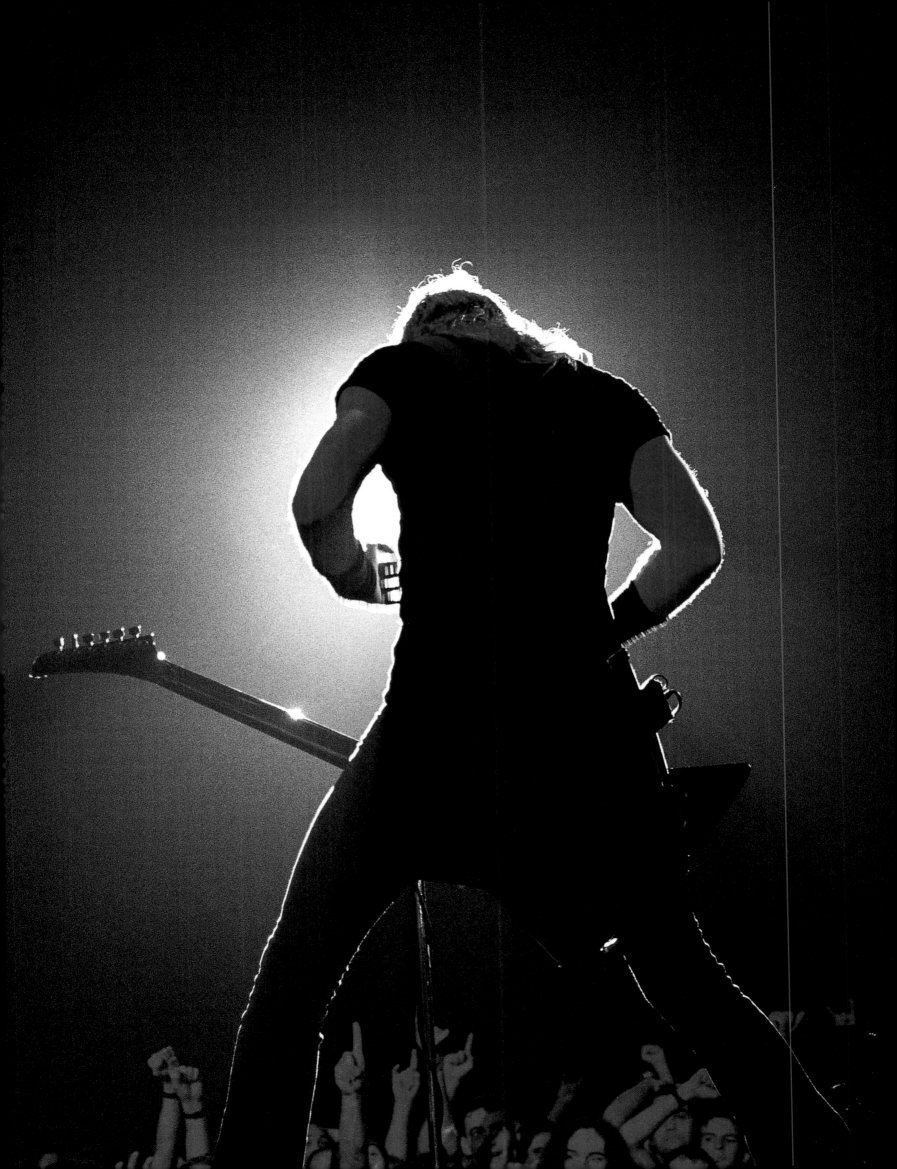

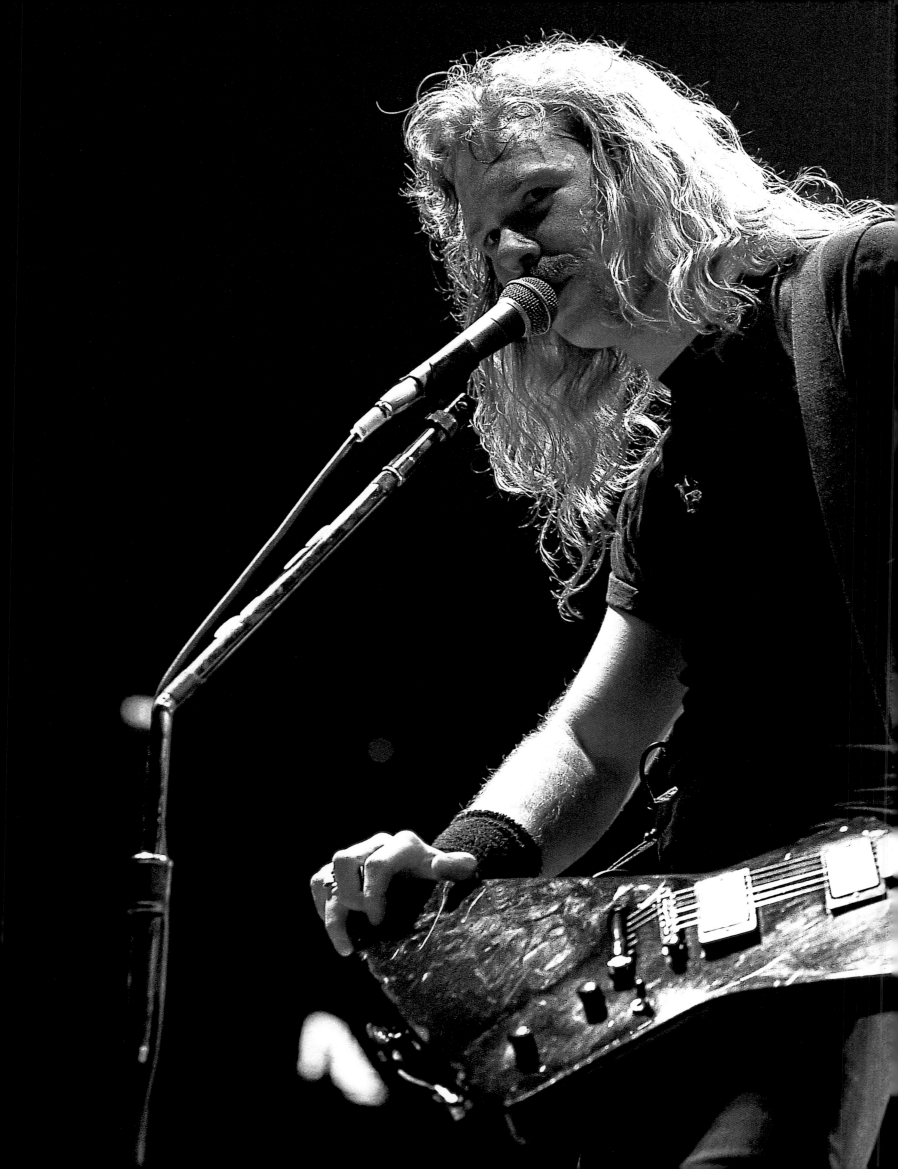

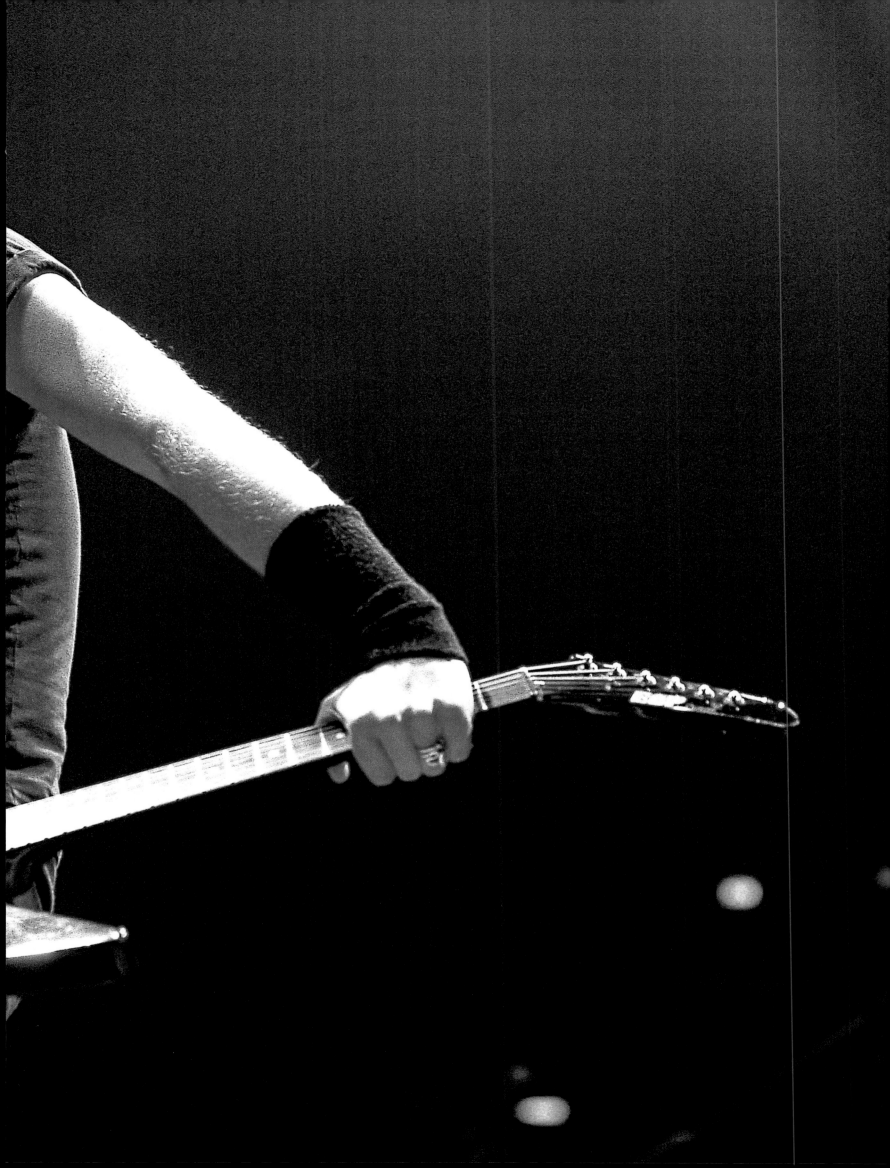

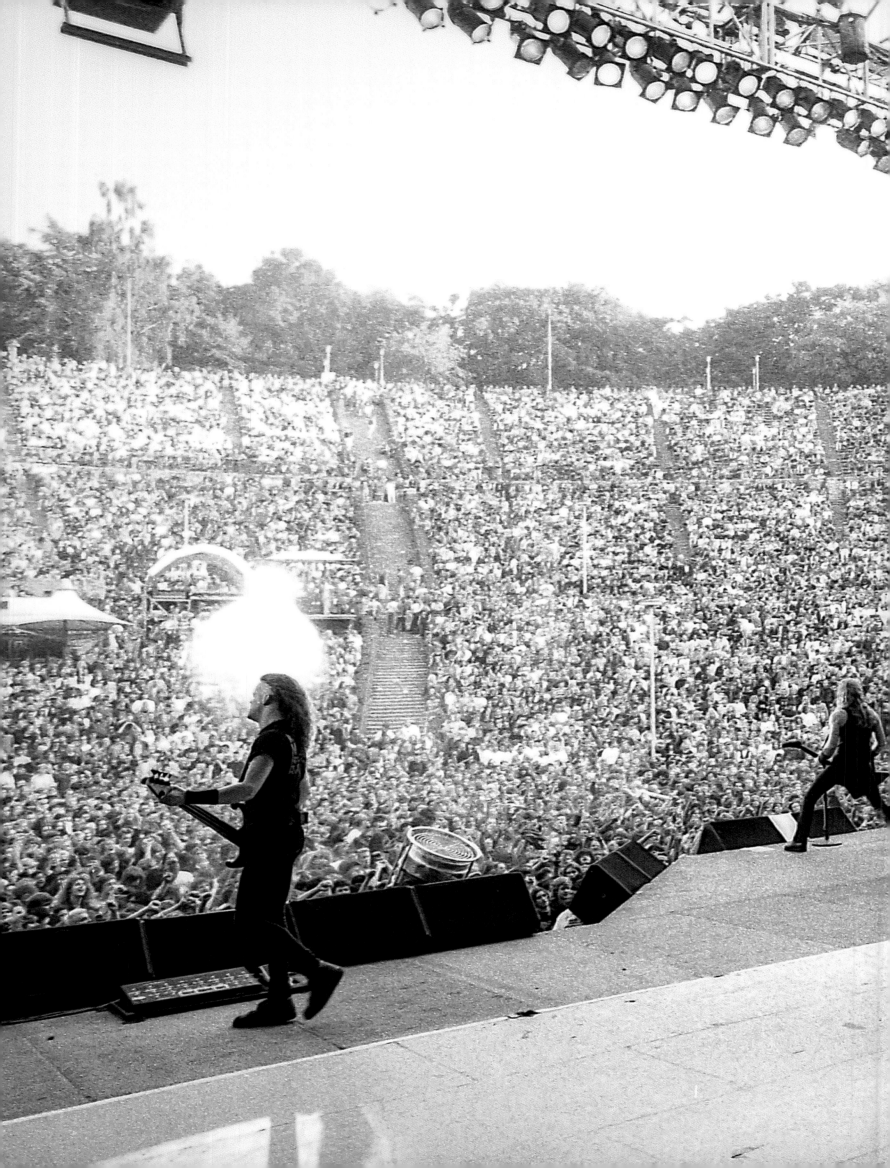

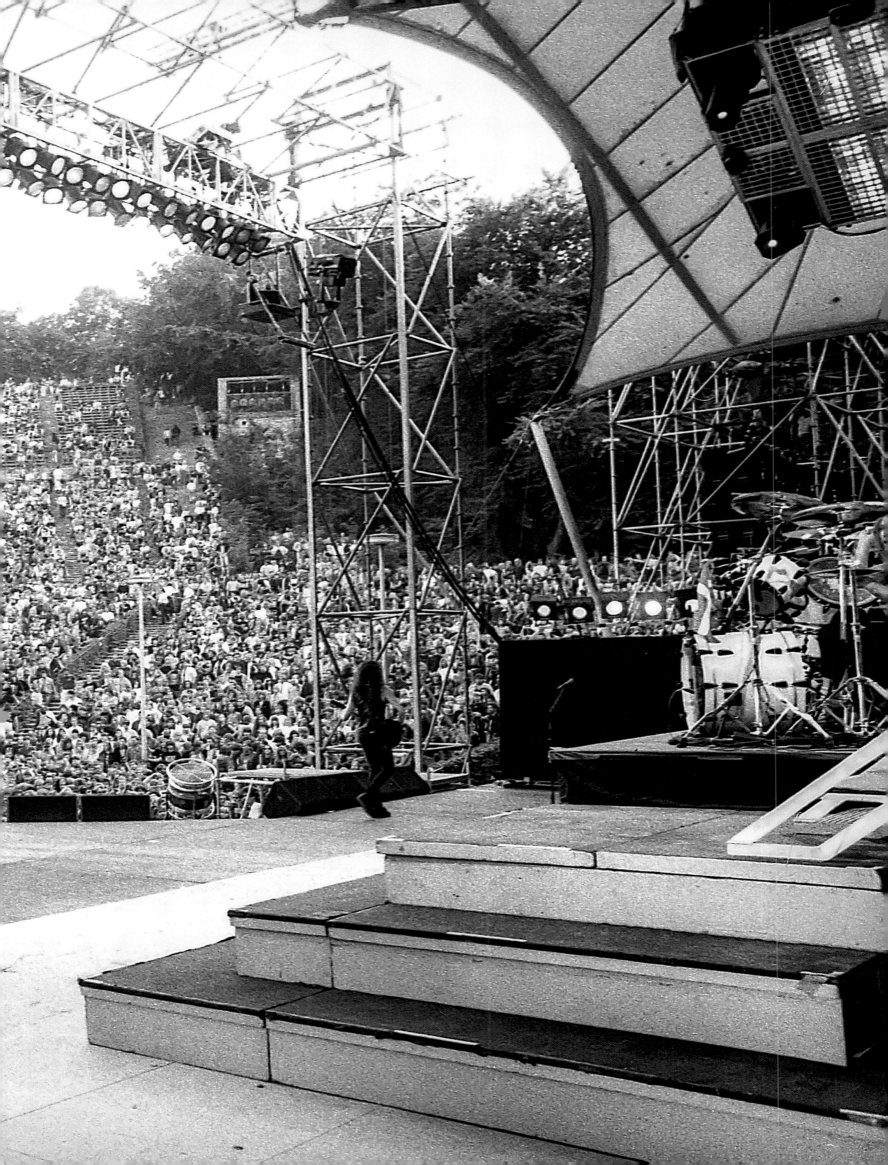

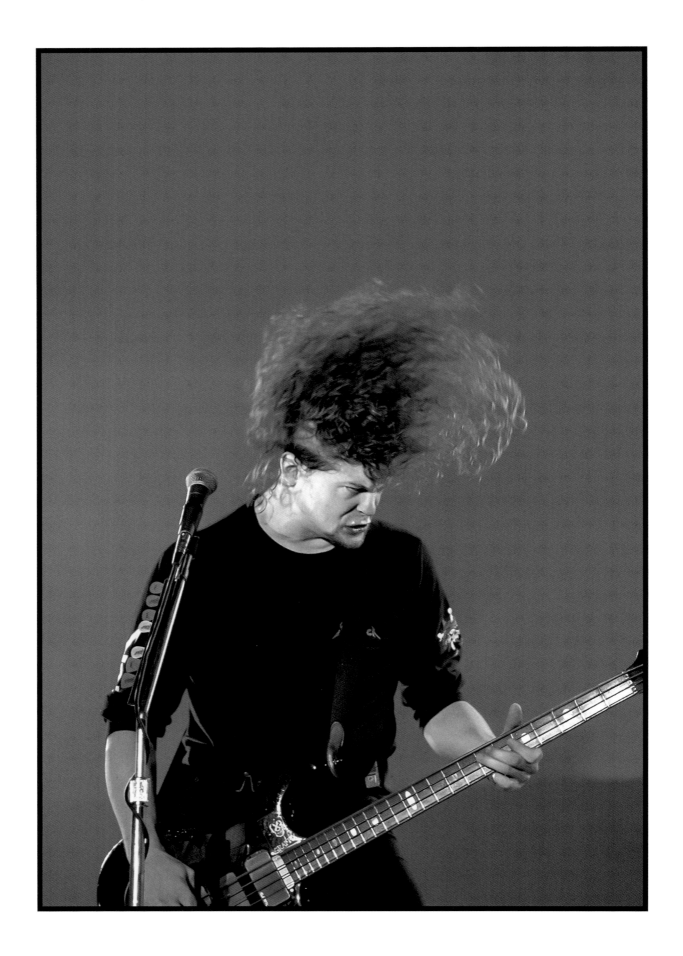

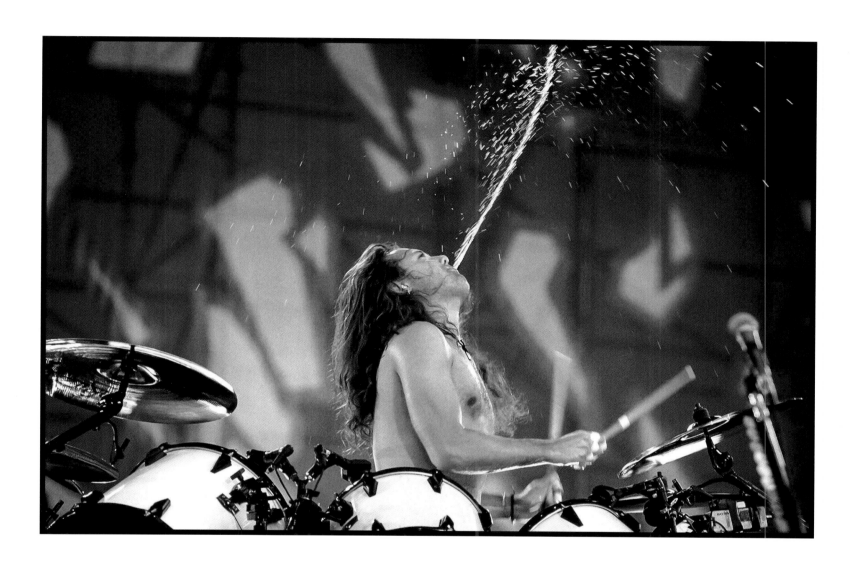

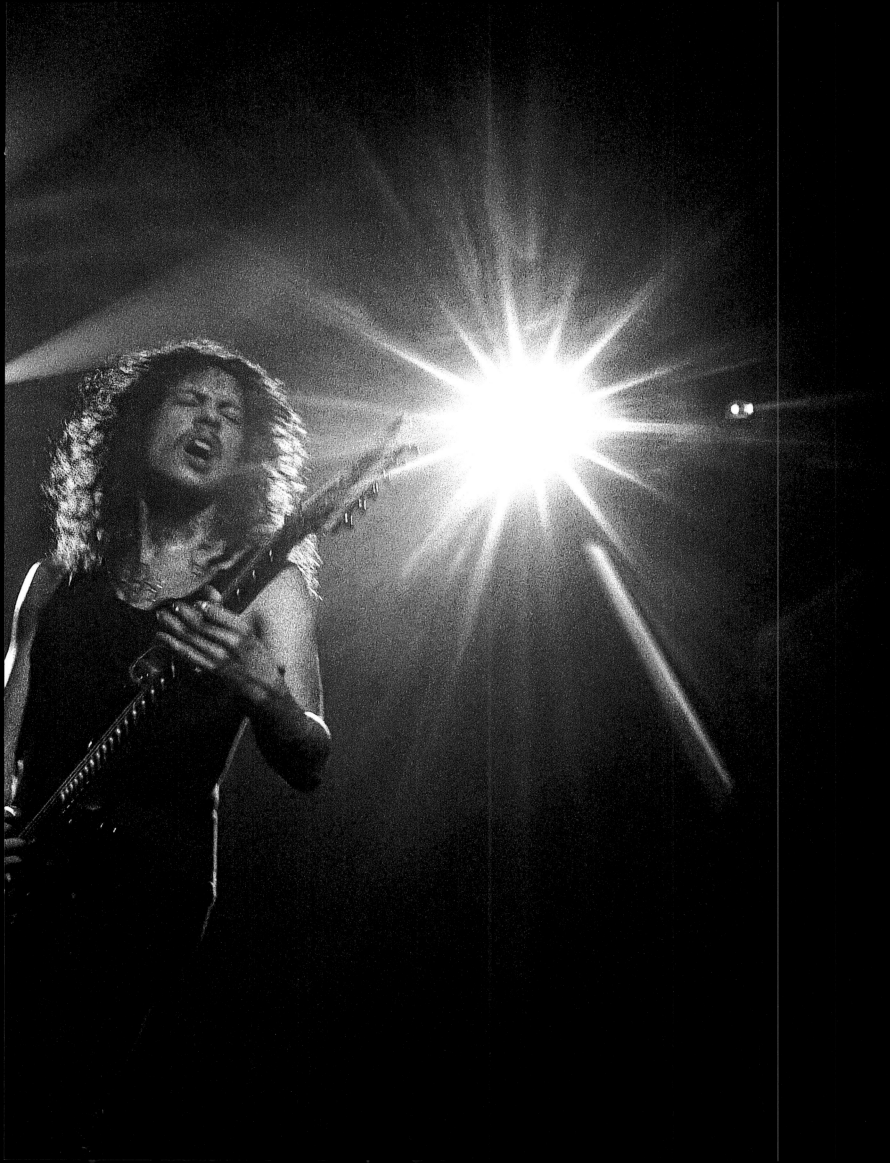

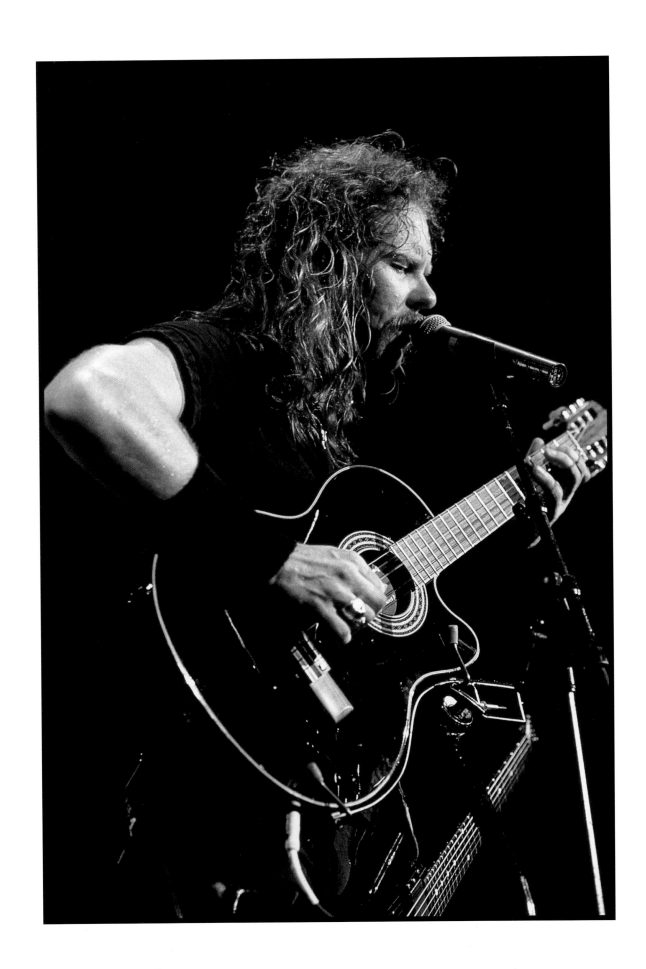

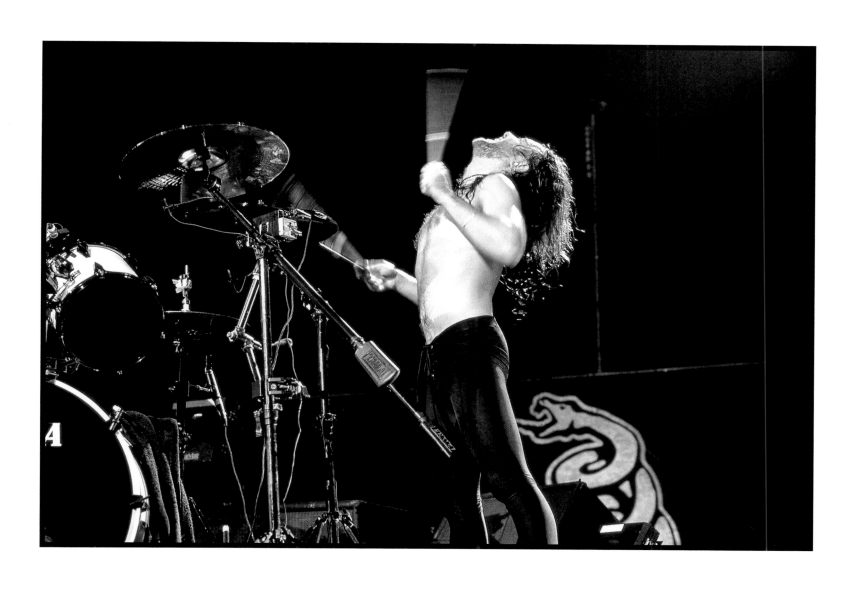

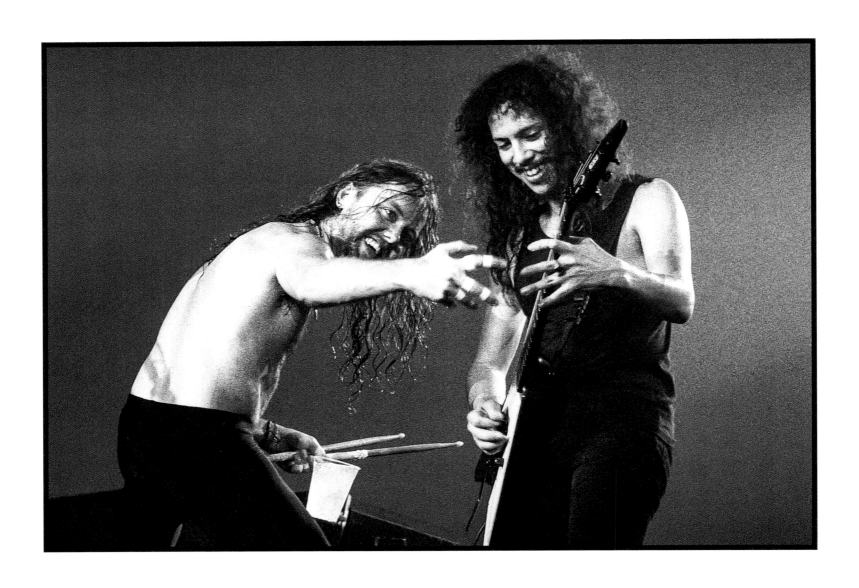

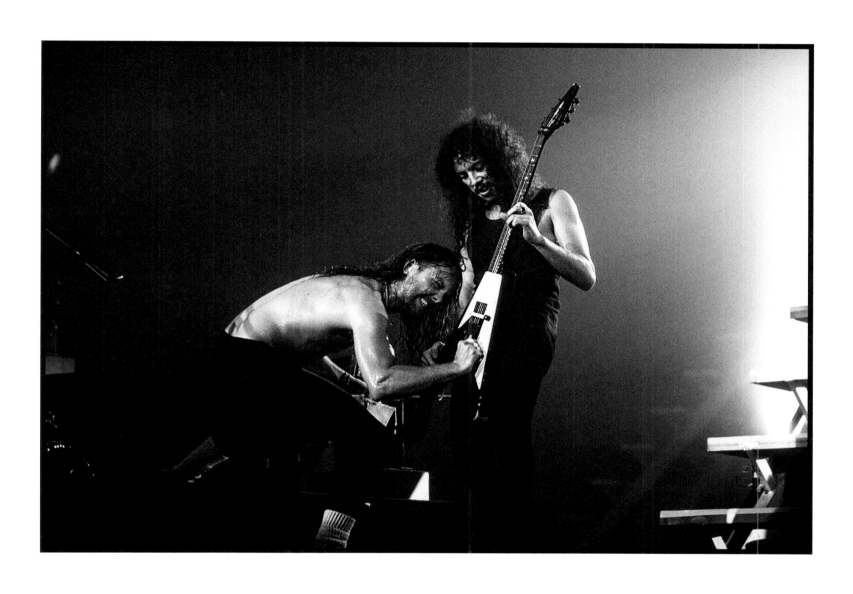

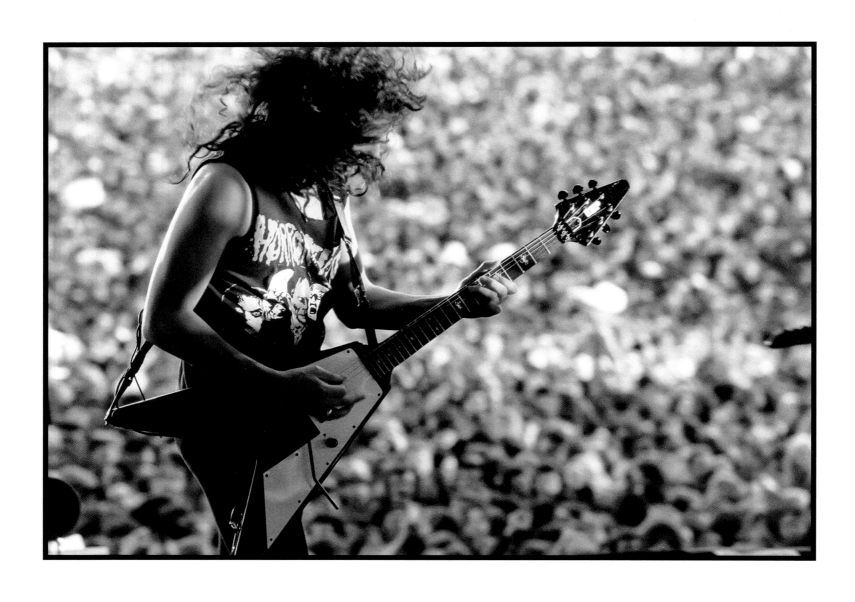

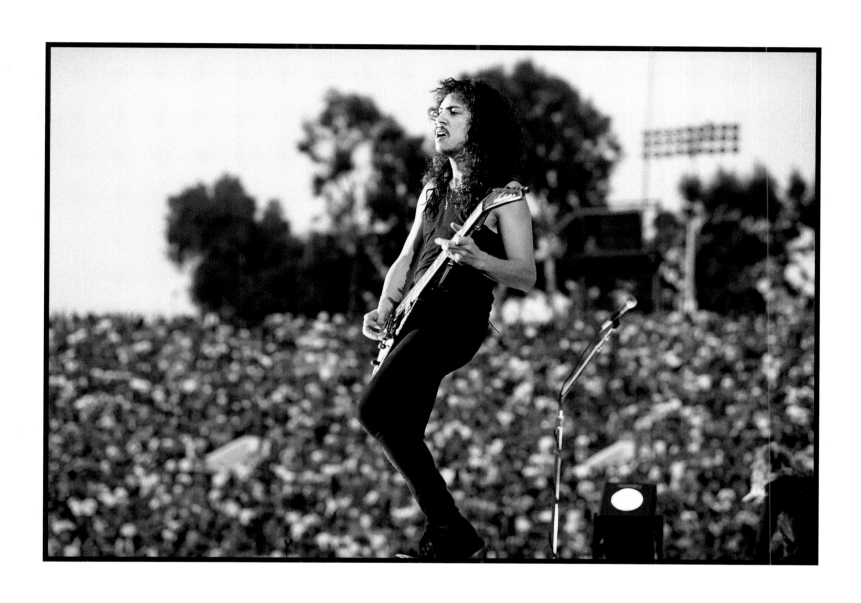

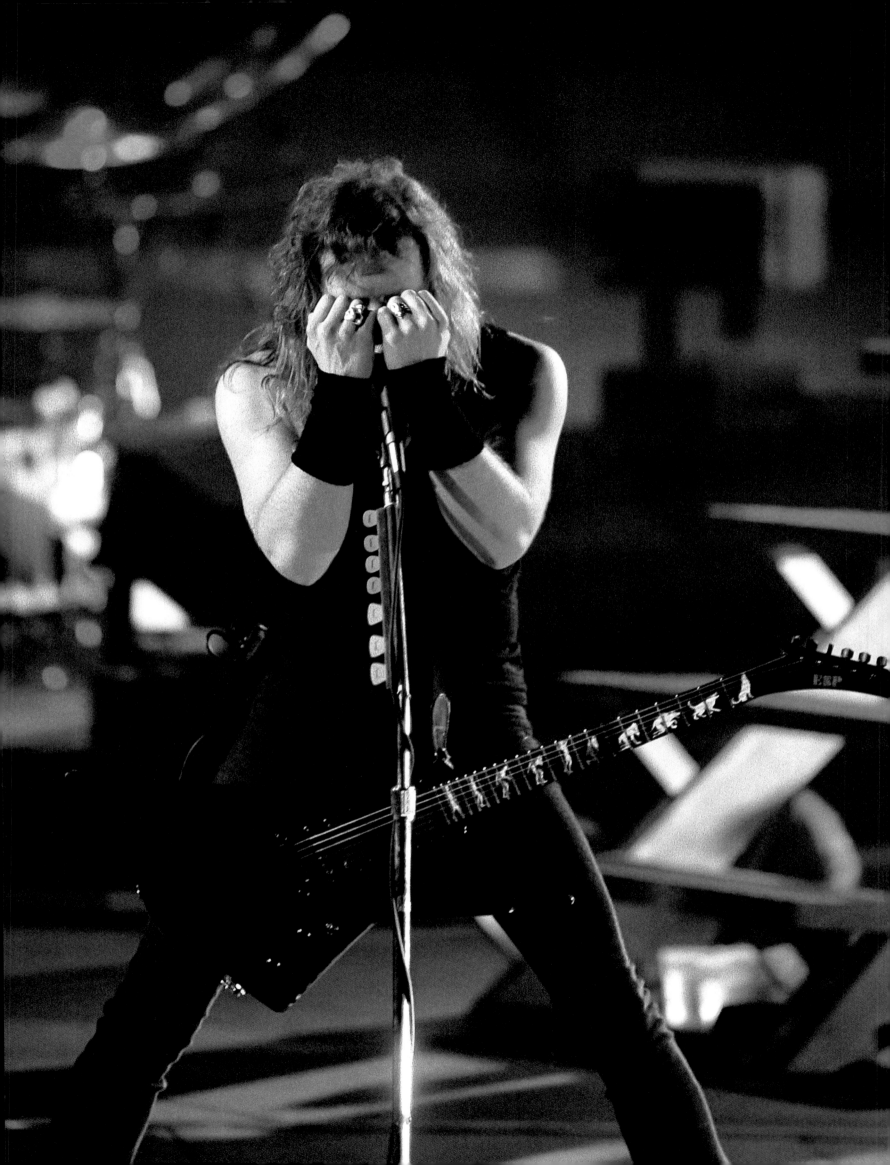

Seeing crowds from all over the globe – despite our cultural differences, we're all the same. Everyone showing their passion, love and identification with our music.

JAMES

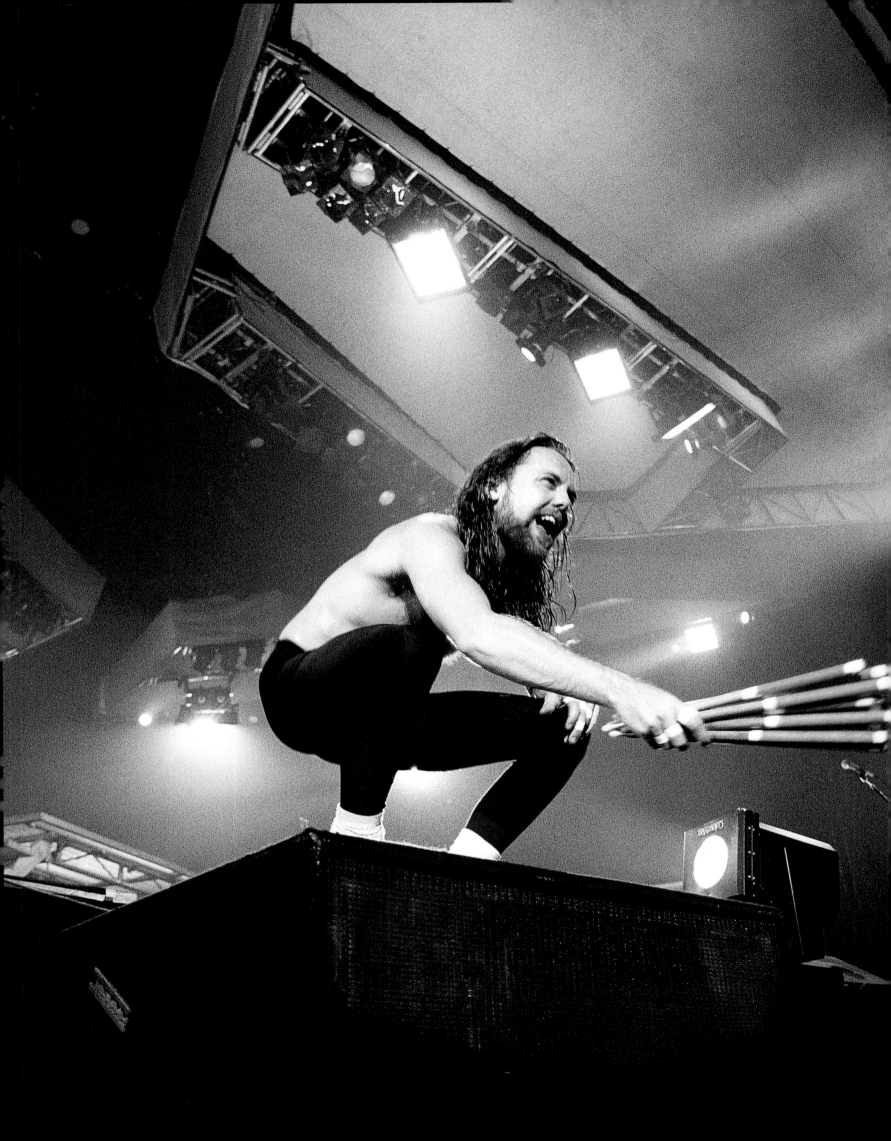

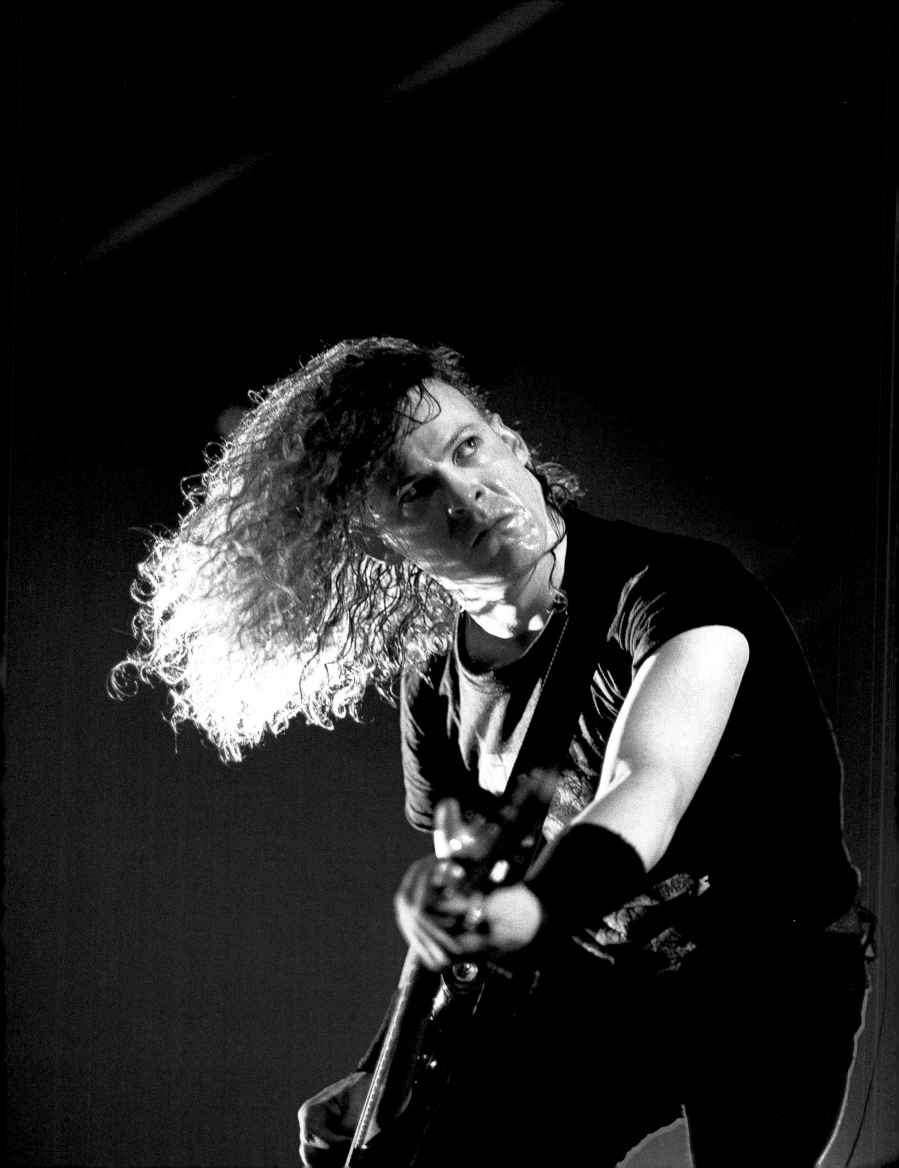

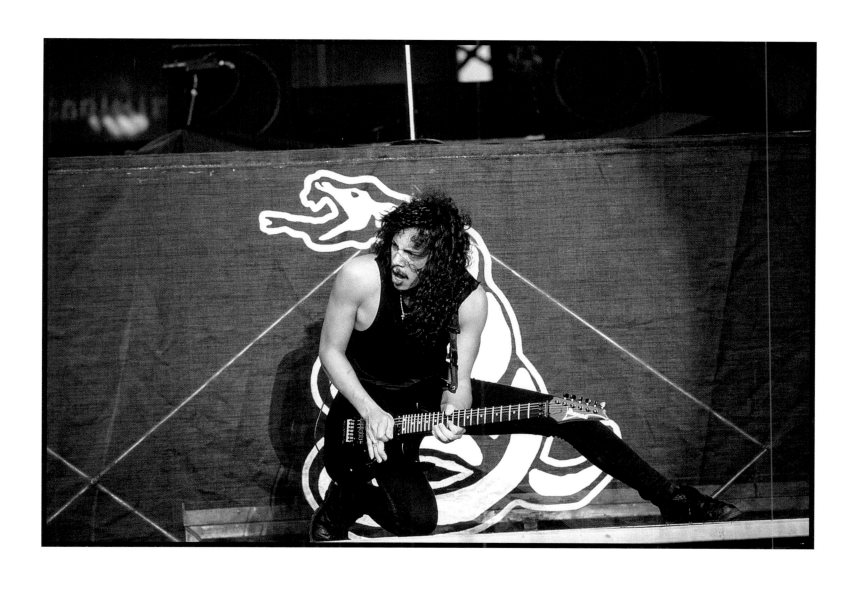

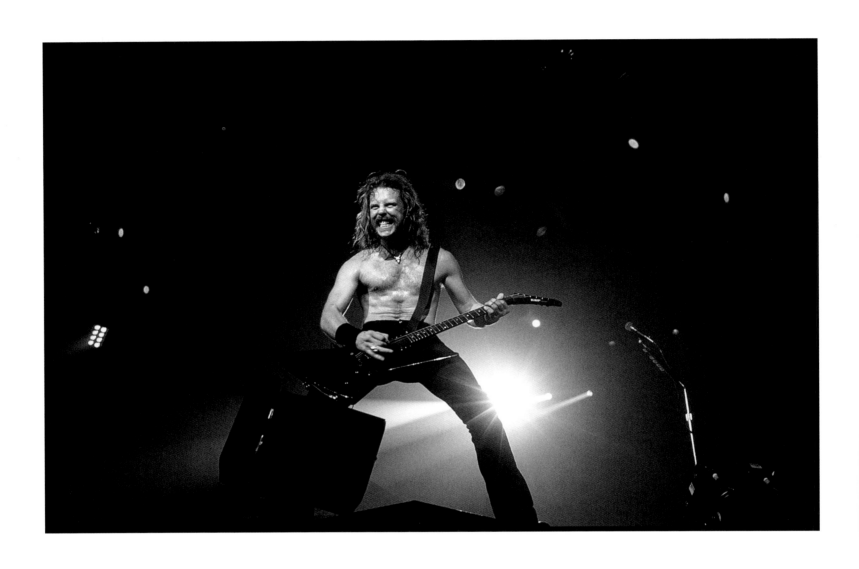

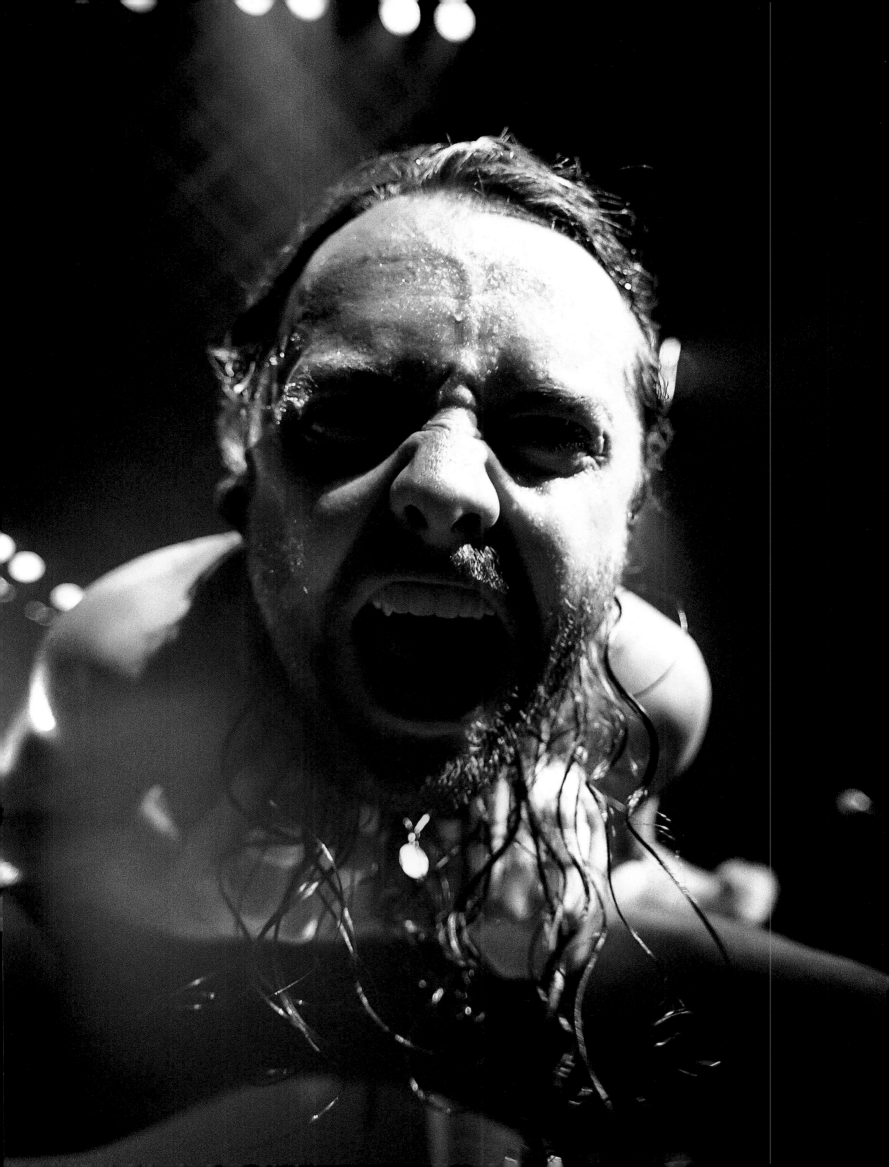

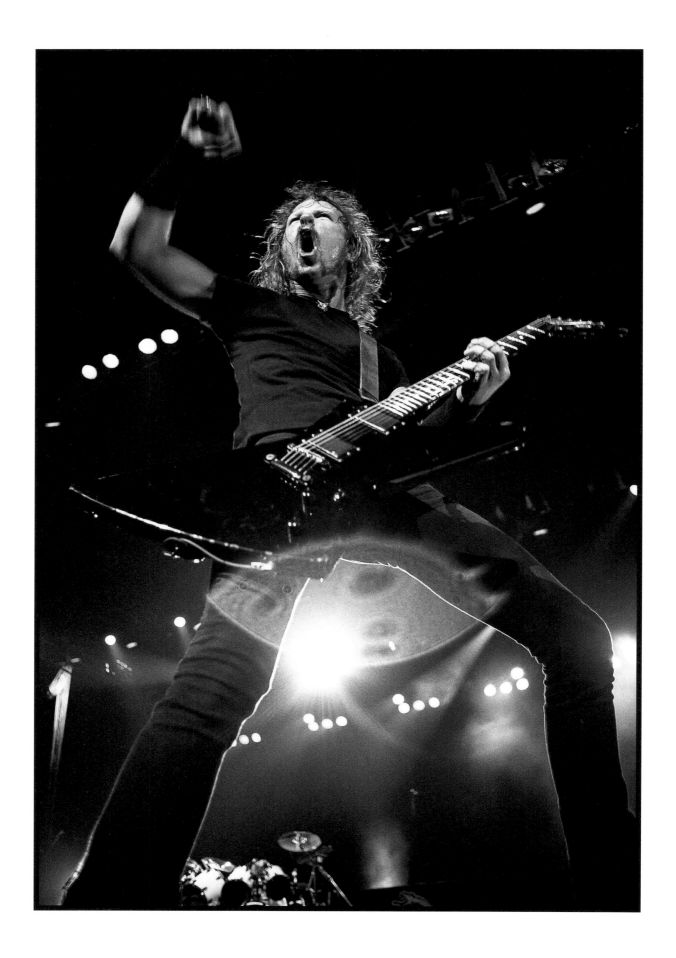

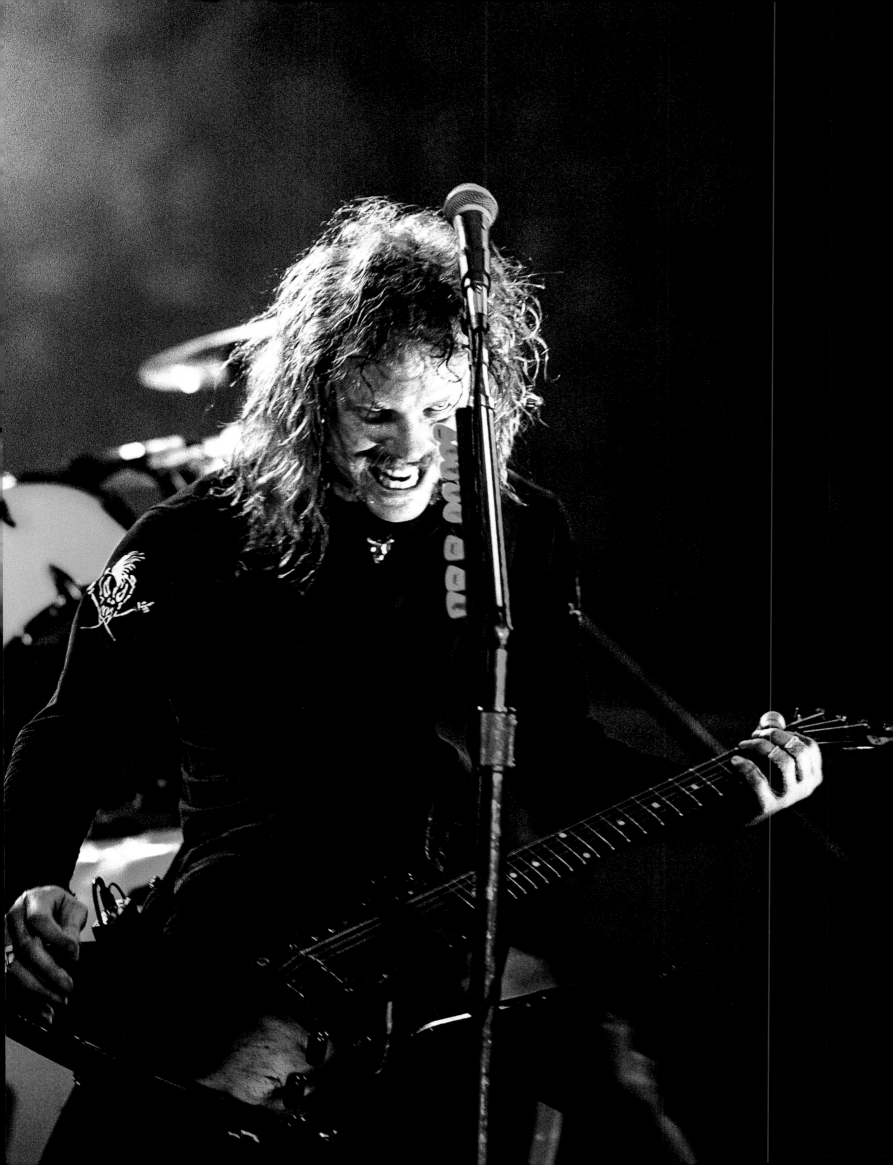

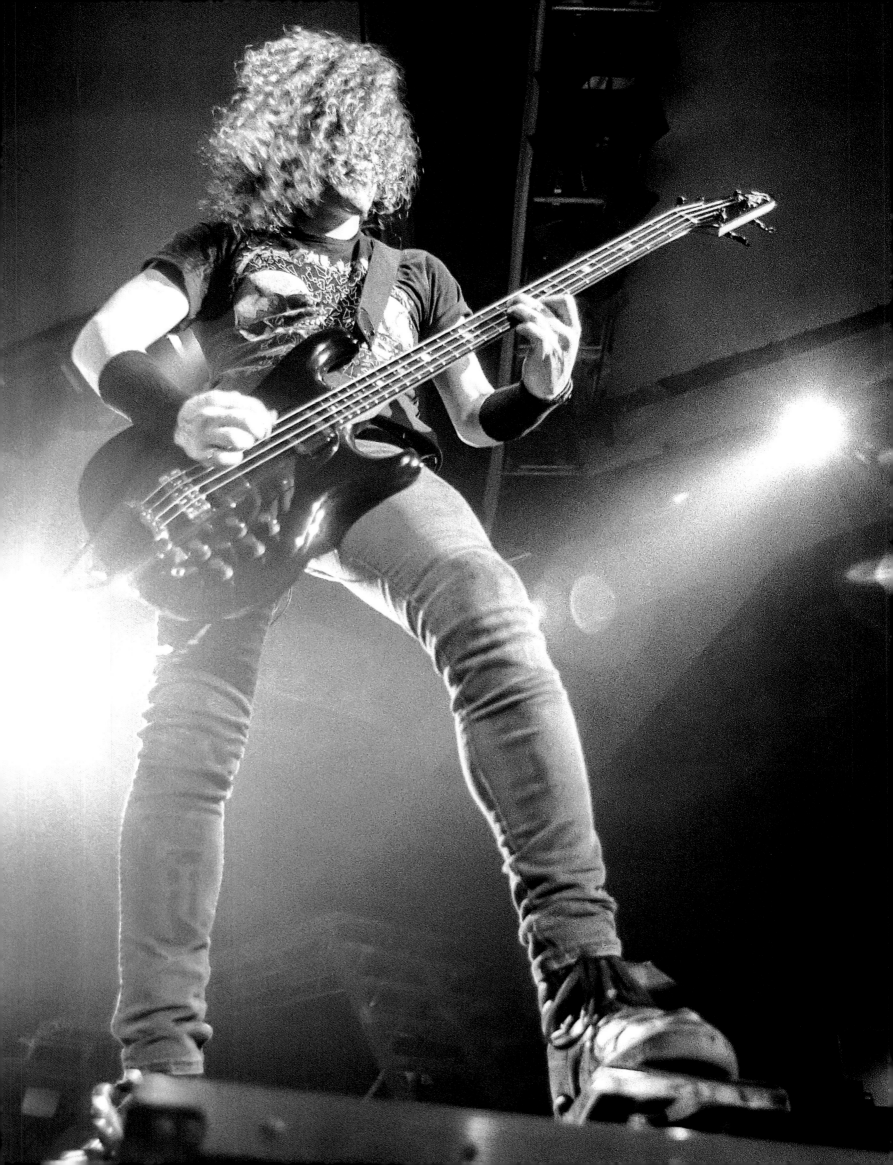

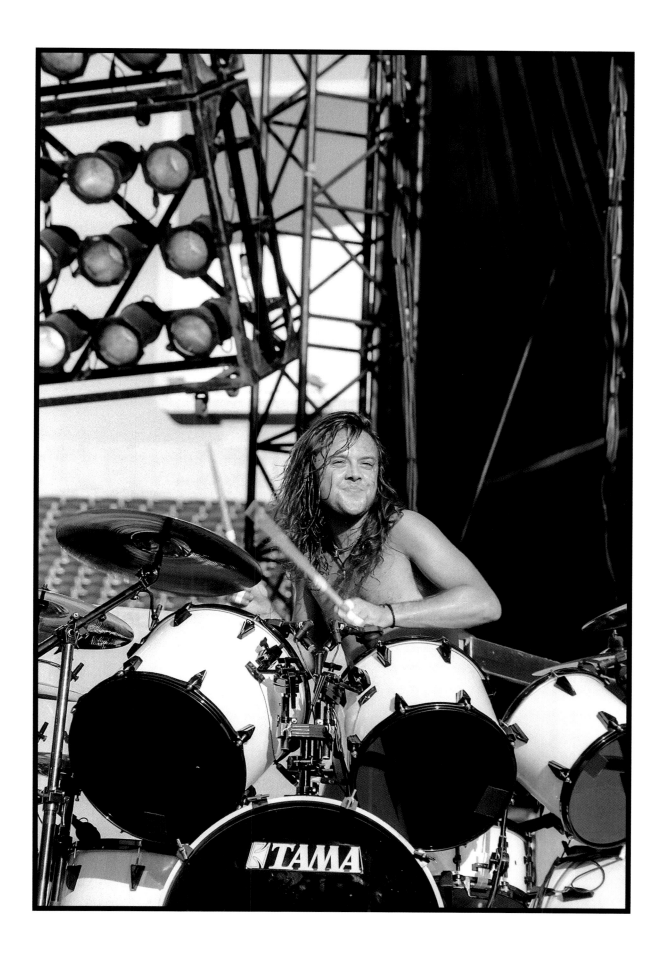

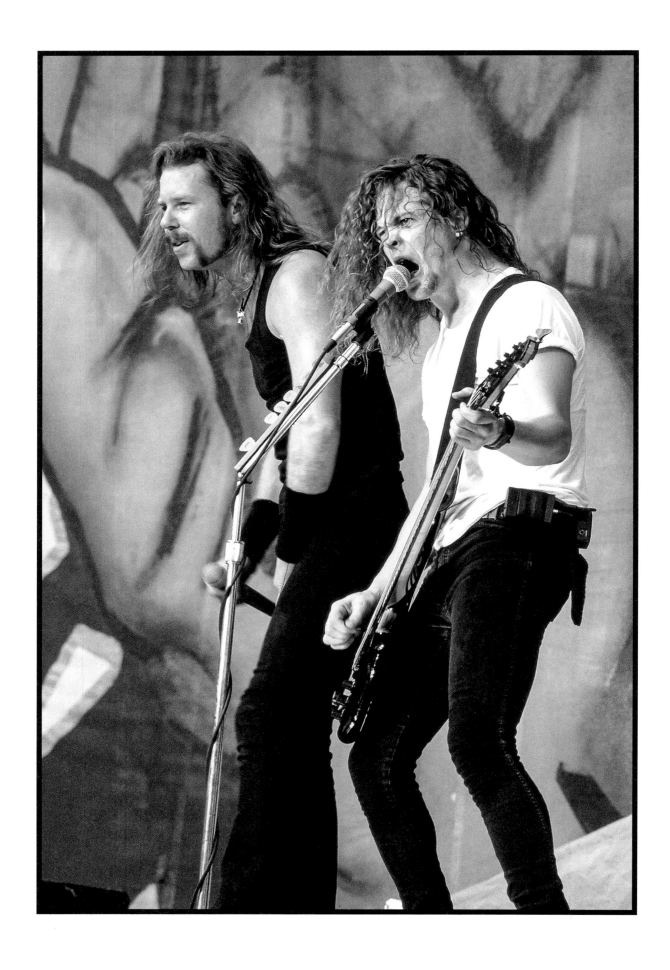

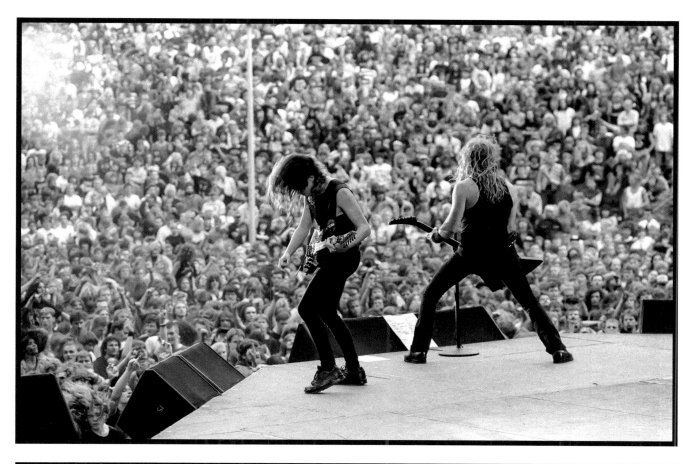

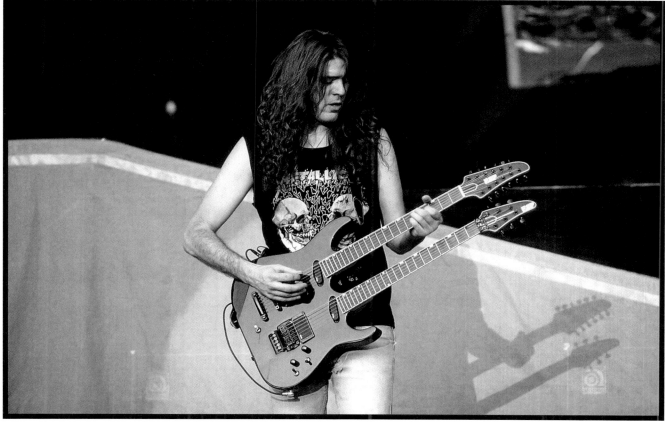

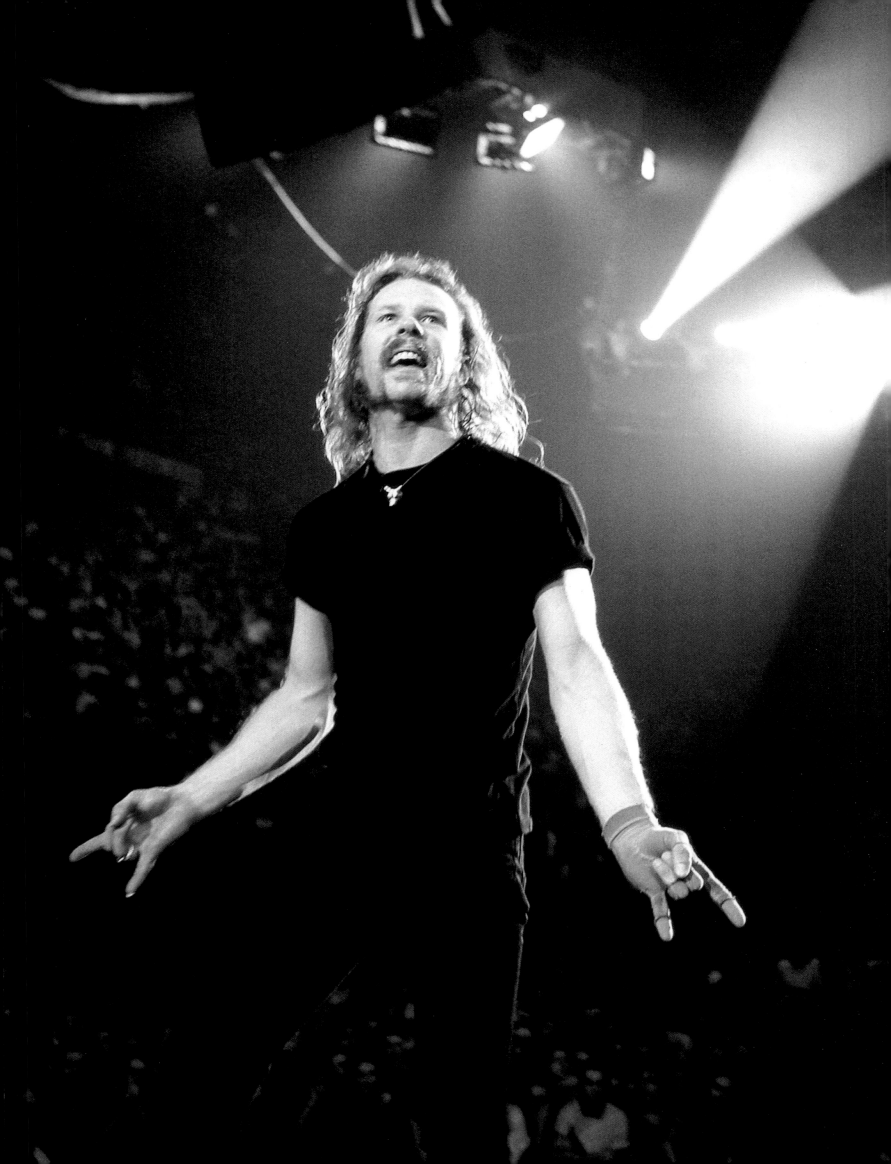

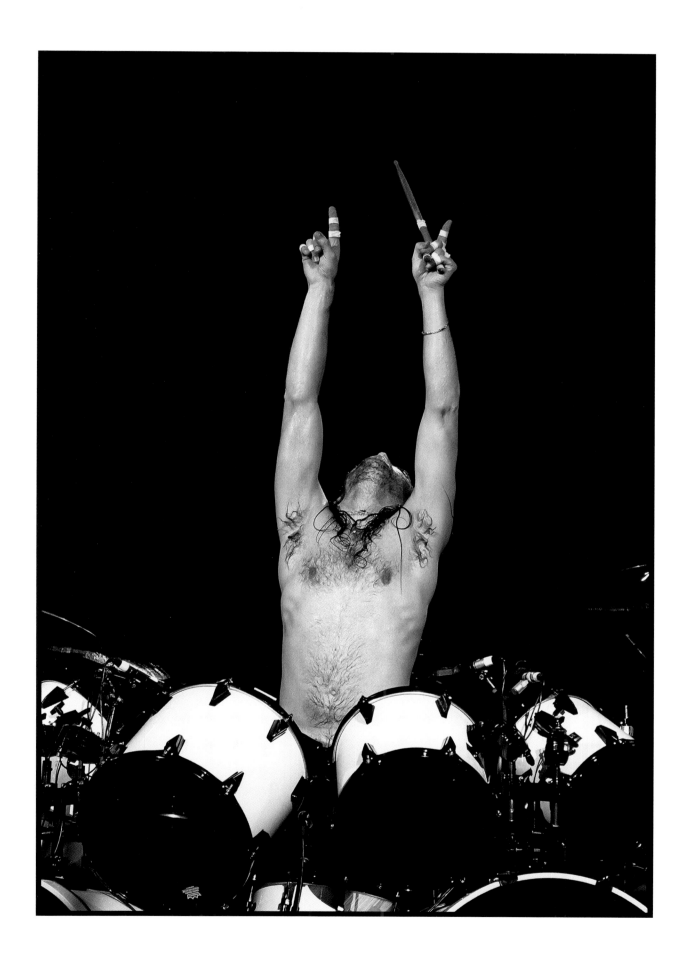

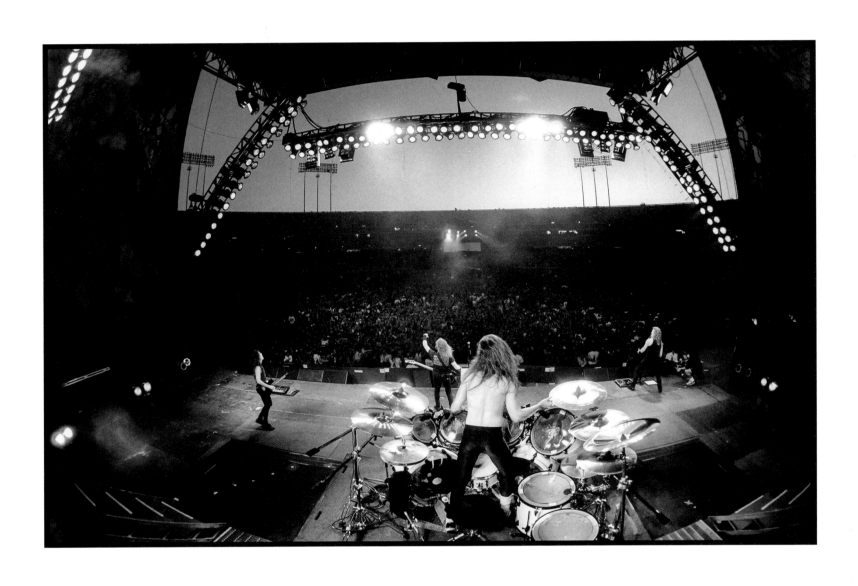

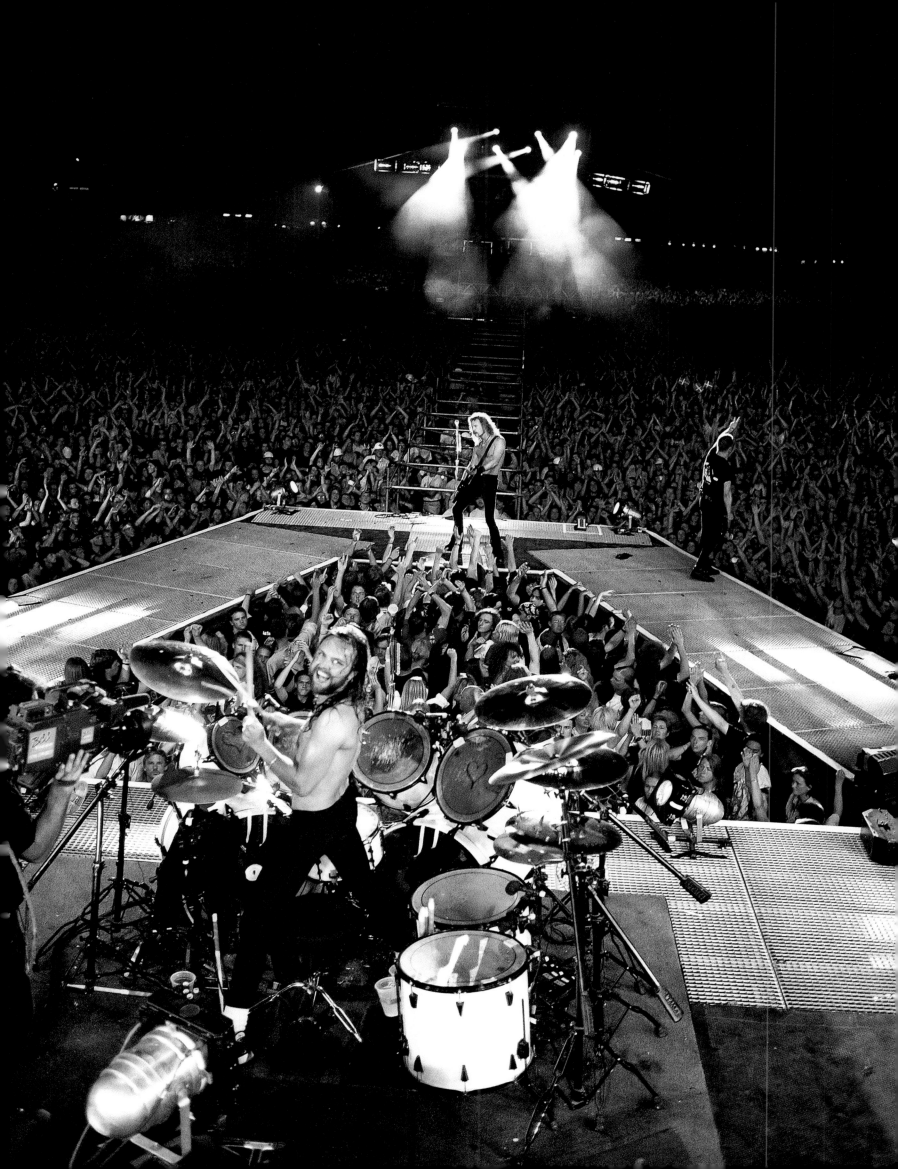

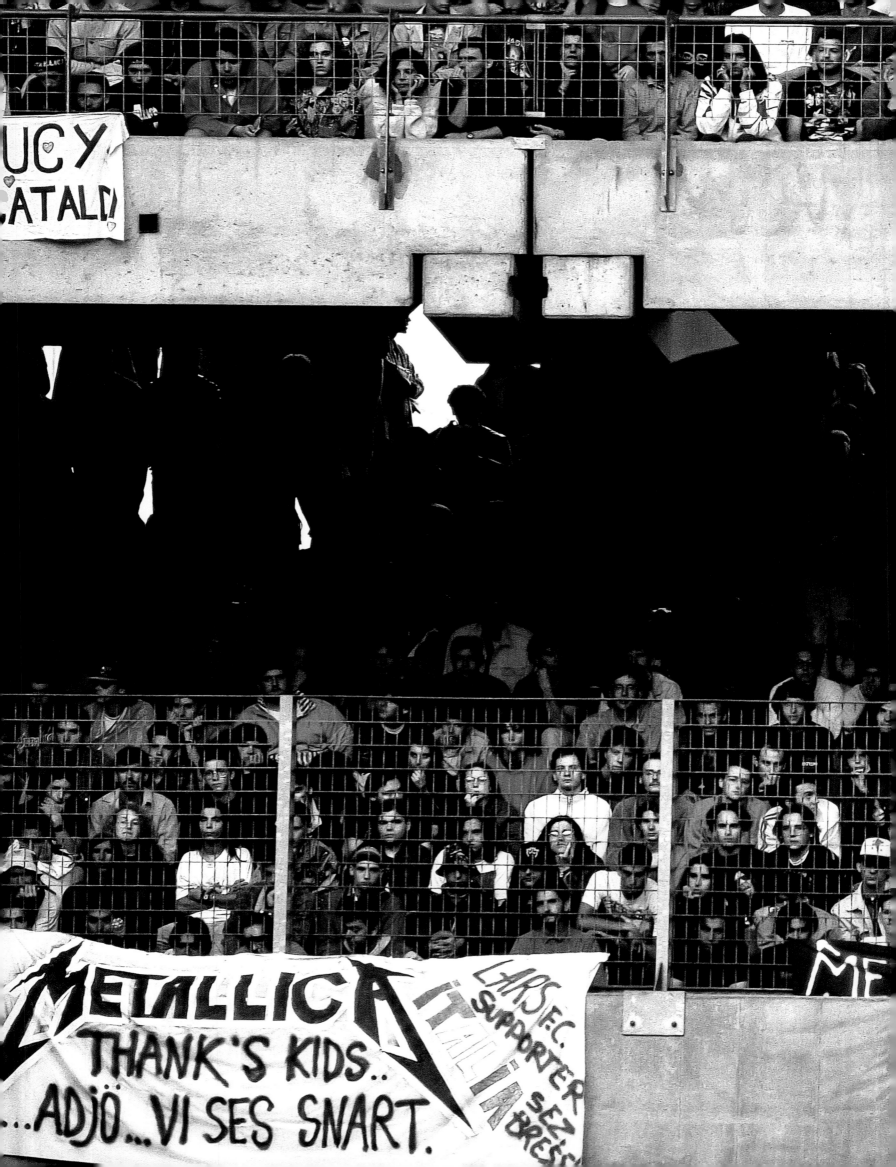

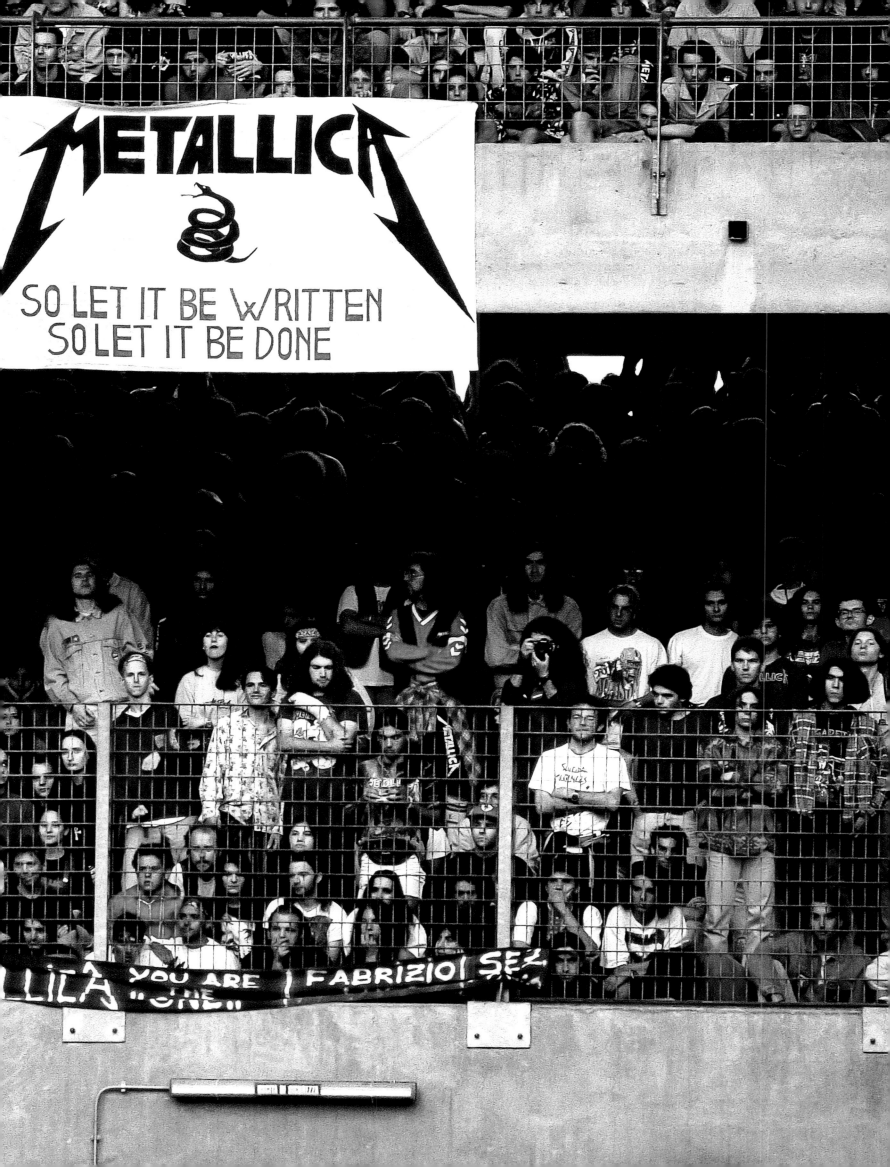

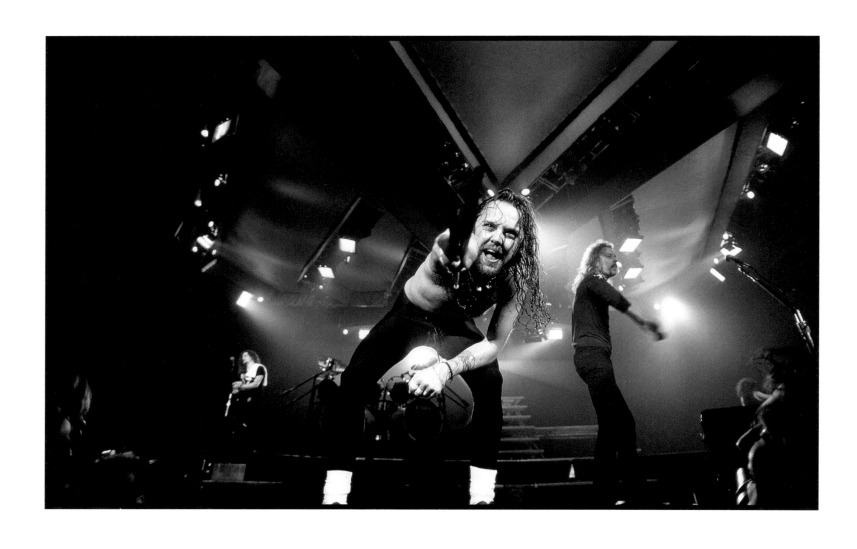

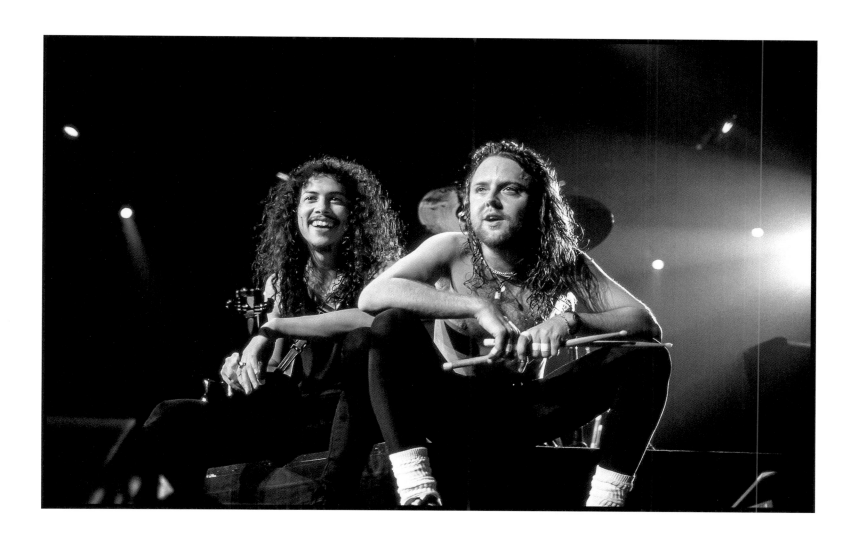

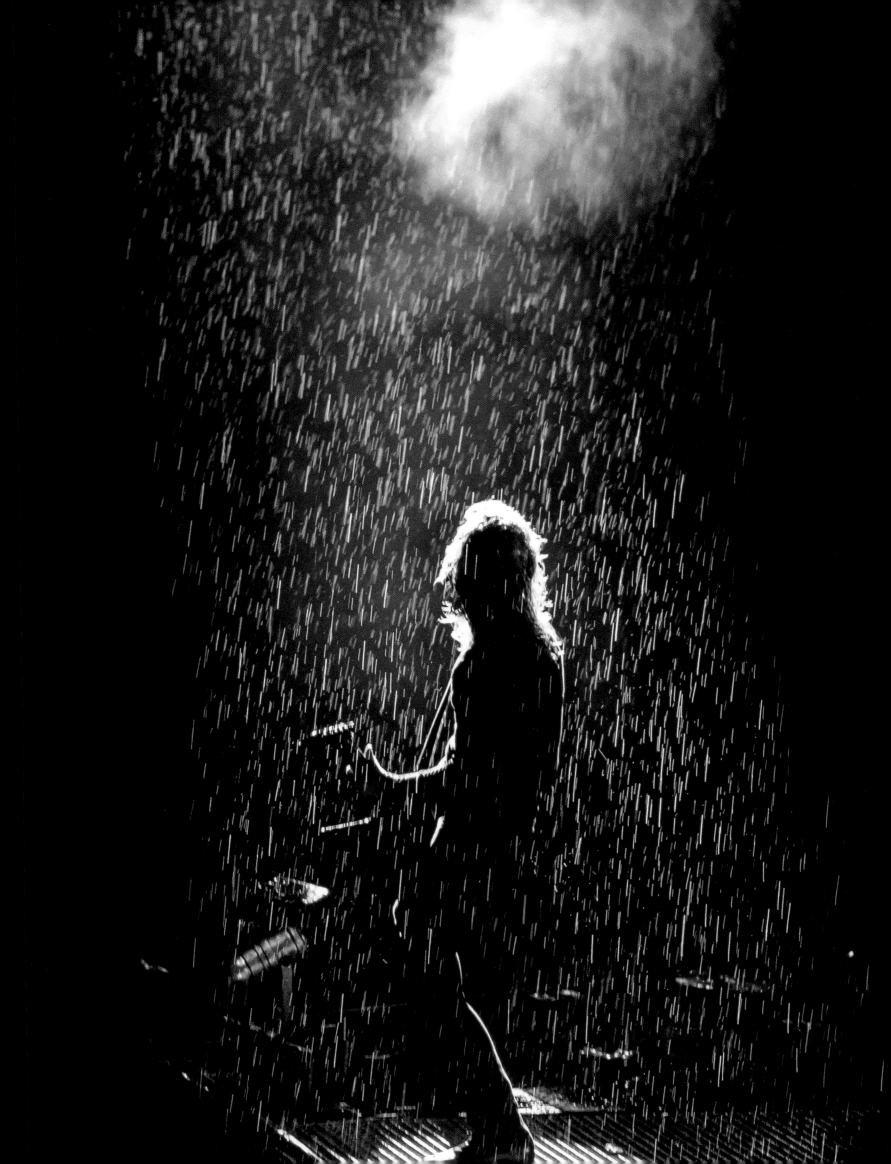

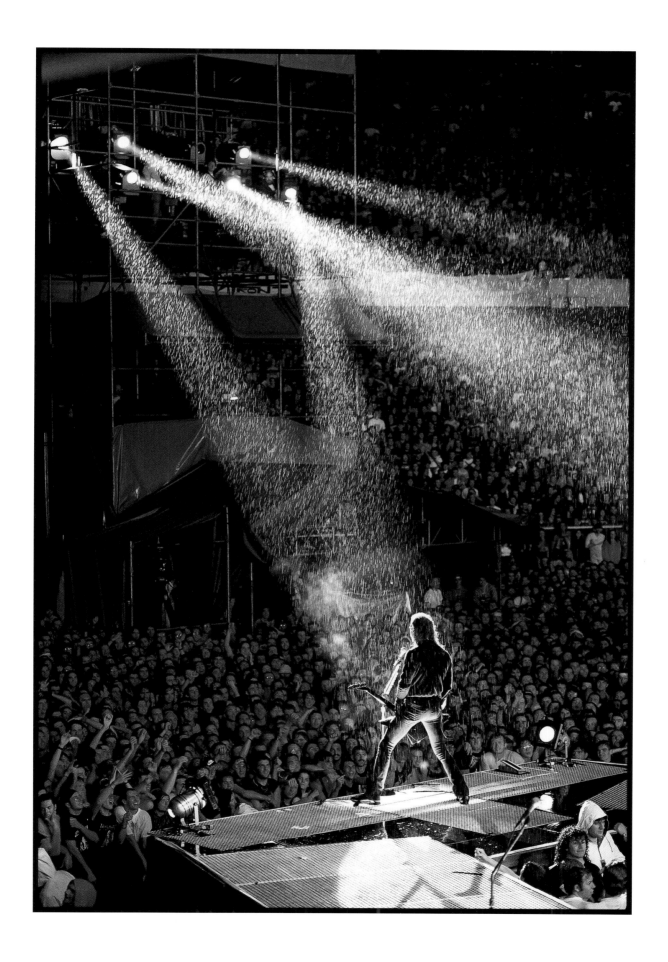

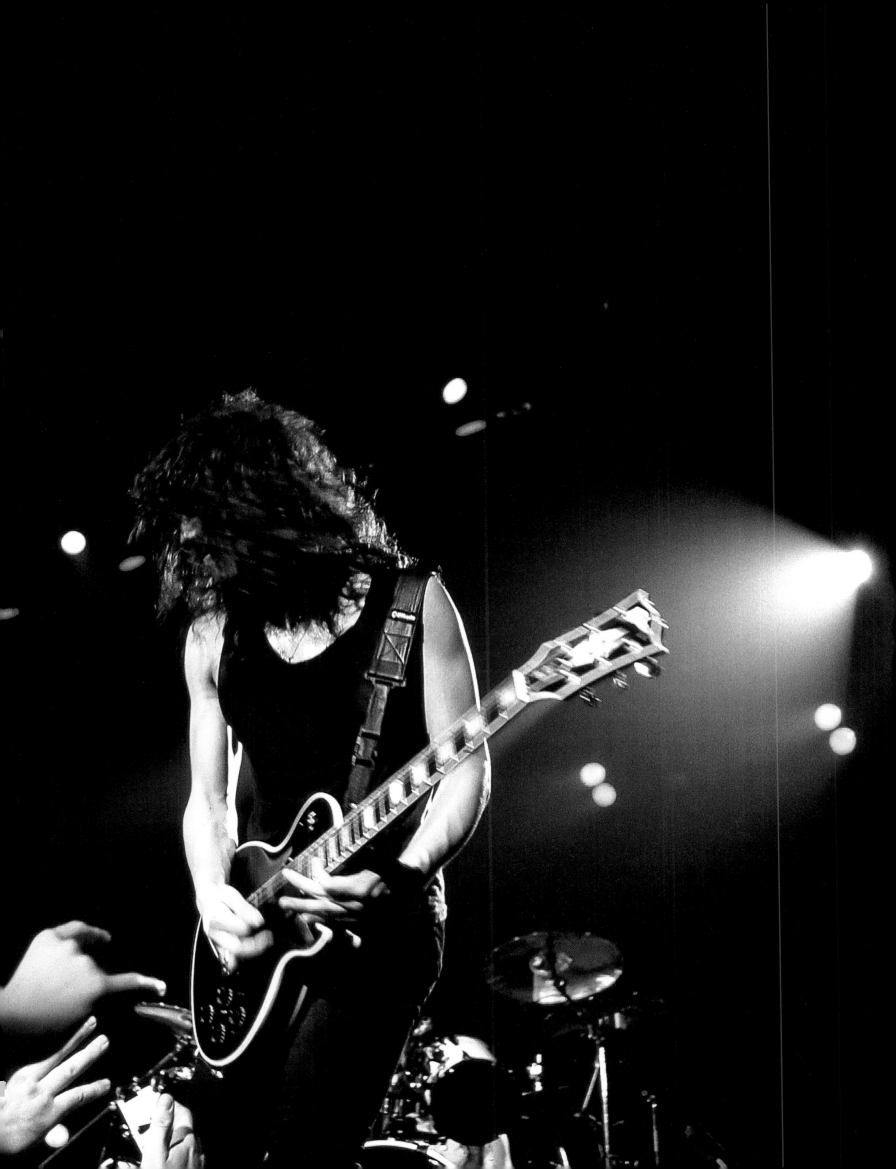

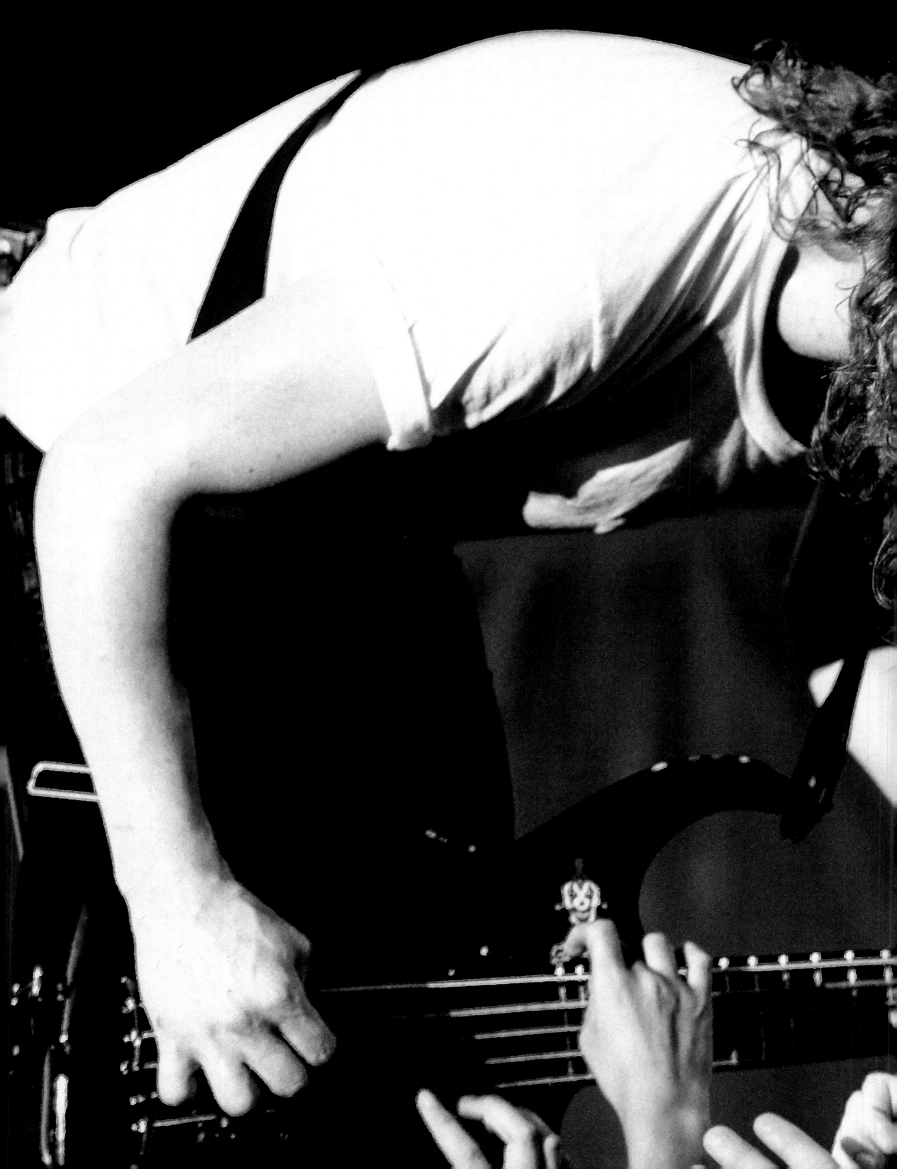

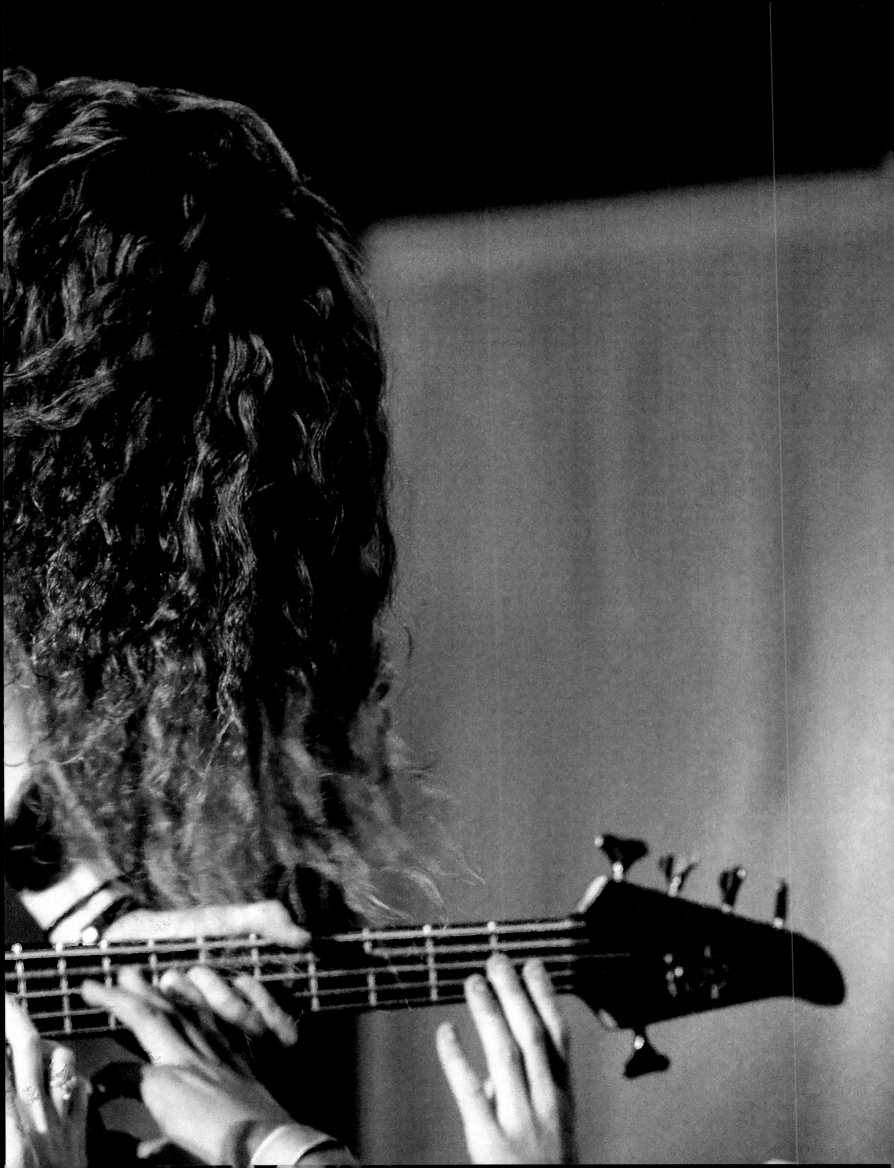

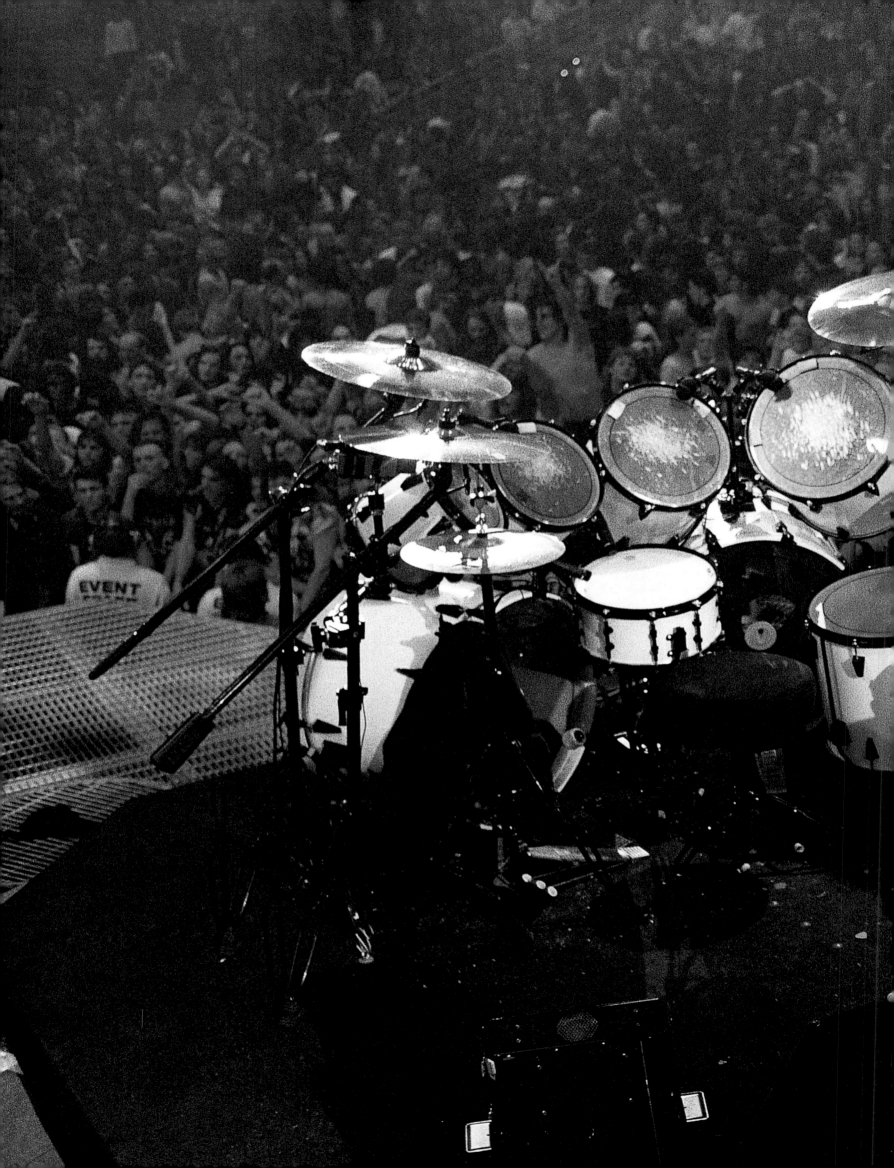

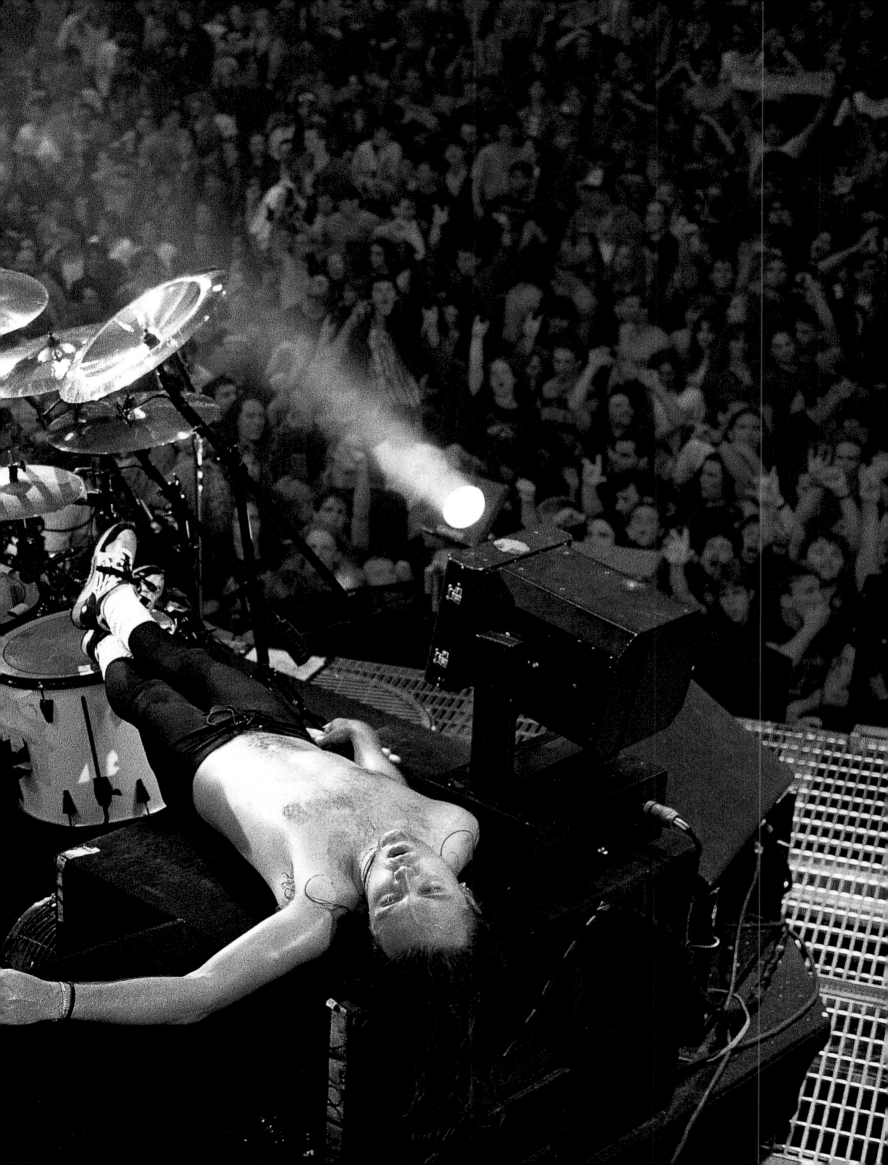

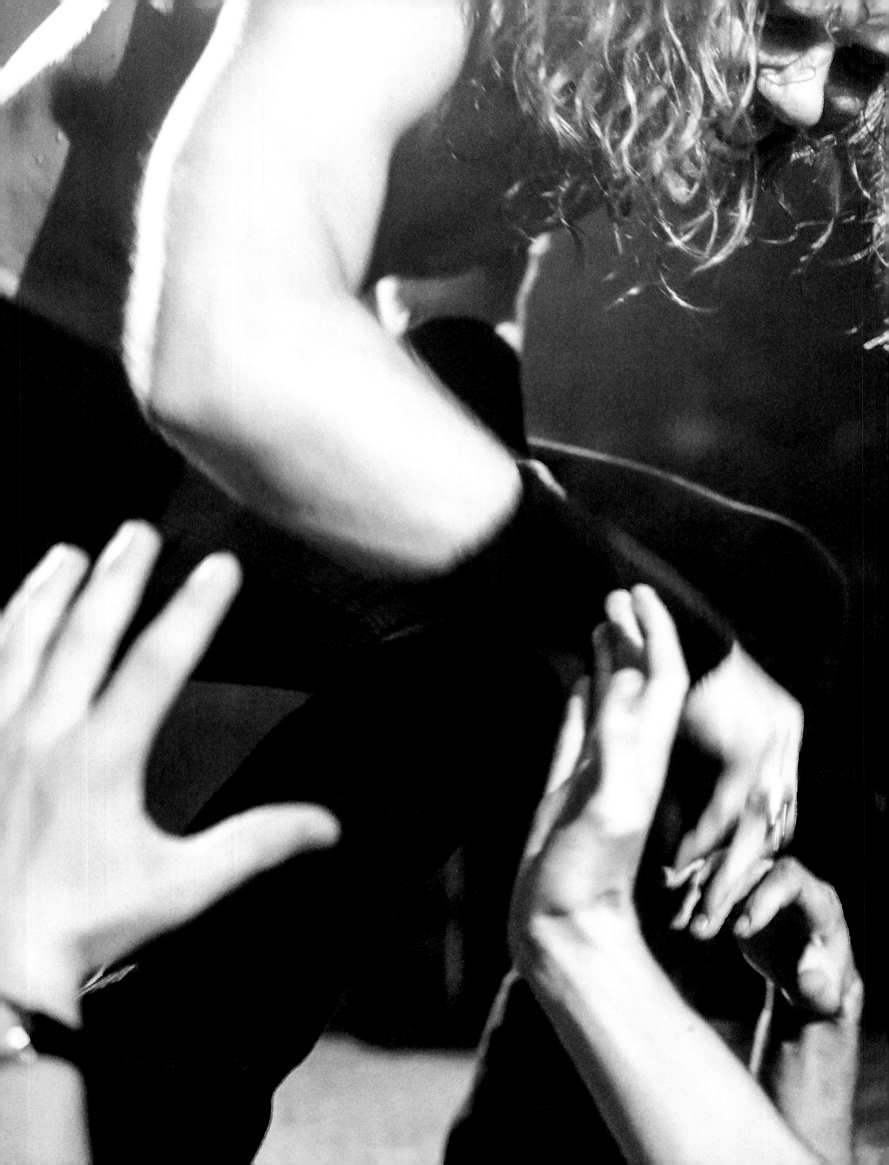

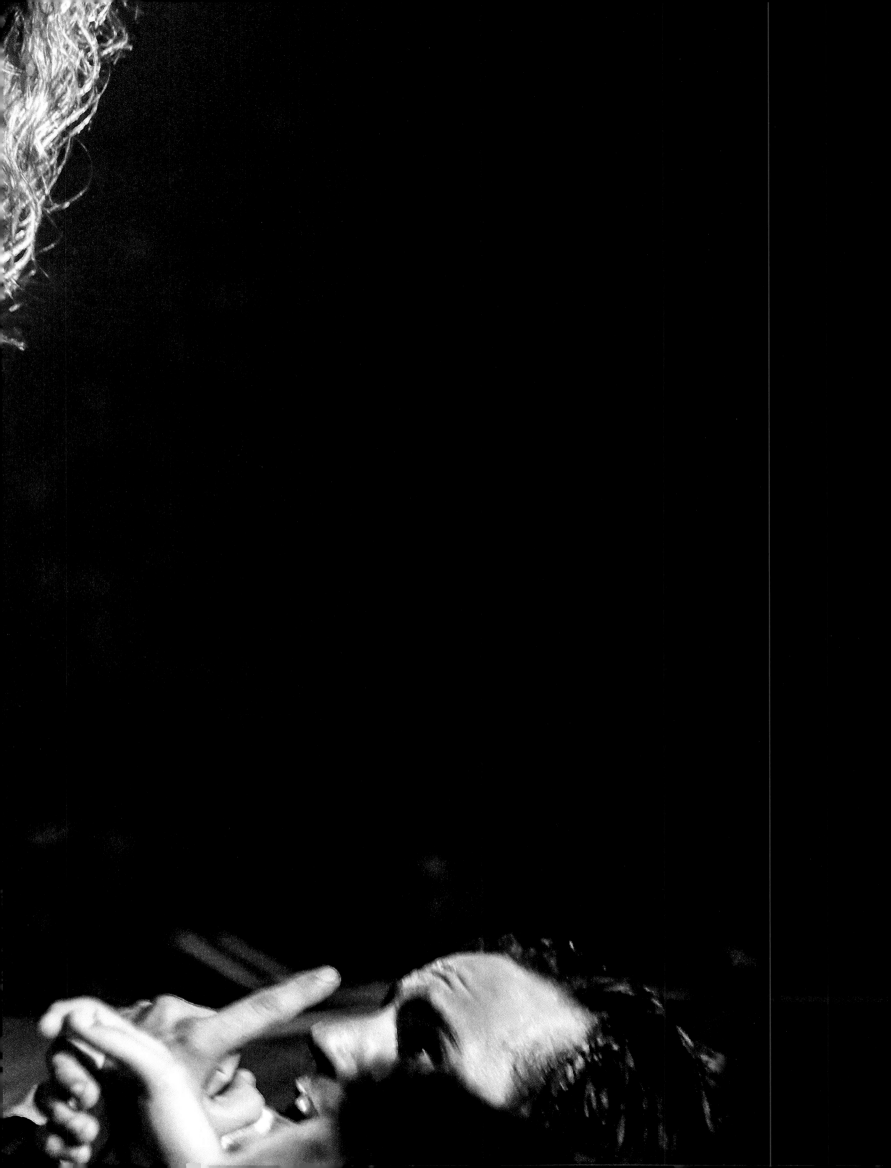

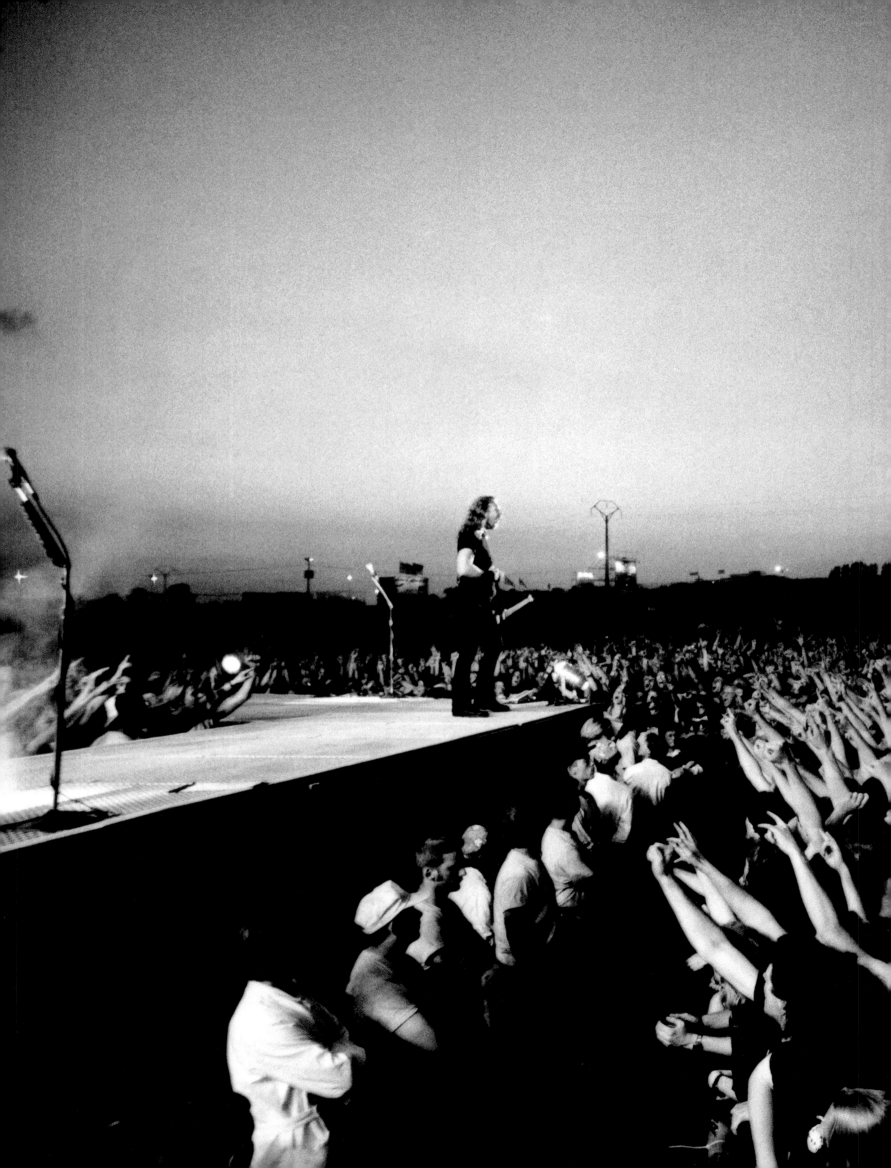

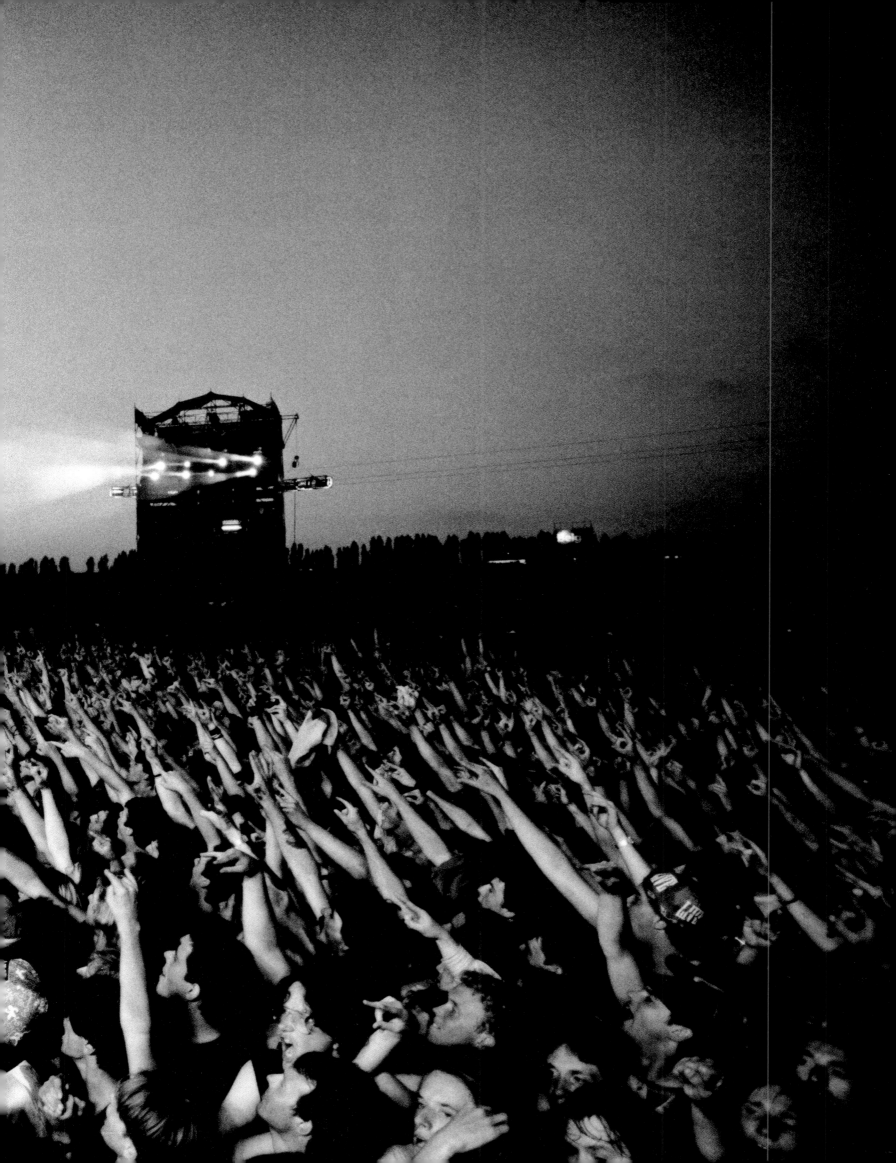

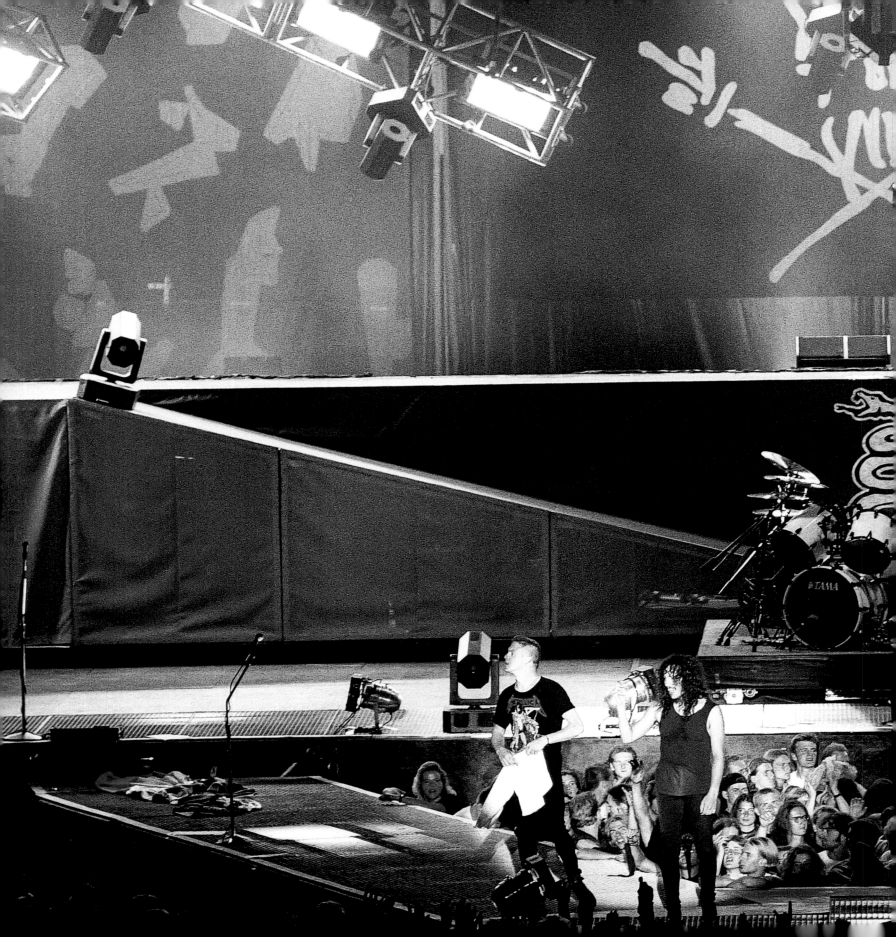

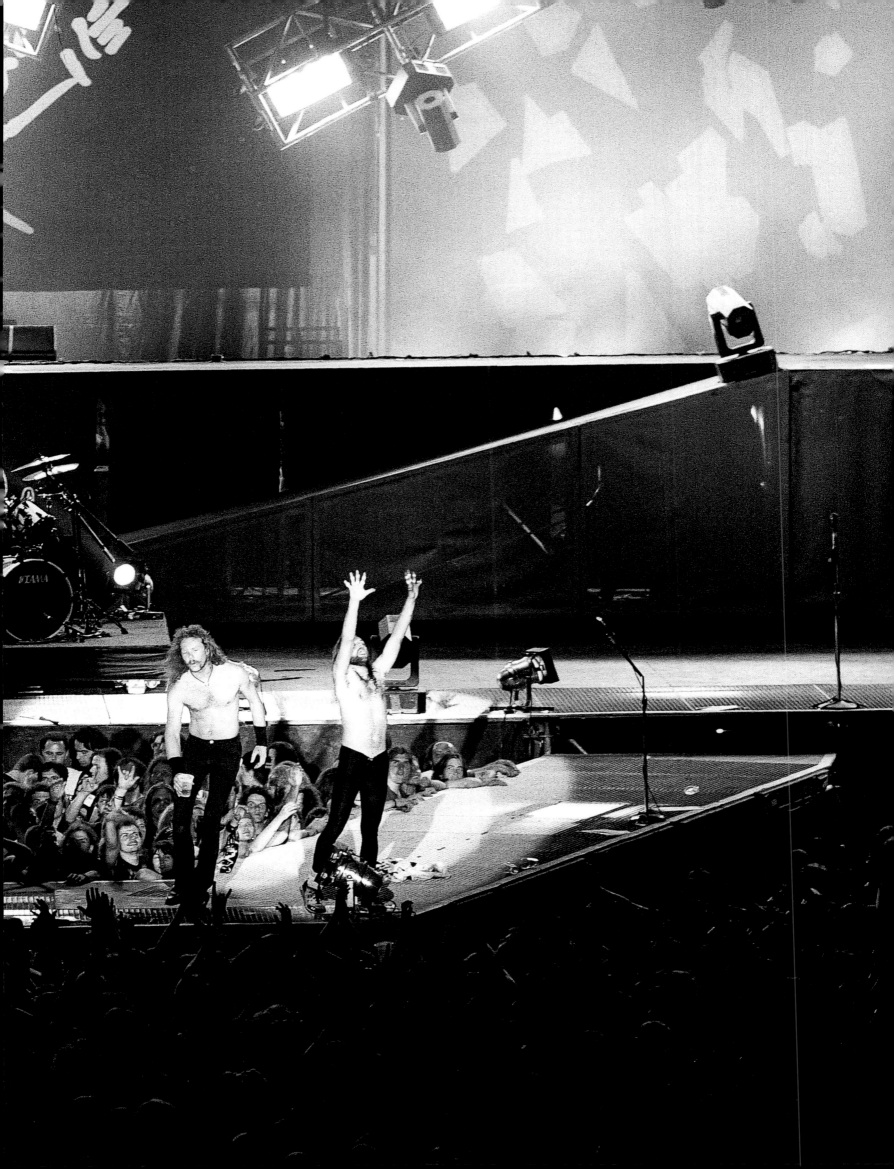

METALLICA (THE BLACK ALBUM) WAS RECORDED BETWEEN OCTOBER 6, 1990 AND JUNE 16, 1991

THE ALBUM WAS RELEASED ON AUGUST 12, 1991

THE BAND TOURED BETWEEN AUGUST 1991 AND JULY 1993 IN SUPPORT OF THE ALBUM, PERFORMING CLOSE TO 300 SHOWS.

MONSTERS OF ROCK TOUR

August 1-2, 1991, North America
August 10 – September 24, 1991, Europe
September 28, 1991, Russia

WHEREVER WE MAY ROAM TOUR

August 10 – September 28, 1991, Monsters of Rock, Europe
October 12 – December 23, 1991, North America
December 31, 1991, Japan
January 4 – April 16, 1992, North America
April 20, 1992, Freddie Mercury Tribute Concert, UK
May 6 – July 5, 1992, North America
July 17 – October 6, 1992, Metallica/Guns N' Roses Stadium Tour, North America
October 22 – December 18, 1992, Europe

NOWHERE ELSE TO ROAM TOUR

January 22 – March 13, 1993, North America
February 25 – March 2, 1993, Mexico
March 12-13, 1993, North America
March 16 – March 23, 1993, Japan
March 26, 1993, New Zealand
March 27 – April 8, 1993, Australia
April 10 – April 11, 1993, Indonesia
April 13, 1993, Singapore
April 15, 1993, Thailand
April 17, 1993, Philippines
May 1 – May 8, 1993 South America
May 19 – July 4, 1993, Europe

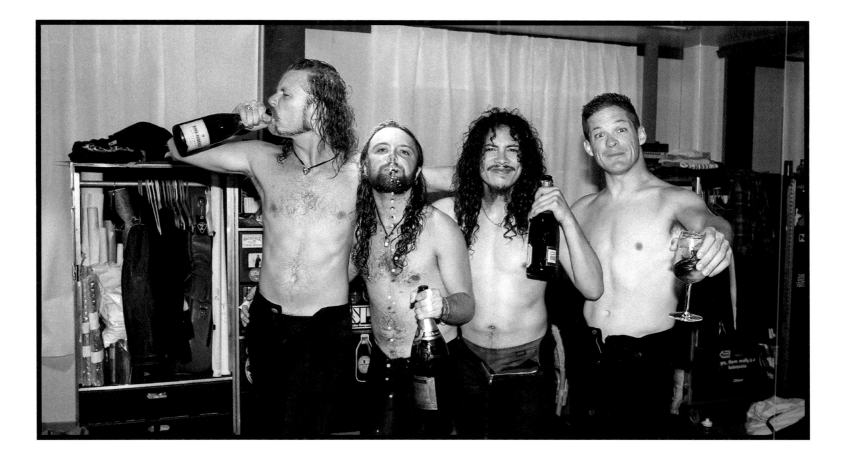

CAPTIONS

Ross Halfin would like to thank Kazuyo Horie, Noriaki Watanabe and David Silver

Reel Art Press would like to thank Steve Matthews for all his help with this project

Editor: Dave Brolan
Art direction and design: Joakim Olsson
Managing editor: Alison Elangasinghe

First published 2021 by Reel Art Press, an imprint of Rare Art Press Ltd., London, UK.

reelartpress.com

First Edition
10 9 8 7 6 5 4 3 2 1

ISBN: 978-1-909526-76-1

Printed by Graphius, Gent